Masters of
Modern Design

THE MONACELLI PRESS

George H. Marcus

Masters of
Modern Design
A Critical
Assessment

First published in the United States of America in 2005 by
The Monacelli Press, Inc.
611 Broadway, New York, New York 10012

Copyright © 2005 by The Monacelli Press, Inc.
Text copyright © George H. Marcus

All rights reserved under International and Pan-American
Copyright Conventions. No part of this book may be
reproduced or utilized in any form or by any means, electronic
or mechanical, including photocopying, recording, or by any
information storage and retrieval system, without permission
in writing from the publisher. Inquiries should be sent to
The Monacelli Press.

Library of Congress Cataloging-in-Publication Data

Marcus, George H.
 Masters of modern design : a critical assessment / George H.
Marcus.
 p. cm.
 Includes bibliographical references and index.
 ISBN 1-58093-160-X
 1. Designers--Biography--History and criticism. 2. Design--
History--20th century. I. Title.
 NK1390.M272 2005
 745.2'092'2--dc22
 2005020086

Design by David Blankenship

Typeset in Foundry Form Serif and Foundry Form Sans

Printed and bound in China

The Library
University College for the Creative Arts
at Epsom and Farnham

745.
209
22
MAR

82574

7

170

172

173

1

William Morris

9

2

Henry van de Velde

23

3

Josef Hoffmann

35

4

Frank Lloyd Wright

47

5

Le Corbusier

63

6

Marianne Brandt

77

7

Raymond Loewy

91

8

Charles and Ray Eames

105

9

Achille Castiglioni

119

10

Ettore Sottsass, Jr.

133

11

Shiro Kuramata

147

12

Philippe Starck

159

Preface

When I set out to write this book after having taught a course of the same name at the University of Pennsylvania, I still imagined that the chapters would present evenhanded surveys of the work of these twelve masters of modern design. But that's not how it worked out. The format was slender for that, and in any case larger studies and monographs that do greater justice to such coverage are readily available. What happened as the writing evolved is that I became more interested in how these designers have been cast by critics and historians and especially how they have been portrayed against the vicissitudes of modernism, the dominant aesthetic of twentieth-century design. Each of these designers took a definite stance with regard to modernism; as major figures immersed in the currents of design, they could hardly avoid it. Even when their purpose was to contradict it, none escaped its grasp. Nor were they isolated or alone; their issues, it turns out, were closely interrelated, and the extensive connections that may be found among these designers was the great surprise of my research.

Modernism, like Art Nouveau, the movement that preceded it, rejected the historic styles of the past, but took its repudiation still further by rejecting any sort of ornamentation as well. The modernist aesthetic was spare and puritanical, and deadly serious, emphasizing a belief in the utilitarian benefits that economical and honestly made products would bring to the lives of the masses; with this in mind, there was little need to decorate the useful forms that design sought to improve. The triumph of modernism was not inevitable, however, even if the architectural historian Nikolaus Pevsner insisted in his *Pioneers of the Modern Movement* (1936) that it was the "genuine" (and, as he added in later editions, "legitimate") style of his century.[1] But it would be hard to deny Pevsner's prescience — and the staying power of the philosophy in his book. His volume established the direction of twentieth-century design history and discourse, and, through its several editions and many reprints, it was for decades the most widely read source on design. Pevsner's vision of what design should be has now been critically discredited, but the modernist aesthetic he disseminated, with its unwarranted presumption of superiority over other styles, has overwhelmed every other viewpoint, and it continues to color the public's understanding of design and the creative philosophy of much of design practice today.

The demise of modernism was much heralded (but never realized) in the latter part of the twentieth century. Postmodernism's theoretical rejection of its ideals in the 1980s had little lasting effect. The emergence of divergent decorative motifs and the revival of historic forms that accompanied postmodernism were minor skirmishes on the battlefield of modernism, squelched uprisings in the continuing rampage of the modernist psyche. The reintroduction of ornament was short-lived, and the pillars and pediments we see on so many buildings today are but mannerisms distanced from any content that these gestures might have had a quarter century ago. The sole legitimate legacy of postmodernism has been the ironic humor that has inserted itself into design, allowing for the introduction of allusion and figuration, an accommodation that modernism has graciously made rather than any rupture in the integrity of its armor.

Recently, however, another chink has appeared, the challenge of historicism in the work of Philippe Starck. Alone of all contemporary designers, Starck has engineered a solid rapprochement between the modern present and the historic past, and his mass-produced Louis Ghost plastic chair in a distilled, eighteenth-century form (see Starck, fig. 13) has unexpectedly been accepted in modernist circles. But no one has with equal conviction brought us a rapprochement with ornamentation, the last taboo of the modernist aesthetic; if that were to be achieved, the unity of sculptural form and surface ornament that existed in design before modernism would finally be restored.

Cornwall, Vermont
June 2005

William Morris
Joy to the maker

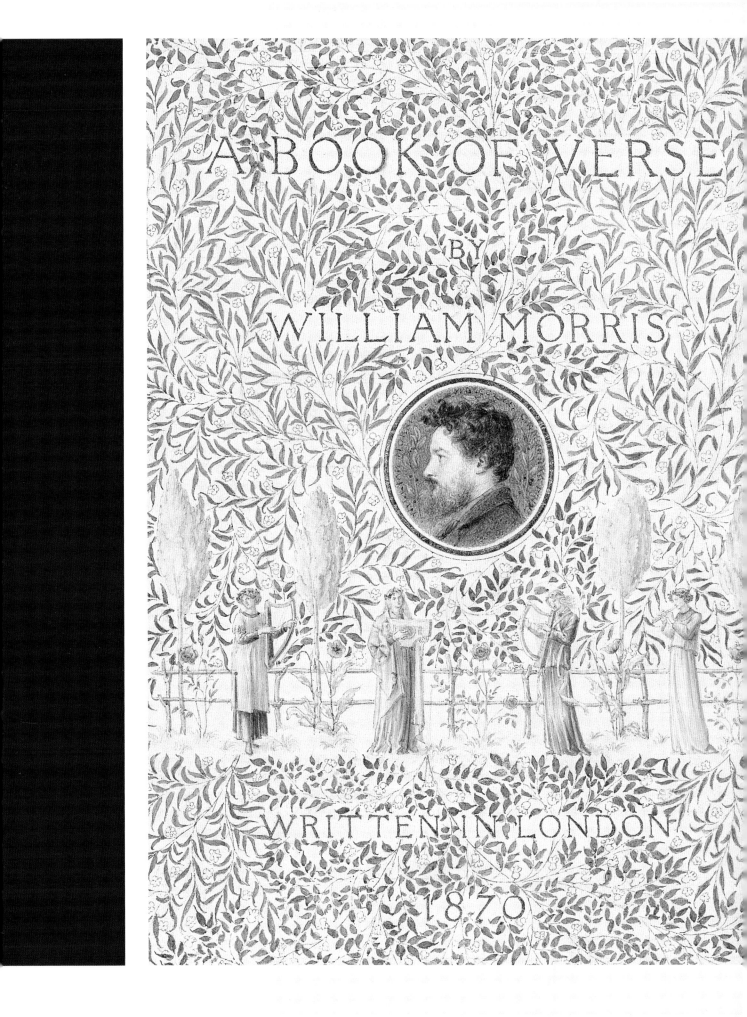

A BOOK OF VERSE

BY

WILLIAM MORRIS

WRITTEN IN LONDON

1870

Design begins with William Morris (1834–1896), or rather modern design begins with William Morris (fig. 1), for by introducing a new aesthetic of the everyday object, this Victorian artist, designer, entrepreneur, poet, and social critic established the ground rules for a new approach to design discourse. Morris defended simplicity at a time when intense eclecticism and a profusion of ornament were *de rigueur,* and he emphasized the values of craftsmanship and the honest use of materials when mass production was flooding the market with "cheap" and "nasty" products.[1] Most important, he was convinced that design should be democratic, devoting himself to educating the public about its ennobling possibilities. He repeatedly admonished the large audiences of working people who came to hear his celebrated lectures to "have nothing in your houses that you do not know to be useful, or believe to be beautiful,"[2] and he expected that his decorating firm, Morris and Company, would be able to provide them economically with all the useful and beautiful objects they needed.

As progressive as his reform principles of design may have been, aspects of Morris's aesthetic were retrogressive from the viewpoint of twentieth-century modernism. For Morris—and for his contemporaries—design meant decoration, and the aesthetic controversies of the nineteenth century (unlike those of the twentieth) centered not on if ornament should be applied to products and household interiors but on what type and what style of decorative design should be introduced. Some supported a close and realistic adherence to nature, while others, such as the architect Owen Jones in *The Grammar of Ornament* (1856), called for conventionalized geometrical motifs that would adapt natural forms to a new ornamental orthodoxy. Morris preferred his design somewhere in between, "suggestive rather than imitative"[3] of nature. He looked to the medieval period, which he, like many other supporters of the Gothic Revival style, valued not only for its artistic naturalism but also for the moral authority they inferred from its history. In so doing, he advocated a second retrogressive stance, the return to a model of individual workmanship based on the social organization of medieval craft guilds. He lamented the alienation of the individual that resulted from large-scale industrial production, which he blamed for a stranglehold on design in his day that he saw as debasing quality and devaluing creativity.

In rejecting industrialization, Morris embraced an ethical system for design in which each object carried a message greater than the sum of its physical attributes. What was most important for him was the spirit of the human endeavor that had contributed to its manufacture. The pleasure that man took in his labor became the guiding principle of his aesthetic, and he attributed value to any object that had given "joy to the maker"[4]—hardly possible with products turned out in identical series through the division of labor, an industrial system that broke down the stages of production into distinct components, each carried out by a different worker. His faith in the inevitability of an egalitarian, Marxist social system based on an innate, universal love of meaningful handiwork took him to extremes of political activism, which, for all of his commercial and critical success, turned him into a somewhat tragic and, for some of his contemporaries, foolish figure. One need only read his utopian

1
C. Fairfax Murray (portrait of William Morris, after a photograph) and George Wardle (ornamentation). Title page of *A Book of Verse* by William Morris, 1870. Watercolor and ink, with gilding. Victoria and Albert Museum, London. This keepsake volume of Morris's poetry was executed in calligraphy by Morris and his associates.

novel *News from Nowhere* (1890), depicting a communitarian society in which everyone shares a devotion to labor and craftsmanship, to realize how great his frustration with the dispassionate, laissez-faire structure of Victorian England must have been.

Morris's attitudes had come principally from John Ruskin, the nineteenth century's most eloquent art critic, whose writings Morris knew even before his years at Oxford, when the two became acquainted. It was Ruskin's *Stones of Venice* (1853), particularly its chapter "The Nature of Gothic," that formed the core of Morris's aesthetic thinking. When Morris reprinted this chapter as a separate publication at his Kelmscott Press in 1892, he assured his readers that "in future days" it would "be considered as one of the very few necessary and inevitable utterances of the century."[5] In a blistering condemnation of industrialization, unexpectedly inserted in a discussion of the expressive superiority of Gothic creativity, Ruskin had lamented: "We have much studied and much perfected, of late, the great civilized invention of the division of labour; only we give it a false name. It is not, truly speaking, the labour that is divided; but the men:—Divided into mere segments of men—broken into small fragments and crumbs of life; so that all the little piece of intelligence that is left in a man is not enough to make a pin, or a nail, but exhausts itself in making the point of a pin or the head of a nail."[6] Ruskin would have none of this dehumanization, nor the extreme refinement of machine-made wares, and he railed especially against the impersonality of the high finish and godless perfection that the machine offered. He took solace in the deeply individualistic and spiritual nature that he saw as infusing the creation and ornamentation of Gothic buildings. Every aspect of the Gothic style that Ruskin preferred—roughness, inaccuracy, asymmetry, irregularity—was antithetical to the principles of refinement espoused in his time, which, not coincidentally, were those that could be best achieved through machine manufacture. Morris inherited Ruskin's values, and his reliance on hand manufacture meant that most of the goods sold by his firm remained beyond the reach of common citizens. He never did succeed in achieving his goal of the universal accessibility of beautiful and useful design.

Morris did not set out to be a craftsman when in 1853 as a young man with an independent income he went off to study at Oxford. (Nor could he have, given his social position; yet his success in restoring what he called the "lesser arts" to a place of honor paved the way for others afterward to do so.) The church, architecture (as an apprentice in the office of the Gothicist George Edmund Street), and then painting preceded his settling on the decorative arts. The decision came about through happenstance: the exigencies of decorating and furnishing his own living spaces—the bachelor quarters he took in London with the painter (later Sir) Edward Burne-Jones when Street's office moved there from Oxford; and then, after he had become engaged in 1858 to his beguiling model Jane Burden, Red House, in Kent—led to a realization that the decoration of interiors in a simple reform style could become a lucrative business venture.

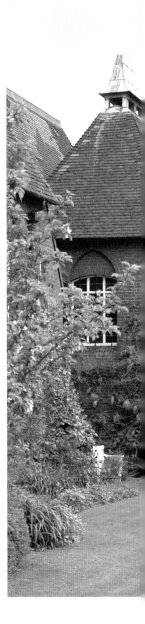

Built in 1859, Red House (fig. 2), which Morris commissioned from Philip Webb, a colleague in Street's office, took much of its form from Morris's vision. The picturesque elements of vernacular building that provided its formal vocabulary were favored by both the client and the architect, who chose for the exterior the red-orange bricks that he admired in rural structures but which had long been out of fashion. Specifically medieval touches, such as pointed arches, turrets, and asymmetrically placed windows in a variety of shapes and sizes, add special charm to the design. Such elements were not restricted to the exterior, for Morris's house also included romantic statements in its interior—an imposing brick hearth, massive oak staircase (fig. 3), medieval-style fittings, and bold decorative embellishment on walls, ceilings, and much of its furniture. Designs depicting heroic exploits, both classical and chivalric, as well as simple naturalistic and abstract patterns, were painted as murals or were worked as embroidery panels following the sketches of Morris, Burne-Jones, and their mentor and friend, the Pre-Raphaelite painter Dante Gabriel Rossetti. The decorative painting and needlework for Red House were executed by the Morrises, aided by friends from Oxford and their wives, who rode the ten miles out from London to enjoy a visit to the country and the good fellowship that was to be found in working together to create a new

2
Philip Webb. Red House, Bexleyheath, Kent, 1859. Designed for William Morris

3
Philip Webb. Red House, 1859. Medieval-style oak staircase with ceiling painted by William and Jane Morris

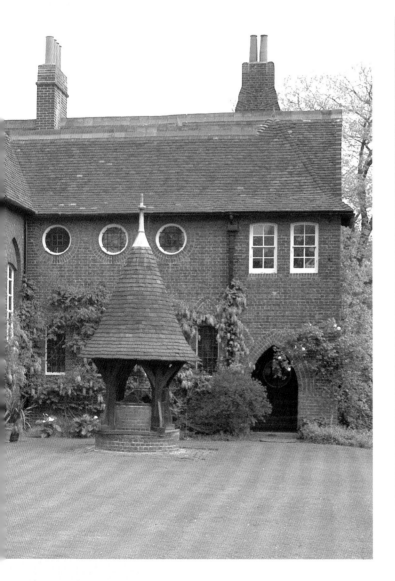

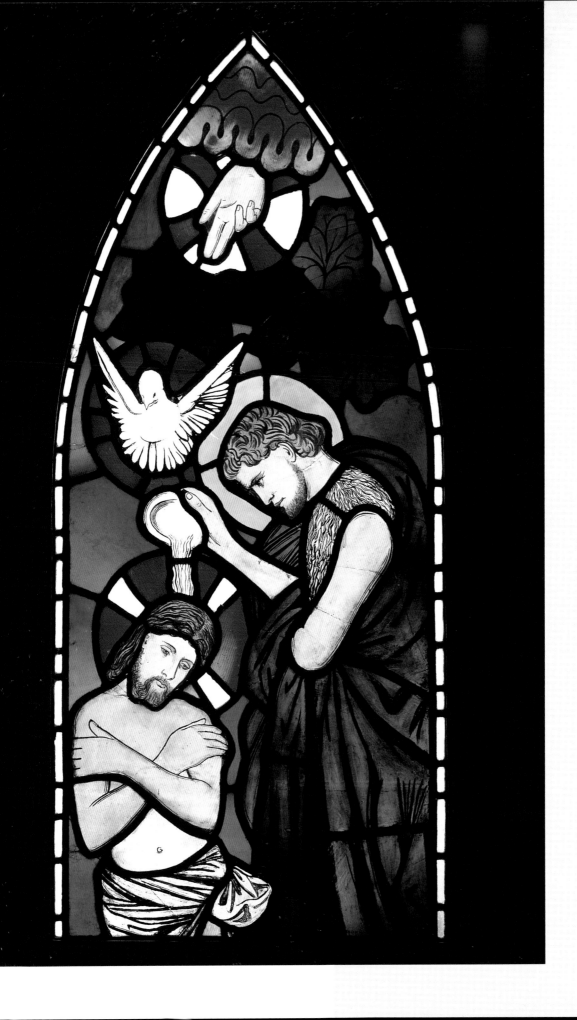

approach to interior decoration. The bonhomie of these weekend visits, perhaps reminding them of undergraduate days, and the group's aspirations for the acceptance of their new style of ornamental handwork led them to create an innovative decorating establishment. In 1861 Morris, Burne-Jones, Rossetti, and Webb were joined by the somewhat more senior painter Ford Madox Brown and two Oxford colleagues, Peter Paul Marshall and Charles Faulkner, in founding the cooperative firm Morris, Marshall, Faulkner and Company, with Morris serving full-time as paid business manager. Their goal was to make simple furnishings available at prices that many could afford, while raising design standards and improving taste in England. (The company endured for about fifteen years, although not without considerable dissension about the amount of time the partners spent on the firm's work and their remuneration; this led, in 1875, to its reorganization under the sole ownership of Morris and the change of its name to Morris and Company.)

Morris, Marshall, Faulkner and Company, using designs supplied by the partners and produced in its workshops in London (as well as by other manufacturers), was soon caught up in the medieval revival. Stained glass (fig. 4) for newly constructed Gothic churches or those under restoration gave immediate impetus to the business, which also offered furniture, tilework, glass, metalwork, and ecclesiastical textiles. Introduced early on was a line of simple rush seating named "Sussex" (fig. 5), based on historic and country furniture. Its departure from popular ornate eclecticism and its suggestion of stylistic anonymity established its success with those who wanted a plain approach to decoration. These chairs were among the most profitable of the firm's offerings. Equally successful was an adjustable armchair designed by Webb and soon known popularly as the "Morris chair," which was similarly based on a rustic form. Webb designed much of the firm's other furniture as well, including the cabinet on a turned stand that Morris painted with four scenes from the story of Saint George and the Dragon (fig. 6). This was one of a number of medieval-style furnishings shown at the International Exhibition in London in 1862, where the firm made its public debut.

4
Sir Edward Burne-Jones. *The Baptism of Christ in Jordan,* 1862. Stained and painted glass. Made by Morris, Marshall, Faulkner and Company. Victoria and Albert Museum, London. This stained-glass panel was probably among the medieval-style works shown at the International Exhibition in London in 1862, when Morris, Marshall, Faulkner and Company made its public debut.

5
"The Sussex rush-seated chairs." Morris and Company catalogue. Victoria and Albert Museum, London

6
Philip Webb (cabinet design) and William Morris (painting). Cabinet on stand with *The Legend of Saint George,* 1861–62. Painted and gilded mahogany, oak, and pine. Made by Morris, Marshall, Faulkner and Company. Victoria and Albert Museum, London

THE SUSSEX RUSH-SEATED CHAIRS
MORRIS AND COMPANY
449 OXFORD STREET, LONDON, W.

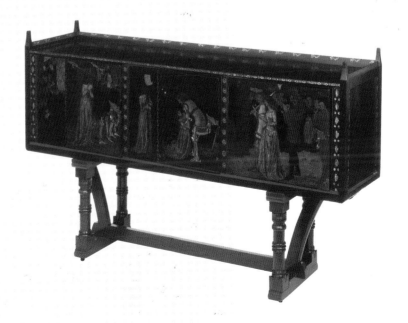

Taking advantage of clients secured by Burne-Jones and Rossetti as fashionable artists, the partners collaborated on important early commissions in London, including the decoration of the Armoury and the Tapestry Room at St. James's Palace (1866–67) and the Green Dining Room at the South Kensington (now Victoria and Albert) Museum (1865–67) (fig. 7). The walls of the Green Dining Room were covered with ornamental patterning arranged in horizontal bands following a medieval precedent, a design more distinctly articulated than the customary entanglement of Victorian decoration. In the panels that cap the solid green-blue dado, painted figures of the months and the zodiac by Burne-Jones (who also did the stained glass figures) alternate with branches of fruit trees designed by Morris; above, an allover pattern of naturalistic olive branches designed by Webb was modeled in plaster and then painted. The gilded classical frieze showing hounds chasing hares culminates in a white ceiling painted with conventionalized floral designs. This layering of richly patterned, if rigorously controlled, ornamentation anticipates the many luxuriant interiors that Morris would produce in the next decades, which became synonymous with his name. Those interiors would be more efficiently decorated, however, with Morris wallpapers and printed and woven textiles.

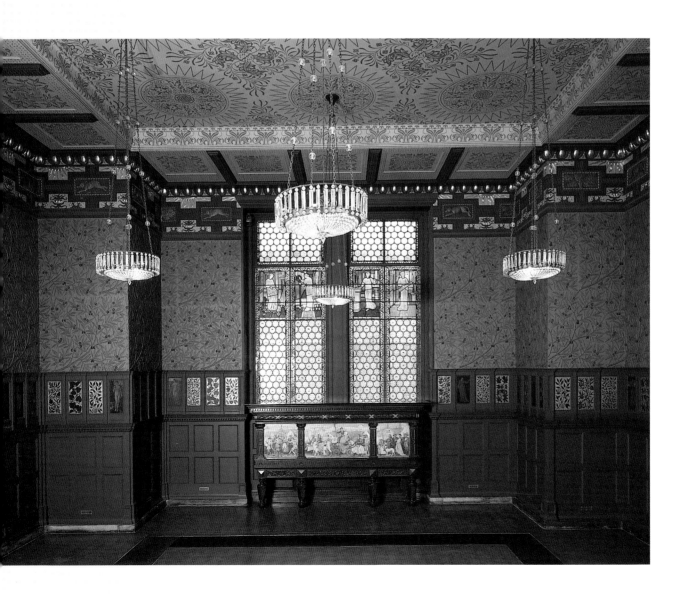

7
Philip Webb, Sir Edward
Burne-Jones, and William
Morris. Green Dining Room,
South Kensington
(now Victoria and Albert)
Museum, London, 1865–67.
Decorated by Morris,
Marshall, Faulkner and
Company. Victoria and
Albert Museum, London

8
William Morris. *Minstrel
(Woman Playing a Lute),*
c. 1874. Stained and painted
glass. Made by Morris,
Marshall, Faulkner and
Company. Victoria and
Albert Museum, London.
Morris also designed the
flowers, simplified from
nature, which decorate the
painted background panels
of this and many other
examples of the firm's
stained glass.

9
William Morris. Design for
Tulip and Willow textile,
1873. Pencil and watercolor.
City of Birmingham
Museum and Art Gallery

10
William Morris. Cray
furnishing textile, 1884.
Block-printed cotton.
Made by Morris and
Company. Victoria and
Albert Museum, London

Pattern was Morris's forte. His talent for decorative design can be seen in all his endeavors, from his early painted and embroidered designs for Red House to the floral backgrounds he provided as settings for figurative stained glass (fig. 8) and the ornamental motifs with which he embellished his calligraphic books. But it was in wallpapers and textiles that his gift for ornamental pattern was most fully explored. Nature was his inspiration, but it was regulated by the artist's sense of order, as he explained to the audience attending his 1881 lecture "Some Hints on Pattern-Designing." Order, he wrote, "both builds a wall against vagueness and opens a door therein for imagination to come in by . . . order invents certain beautiful and natural forms, which, appealing to a reasonable and imaginative person, will remind him not only of the part of nature which, to his mind at least, they represent, but also of much that lies beyond that part."[7] In the final drawing for his early Tulip and Willow printed textile, of 1873 (fig. 9), one can see how Morris systematized the design by choosing two flat colors to animate the dense pattern of willow leaves and using short, repeated, parallel strokes to describe the forms of the flowers. Each of the petals is outlined—for Morris, a necessary technique in pattern design.

His subjects were for the most part flowers, fruit, and animals, depicted with enough variety and feeling to take on anecdotal interest. He combined these motifs into dense and highly structured although not readily apparent arrangements based on underlying rectangular or diamond-shaped grids, with subsidiary designs in reduced scale filling the spaces behind the dominant motifs. This approach worked equally well for printed or woven textiles or for wallpapers, although he clearly distinguished between the degrees of refinement that each technique permitted. Some of his patterns were very complex and extremely difficult to print; his Cray textile (fig. 10) required thirty-four separate printing blocks to achieve its

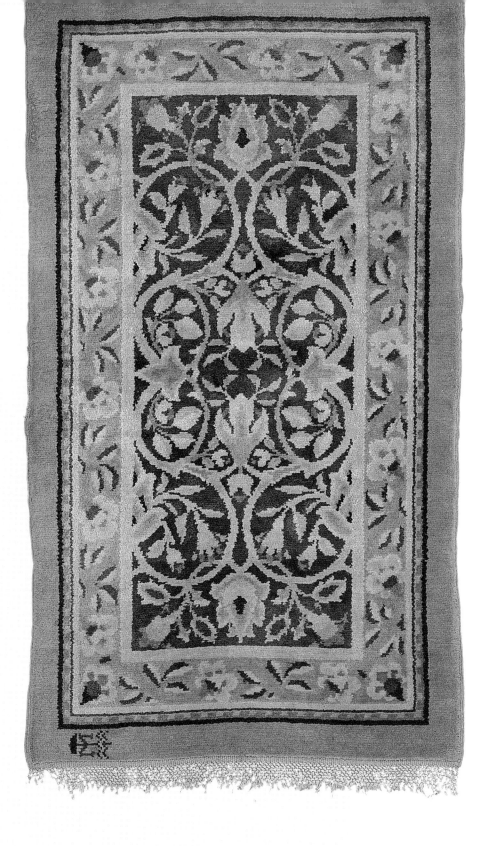

richly colored vibrancy. Morris provided detailed instructions for the execution of his works, and he was assiduous in trying to maintain consistent quality, regardless of whether designs were executed by his own workshop or by the commercial suppliers he called upon when large quantities of goods were required by his business.

Craftsmanship was Morris's obsession. He threw himself into learning a succession of crafts; he wove carpets (fig. 11) and tapestries, which occupied a great deal of his time in his later years, and he made woodcuts to ornament his printed books. He also cared deeply about his materials, going to great lengths to get them right. He spent long hours at the dyeing vat, perfecting the natural dyes that made his textiles so rich. Many of these techniques Morris taught himself, in some cases reviving those then in danger of being lost, such as the labor-intensive art of indigo dyeing, which created a dense blue, and the indigo-discharge printing process, which gave the dyed fabric a two-toned pattern by bleaching out selected areas of color. These white areas could then be dyed with other colors to enrich the design further, as illustrated by the chromatic arrangement of his Strawberry Thief fabric of 1883 (fig. 12). The process of indigo dyeing and discharge printing was described in detail in a Morris and Company catalogue: "The cloth is first dyed all over in an indigo vat to a uniform depth of blue, and is then printed with a bleaching reagent which either reduces or removes the color as required by the design. Mordants [fixatives] are next printed on the bleached parts and others where red is wanted and the whole length of material is then immersed in a madder vat calculated to give the proper tint. This process is repeated for the yellow (welds), the three colours being superimposed on each other to give green, purple or orange. All loose colouring matter is then cleared away and the colours set by passing the fabric through soap at almost boiling heat. The final treatment in the process is to lay the cloth flat on the grass, with printed face to the light, so that the whites in the designs may be completely purified and all fugitive colour removed in nature's own way."[8]

Morris's final obsession was printing, at the Kelmscott Press, which he established in London in 1889. Books were one of his great passions. He not only wrote poetry, fiction, and essays and translated foreign classics but also collected manuscripts, fine typography, and printed books from the past. He paid great attention to the way his literary works were designed, ornamented, and published, but it was not until he was nearing the end of his career that he actually set about making books. When he did, he went at it with immense gusto, publishing sixty-six volumes in less than a decade. Morris designed both books and type, besides creating many of the large decorated initials and ornamental borders and vignettes that tied his works to outstanding examples of earlier printing. He paid great attention as well to production qualities, seeking out exotic handmade papers and special inks, and he closely supervised the hand letterpress production that made his volumes landmarks in the history of fine printing—once again a retrogressive undertaking. While many were modest productions, some were extraordinary in their scale and ornament, most notably the Kelmscott edition of Chaucer with type and borders by Morris and illustrations by Burne-Jones, which appeared shortly after Morris died in 1896 (fig. 13).

11
William Morris. Rug, c. 1879–81. Hand-knotted wool on cotton warp. Made by Morris and Company. Victoria and Albert Museum, London

12
William Morris. Strawberry Thief furnishing textile, 1883. Indigo-discharge and block-printed cotton. Made by Morris and Company. Victoria and Albert Museum, London

Have litel thought but on hir play,
Hir lemman was bisyde alway,
In swich a gree, that he hir kiste
At alle tymes that hym liste,
That al the daunce mighte it see;
They make no fors of privetee;
For who spak of hem yvel or wel,
They were ashamed never a del,
But men mighte seen hem kisse there,
As it two yonge doves were,
For yong was thilke bachelere,
Of beaute wot I noon his pere;
And he was right of swich an age
As Youthe his leef, and swich corage.

THE lusty folk thus daunced there,
And also other that with hem were,
That weren alle of hir meynee;
Ful bende folk, and wys, and free,
And folk of fair port, trewely,
Ther weren alle comynly.

WHAN I hadde seen the counte-
naunces
Of hem that ladden thus these
daunces,
Than hadde I wil to goon & see
The gardin that so lyked me,
And loken on these faire loreres,
On pyn-trees, cedres, and oliveres.

The daunces than yended were;
For many of hem that daunced there
Were with hir loves went awey
Under the trees to have hir pley.

A, lord! they lived lustily!
A gret fool were he, sikerly,
That nolde, his thankes, swich lyf
lede!
For this dar I seyn, out of drede,
That whoso mighte so wel fare,
For better lyf thurte him not care;
For ther nis so good paradys
As have a love at his devys.

OUT of that place wente I tho,
And in that gardin gan I go,
Pleying along ful merily.
The God of Love ful hastely
Unto him Swete-Loking clepte,
No longer wolde he that he kepte
His bowe of golde, that shoon so bright,
He bad him bende it anon-right;
And he ful sone it sette on ende,
And at a braid he gan it bende,
And took him of his arowes fyve,
Ful sharpe and redy for to dryve.
Now God that sit in magestee
Fro dedly woundes kepe me,
If so be that he wol me shete;

For if I with his arowe mete,
It wol me greven sore, ywis!
But I, that nothing wiste of this,
Wente up and doun ful many a wey,
And he me folwed faste alwey;
But nowher wolde I reste me,
Til I hadde al the yerde in be.

THE gardin was, by mesuring,
Right even and squar in compassing;
It was as long as it was large,
Of fruyt had every tree his charge,
But it were any hidous tree The Trees
Of which ther were two or three.
Ther were, and that wot I ful wel,
Of pomgarnettes a ful gret del;
That is a fruyt ful wel to lyke,
Namely to folk whan they ben syke,
And trees ther were, greet foisoun,
That baren notes in hir sesoun,
Such as men notemigges calle,
That swote of savour been withalle.
And alemandres greet plentee,
Figes, and many a date-tree
Ther weren, if men hadde nede,
Through the gardin in length and brede.
Ther was eek wexing many a spyce,
As clow-gelofre, and licoryce,
Gingere, and greyn de paradys,

Canelle, and setewale of prys,
And many a spyce delitable,
To eten whan men ryse fro table.
And many hoomly trees ther were,
That peches, coynes, and apples bere,
Medlers, ploumes, peres, chesteynes,
Cheryse, of whiche many on fayn is,
Notes, aleys, and bolas,
That for to seen it was solas;
With many high lorer and pyn
Was renged clene al that gardyn;
With cipres, and with oliveres,
Of which that nigh no plente here is.
Ther were elmes grete and stronge,
Maples, asshe, ook, asp, planes longe,
Fyn ew, popler, and lindes faire,
And othere trees ful many a payre.

WHAT sholde I telle you more of it?
Ther were so many trees yit,
That I sholde al encombred be
Er I had rekened every tree.

THESE trees were set, that I devyse,
Oon from another, in assyse,
Five fadome or sixe, I trowe so,
But they were hye and grete also;
And for to kepe out wel the sonne,
The croppes were so thikke yronne,
And every braunch in other knet,

Numerous designers in Great Britain and abroad followed the aesthetic lead and the social imperatives of William Morris, with many studio workshops being established from which beautiful and useful objects could be widely disseminated. His immediate disciples were those at home who in 1888 had founded the Arts and Crafts Exhibition Society, which gave its name to the movement of reform design that honored Morris's ideals. Many of these designers also taught crafts, founded schools, and created guildlike organizations, furthering Morris's medieval approach to craft production. Among them was Charles Robert Ashbee, who established the Guild and School of Handicraft in London in 1888, later moving the workshops to the English countryside, where a cooperative community of workers in the medieval tradition was created. In the United States, Morris's influence was broadly felt, as his social and aesthetic positions were selectively transplanted to American soil. They ranged from an adherence to the simplicity of vernacular forms, as seen in the work of Gustav Stickley and his Craftsman Workshops, to the introduction of Morris and Morris-style patterning in tasteful interiors. Morris's goals were also imitated throughout Europe, from the Iris Craft Workshops in Finland to the Wiener Werkstätte in Vienna. Not all of these groups subscribed to his views on the machine, however, many using the machine as a means to achieve Morris's greater social goal of making good design widely accessible.

With his insistence on the virtues of hand production, Morris ensured that machine manufacture would be a key issue in the conflicting ideologies of modernism, one that would not be resolved until the 1920s, when an aesthetic of the machine transformed the valuation of design. But Morris's objections to the use of the machine were not as staunch as is often made out, and many of his followers were more deeply devoted to his words than to his own practical example. As a businessman, he had little hesitation in farming out the production of his own textiles and wallpapers to suppliers who used power machines to run them off in large quantities. And he recognized that certain tedious and repetitive undertakings, such as weaving plain cloth, would be better and more easily done industrially by machine. In the end he was a realist, and because he understood that the machine would not go away, he even offered advice for taking honest advantage of its own special temperament: "If you have to design for machine-work at least let your design show clearly what it is," he instructed. "Make it mechanical with a vengeance, at the same time as simple as possible."[9]

13
William Morris, with illustrations by Sir Edward Burne Jones. *The Works of Geoffrey Chaucer.* London: The Kelmscott Press, 1896. Victoria and Albert Museum, London

2

Henry van de Velde
A line is a force

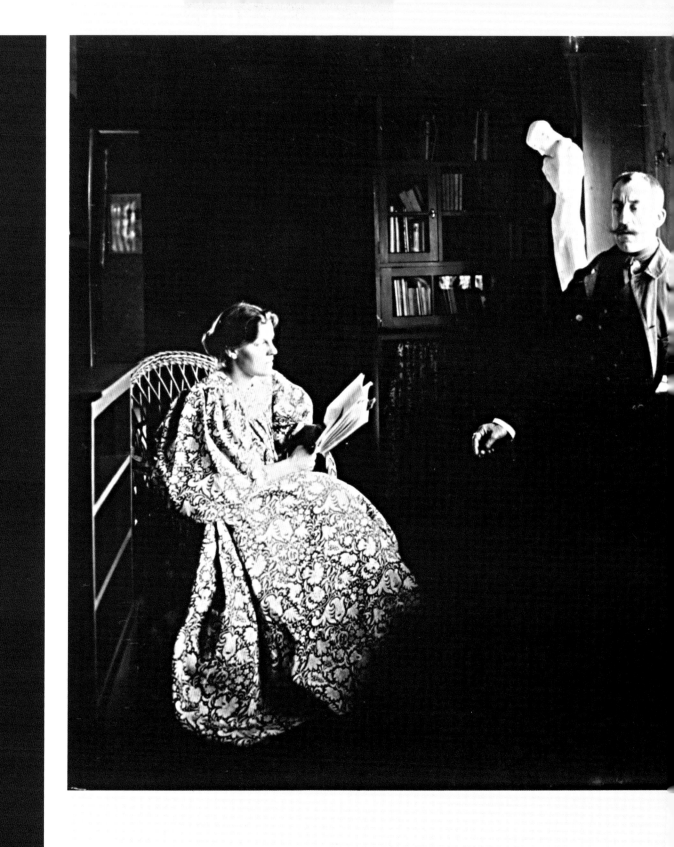

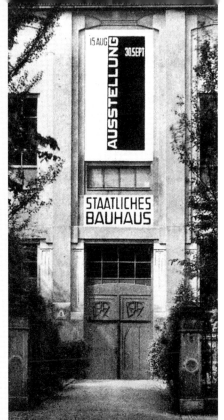

1
Henry van de Velde and
Maria Sèthe van de Velde at
Bloemenwerf, c. 1896.

2
Henry van de Velde.
Entrance to the Academy of
Art, Weimar, 1904–11. The
Bauhaus took over the
school in 1919; the banner
above the entrance adver-
tises the first exhibition of
the Bauhaus, in 1923.

The reverence that modernism pays to the Belgian designer Henry
van de Velde (1863–1957) has always seemed suspect, for his decora-
tive and expressive Art Nouveau creations are completely at odds
with the austere and anonymous products commonly associated
with functionalist design. His reputation as a "pioneer" of the mod-
ern movement originates in the writings of the German-born British
architectural historian Nikolaus Pevsner, who considered him the
crucial link between William Morris, the nineteenth-century precur-
sor of modernism, and Walter Gropius, the founder of the Bauhaus
design school—for Pevsner, modernism's leading figure. To justify
counting van de Velde among the pioneers of a movement that
rejected ornamentation of any kind, Pevsner relied more on what he
said than what he did, emphasizing his rhetorical statements about
rationality, engineering, and the benefits of industrial production,
and playing down the brilliance of his new organic decorative style.
Indeed, Pevsner, as he plainly admitted, was perplexed by van de
Velde's "over-decorated works."[1]

Van de Velde has also been considered a linchpin in the lineage of
modernism because in 1914, as Gropius tells it in his essay "The
Theory and Organization of the Bauhaus" (1923),[2] van de Velde, then
in Germany, recommended Gropius to succeed him as director of the
school of arts and crafts in Weimar. When Gropius eventually
received the appointment, it was as director of the school of arts
and crafts and the academy of art combined, and it was these insti-
tutions and the buildings that van de Velde had designed for them
that he transformed into the Bauhaus (fig. 2). But van de Velde's
recommendation of Gropius was not as decisive as one might sup-
pose, Gropius having failed to acknowledge that he was only one of
three prominent German designers to whom van de Velde gave
equal support (the others were August Endell and Hermann Obrist).[3]

Moreover, the early Bauhaus, with an arts and crafts orientation following the atelier teaching methods of van de Velde, had few of the attributes that would later give it pride of place in the history of industrial design. The Bauhaus did not begin to assume its seminal position until 1924, five years after its founding, when Gropius discarded its initial bias towards the creation of individual objects by workshop production to support a program for the development of prototypes for industrial manufacture.

In changing the direction of the Bauhaus, Gropius was following the progressive principles of the German Werkbund, an organization of designers, manufacturers, and businessmen founded in 1907 that sought to join the forces of art with industry to improve the quality of industrial output. Implied was a methodology of rationalization and standardization that would facilitate efficient production and marketing. Although van de Velde had also been an early member of the Werkbund, he contentiously rejected these principles in a public debate at the association's 1914 convention in Cologne. Dismissing standardization, which, following the example of Henry Ford in the United States, was deemed the answer to the problems of industrial manufacture, he upheld individual creative artistry, which he insisted should be the driving force behind design for the modern era. Van de Velde's ideas about artistic creation and industrial production were contradictory. He had written strongly of his desire "systematically to avoid everything concerned with furniture which could not be manufactured by large-scale industry," and while he said his "ideal would be the reproduction of my creations by the thousand,"[4] he was not willing to commit to the compromises of industrial manufacture that would have made that possible.

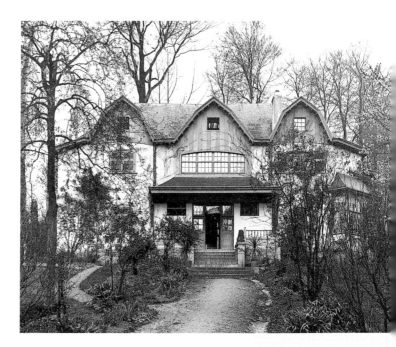

We don't need a tortured pedigree, however, to grant distinction to the achievement of Henry van de Velde. He brought to the field of design a new ornamental vocabulary, proposing a vigorous decorative linearity that found its way into his furniture, textiles, wallpaper, porcelain, silver, and graphics. In doing so he turned his back on the long tradition of the decorative arts of Europe, with its sequence of historic styles. Van de Velde's true contribution to the principles of modernism was in breaking totally with the styles of the past and creating a fresh style for the present, albeit one that still recognized decoration as a major component of design. His was a central role in the formation and, especially, the dispersal, of Art Nouveau, a style that crossed all boundaries to integrate the expressions of art and design into its grand goal, the creation of a building that was a unified and harmonious work of art. Much in favor during the Art Nouveau period, the concept of the total work of art, or *Gesamtkunstwerk* in German, had originated in the mid-nineteenth century with the composer Richard Wagner, who based his ideas on the way that all of the arts had contributed to ancient Greek drama, and it was developed through his operatic productions at Bayreuth.

Art Nouveau had first emerged in the work of a number of Belgian architects and designers in the middle of the last decade of the nineteenth century and had reached across the continent, in a vari-

ety of manifestations, by the early twentieth. Architects such as
Victor Horta and Paul Hankar, borrowing the refreshing simplicity
and decorative vitality of the English Arts and Crafts Movement and
demonstrating an understanding of the structural rationalism of
recent French building, turned the streets of Brussels into a proving
ground for the new style, with facades and interiors swirling with
asymmetrical, often wrought-iron, whiplash ornamentation rooted
in natural forms. Van de Velde worked a parallel course; he took an
energetic ornamental line and applied it universally, steamrolling
everything before him so that the world of objects would be
defined by a unified aesthetic. Van de Velde's own contribution was
uniquely abstract, abjuring the naturalistic underpinning of much of
international Art Nouveau for the electricity of an energy within.

Born in Antwerp in 1863, van de Velde turned to design in the early
1890s after having been a painter, seduced by the willingness of new
Belgian art groups, such as *Les Vingts* (The Twenty), to exhibit the
"minor" or decorative arts alongside painting and sculpture. For
him, painting had become an endeavor with little purpose and
scarcely any social value. In this he followed William Morris (about
whom he lectured and wrote several articles), admiring particularly
his outspoken socialist ideals: Morris "chose to be a socialist," he
commented, "because, in his mind, socialism alone could clear the
course for art in the way he conceived art, could help in the renewal
of art in the way he conceived this renewal."[5] Like Morris, he reject-
ed the rarefied world of painting for the practical arena of design;
by providing alternative products in a new style, he hoped to
reform the popular aesthetic of his day and rid society of the ugli-
ness he perceived in the plethora of manufactured goods that were
competing for the attention of contemporary consumers.

Van de Velde was able to demonstrate his ideas for a new, socially
responsible architecture in his designs for Bloemenwerf (Haven of
Flowers), the house he built for himself and his wife Maria Sèthe at
Uccle, near Brussels, in 1895–96 (fig. 3). Because it does not display
the typical turmoil of Belgian Art Nouveau architecture, the house
may seem less than revolutionary to us today, but according to van
de Velde, its Dutch-style half-timbered stucco exterior, devoid of
the customary decorative ironwork of the "bourgeois" villas in its
vicinity, offended the community and met with extreme derision. As
with Webb's design for Red House (see Morris, fig. 2), the relative
simplicity of its vernacular borrowings was what onlookers found
offensive and what announced its modernity. The interior was also
furnished in a simple manner (fig. 4), meant to satisfy van de
Velde's goal of synthesizing art and design into a unified whole,
and, like William Morris, bringing the joys of art into everyday life.
Van de Velde rigorously applied Morris's dictum, "have nothing in
your houses that you do not know to be useful, or believe to be
beautiful,"[6] to his own house.

"Hideousness is contagious," he wrote in his later autobiography.
"Concerted resistance is a more practical antidote than the conscious
search for some kind of corrective beauty. My wife and I felt in
duty bound to shield our children from the sight of ugly things by
banishing anything liable to pervert a child's visual sensibility
before they were born. . . . I refused to allow the presence of any

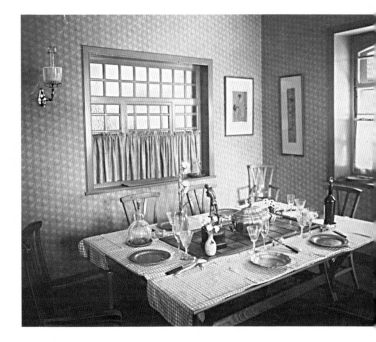

3
Henry van de Velde.
Bloemenwerf (Haven of
Flowers), Uccle (near
Brussels), 1895–96

4
Henry van de Velde.
Dining room at
Bloemenwerf showing van
de Velde's rush-seated
chairs. From *Dekorative
Kunst,* 1899

was solidified in a country that would become his home for a decade and a half. The centerpiece of the Study that van de Velde created for the Munich Secession exhibition was a mammoth kidney-shaped desk, with decorative brass work and attached lighting fixtures demonstrating the richness of its formal conception (fig. 8). A masterpiece of theme and variation, it comprises two ornamental figures subtly intertwined: the fluid, sinuous line that describes the desktop and picks up again at the base; and the jagged zigzag of the brass work at the rear, the flat wooden decorative panel beneath the desktop, and the asymmetrical drawer handles. The design of the Berlin shop of the Havana Cigar Company executed in the same year (fig. 9) equally melds form and decoration into one vigorous and integrated idea, with doorways, woodwork, shelving, furniture, and painted ornamentation in the dynamic van de Velde mold.

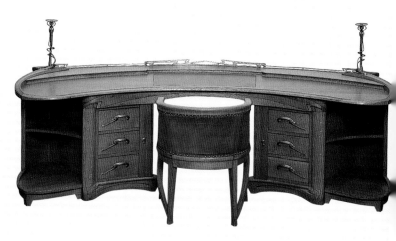

Embraced by Germany, where he immediately was asked to build and furnish houses and apartments and to design commercial interiors, van de Velde moved to Berlin to keep up with his commissions. In 1897 he had inaugurated his own workshop in Brussels, following Morris's model of a close-working craft establishment that made virtually everything required for interior decoration. He advertised that he could supply "complete interior furnishings, furniture, wallpaper, carpets, embroidery, stained glass, fixtures for both gas and electric lighting, jewelry, and useful and ornamental objects." In short, he offered everything that would be required to conform to the new ornamental style. Now designs conceived for production by his own workshop, including his furniture, were taken over by commercial manufacturers. In 1902 he moved to Weimar, where he was commissioned to design and head a school of arts and crafts, which was meant to restore the competitive edge of the local craftspeople. He built several houses there and also constructed the academy of art (1904–11), continuing to direct the school until 1914, when, as an enemy alien during World War I, he had to relinquish his post. He eventually moved to Switzerland in 1917.

Van de Velde's fluid ornamental forms derived from his experience as an artist. He had studied in Antwerp and in Paris, where he was influenced by the Barbizon painters. After seeing the work of Georges Seurat in a Brussels exhibition in 1887, he adapted Seurat's pointillist method to his own work. About 1890 he became associated with the Symbolist painters, and it was the influence of Paul Gauguin, as filtered through the work of the Nabis, that appears to have spurred him to the creation of completely abstract works, using line and form expressively, flattened and independent of the depiction of nature. These served as ornaments for books and journals, including the Flemish Symbolist magazine *Van Nu en Straks* (Of Now and Later) (fig. 10). This tendency is also seen in the composition of his first major piece of decorative design, the large embroidery *Angels Watch* (fig. 11), exhibited as a cartoon sketch at the Salon of *Les Vingts* in Brussels in 1892. The simple figures of angels in Belgian dress surrounding the infant Jesus, the pools of strong color highlighting their clothing, and the swirling landscape and flat decorative patterns were embroidered on a seven-foot-wide

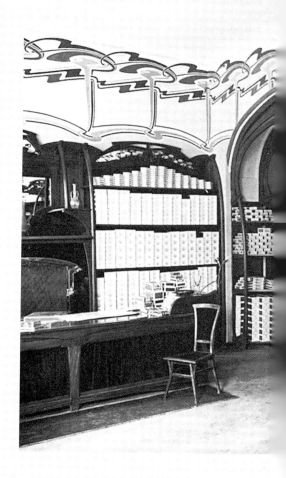

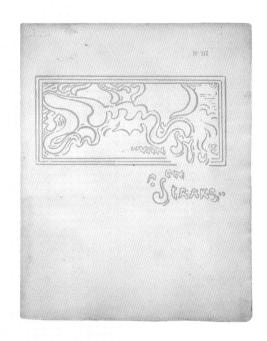

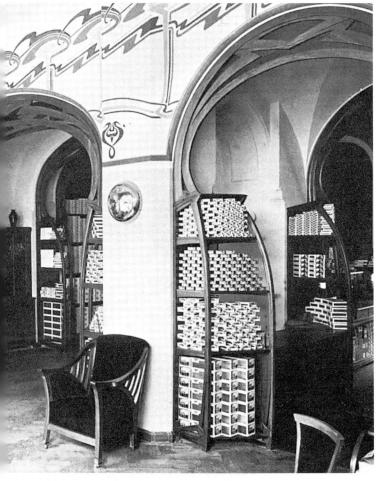

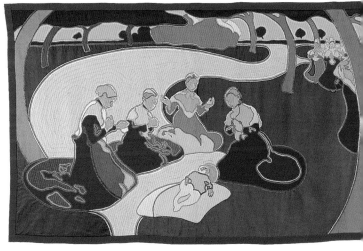

panel by his aunt. Accustomed to more conventional work, she "hoped against hope" that van de Velde "would at least allow her to provide the kneeling angels with their traditional wings and haloes"[9] rather than leave the composition with its strange stark abstractions and decorative linearity.

It is not difficult to see how van de Velde made the leap from the lyrical invention of his abstract studies and his design for embroidery to the vigorous motifs of his decorative works. Much of the ornament he used is tightly controlled, almost emblematic in its compactness, like that of the scarcely three-dimensional molded-and-painted motif of the dinner service he designed for the Meissen porcelain works in Germany (fig. 12). But he could create freer, more expansive ornamental compositions as well. The poster he designed in 1897 for Tropon (fig. 13), a company that produced food supplements from egg white, is an abstract fantasy devoid of literal content, even if some have seen hints of viscous egg fluids in its swirling motif. The colorful diagonal motif and the framing device surrounding the text become one, held in place by concentric linear patterning similar to that of the pathway in *Angels Watch*. Tropon had been founded by one of van de Velde's architectural clients, Eberhard von Bodenhausen, who brought him to the firm. Between 1897 and 1901, when the firm closed, van de Velde designed several versions of the Tropon poster, a score of packaging formats, the company's logo and letterhead, and also its office, becoming one of the first artist-designers to take up the challenge of creating a comprehensive advertising and identity program.

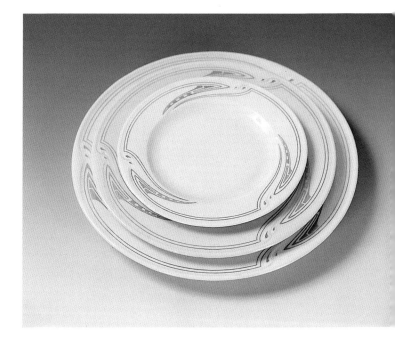

For van de Velde, the essence of his ornamental Art Nouveau design was an energy of line, expressed most forcefully by his Tropon poster. "A line is a force," he wrote, "like all elemental forces. . . . This is an essential truth, and forms the basis of the new ornamentation."[10] This came from his admiration for engineering, with its catalogue of forces and stresses, and he believed that the "same laws which guide the work of an engineer also guide ornamentation."[11] His Bloemenwerf chairs, which openly celebrate structure in dynamic tension, may also be connected with the idea of an engineering style. But for van de Velde the line meant more, for "it takes its force from the energy of the person who has drawn it,"[12] from an intense personal involvement, almost like the impulsive gesture of the abstract expressionist. The bronze candelabrum he designed about 1899 (fig. 14), his most audacious decorative work, clearly encapsulates this idea. Rising from its swirling trilobed base, the sculptural line twists through the stem and emerges at the top of the shaft as flame-like forms lapping at the candleholders, a tour de force of design in which conception and execution, structure and ornament, line and force, energy and action, are one.

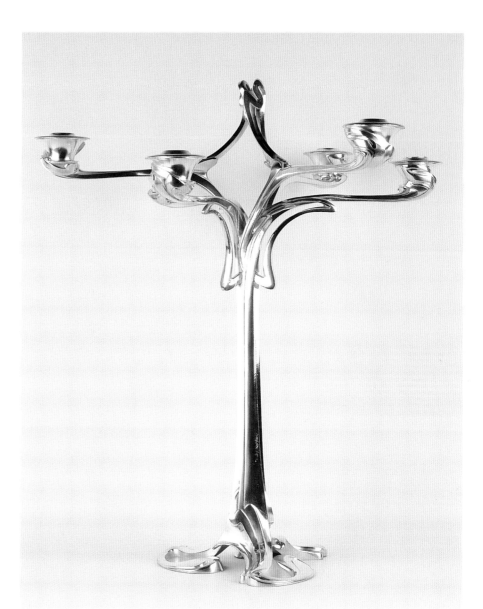

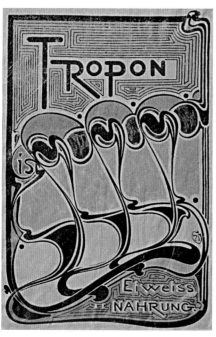

12
Henry van de Velde.
Plates from a dinner service,
1903–4. Gilded porcelain.
Made by Staatliche
Porzellan-Manufaktur
Meissen. Karl Ernst
Osthaus-Museum, Hagen

13
Henry van de Velde.
Poster for Tropon, 1897.
This advertisement for a
food supplement made from
egg white was reprinted as
a special insert in the
German magazine *Pan*.

14
Henry van de Velde.
Candelabrum, c. 1899.
Silver-plated bronze.
Musées Royaux d'Art et
d'Histoire, Brussels

3

Josef Hoffmann
A house should stand as
a perfect whole

Josef Hoffmann (1870–1956) is the Viennese counterpart of Henry
van de Velde: both rejected the syntax of nineteenth-century
historicism as they promoted, and became identified with, a new
decorative idiom for the twentieth. Yet their work is completely
different: Van de Velde's design is Dionysian, rooted in restless
organic movement, while Hoffmann's is Apollonian, expressing
geometric stability (at least in his early Wiener Werkstätte period).
Both, too, were eminently successful, finding a ready and fashionable
audience for the new ornamental languages they introduced. With
the extremes of their organic and geometric decorative vocabularies,
they bracketed the numerous stylistic variations that arose across
Europe at the turn of the century and came together in the
movement known as Art Nouveau.

Like van de Velde, Hoffmann has been forced to serve the myth of
modernism to the detriment of an objective appreciation of his
fundamental contribution to the history of design. While van de
Velde was canonized for his part in forging the lineage of modernist
design, Hoffmann has been beatified for the supposed modernism
of his geometric vocabulary, seen as anticipating the spare aesthetic
of the German Bauhaus. But Hoffmann's design had a different
meaning; while he created interiors and objects using strictly
rectilinear forms, these creations were stylishly elegant and willfully
ornamental, far removed from the austerity associated with the
Bauhaus aesthetic. Those who would reinvent Hoffmann's signifi-
cance by claiming him as a precursor of machine modernism fail to
recognize that if geometry can be austere and mechanistic, it also
can be luxurious, decorative, and replete with the signs and values
of hand manufacture. Hoffmann is most masterful, in fact, in works
of sophistication and decorative inventiveness for which he is least,
and at best begrudgingly, celebrated. The only objects by Hoffmann
that could truly be said to fall into the category of machine-like
products are those made of perforated metal that he and his close
collaborator Koloman Moser designed over a short period, beginning
about 1904. Made from painted industrial sheet iron with square
holes punched to create a grid resembling openwork basketry, this
series included architectonic tables, desks, wastebaskets, and elabo-
rate planters (fig. 2). But these, too, had their ornamental counter-
parts in a group of refined tabletop objects that the two designers
soon began to make, such as inkwells, flower holders, candlesticks,
dessert baskets, and a cruet stand (fig. 3) with similar openwork
grid patterns now transferred to silver. Their luxurious intent refutes
the only possible presumption of a longstanding functionalist
austerity in Josef Hoffmann's work.

Hoffmann was never destined to become a symbol of functionalist
modernism, although he had studied at the academy in Vienna
under Otto Wagner, the city's leading progressive architect, and
belonged to the group of discontented artists, designers, and
architects who in 1897 cut ties with the official Viennese art estab-
lishment to create the Secession Movement. *Ver Sacrum* (Sacred
Spring), its journal, signaled with its spirited name that this was to
be the font from which a rebirth of the arts would arise. Led by the
painter Gustav Klimt, the Secession promoted the advanced
Austrian and international art of its day and, following the lead of
similar groups abroad, exhibited decorative along with fine arts,

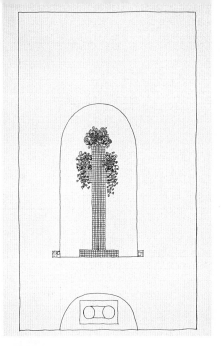

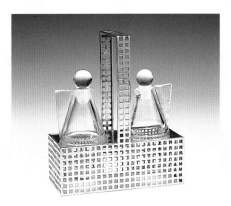

1
Josef Hoffmann, c. 1903

2
Josef Hoffmann. Design
for a flower holder,
1904–5. Pencil, ink, and
color on graph paper.
Österreichisches Museum
für Angewandte Kunst,
Vienna. This is a design for
one of the large painted
sheet-metal objects that
Hoffmann and Koloman
Moser designed for the
Wiener Werkstätte.

3
Koloman Moser. Cruet
stand, c. 1904. Silver and
glass. Made by the Wiener
Werkstätte. The Art
Institute of Chicago

often in elaborate installations. Hoffmann, himself an architect, created complete room settings with furnishings of his own design for these exhibitions. At first, the Secession artists took the organic path of Belgian and French Art Nouveau and the parallel movement in Germany, *Jugendstil* (Style of Youth). But after the 1900 Secession exhibition, which brought to Vienna the restrained and rectilinear work of British designers such as C. R. Ashbee and his Guild of Handicraft and a group of Glasgow artists led by Charles Rennie Mackintosh, Viennese design took an abrupt turn. For a few legendary years, it responded to their example, favoring a reductive ornamental geometry with a decorative vocabulary of square forms and a palette strongly dependent on black and white (in imitation of the white interior and black furniture of the Glasgow room at the exhibition). This introduced a distinct Secession style (*Sezessionstil*) that would soon become closely identified with the city.

In his polemical article "Simple Furniture," which was published in the magazine *Das Interieur* in 1901, Hoffmann for the first time presented a clear statement of his professional goals as he separated his work from the historic revival style that Vienna had been embracing. He emphasized an aesthetic of simplicity, quality, and workmanship over the modernist imperatives of function, structure, and economy. He based it on Arts and Crafts principles, not on a machine aesthetic and the requirements of large-scale factory production, which in any case would have been irrelevant in the context of Austria at that time, where small workshops were the dominant mode of production. With larger manufacturers lacking interest in the type of decorative designs he and his colleagues had shown at the Secession exhibitions, Hoffmann soon found himself at the head of a small craft workshop determined to put these works into commercial production. In 1903, funded by an industrialist, Fritz Wärndorfer, he and Moser joined together to establish the Wiener Werkstätte, or Vienna Workshop. Swearing allegiance to the craftsmanlike ideals of simplicity, honesty, and integrity espoused by William Morris, they set out to create useful goods that met simple needs with the means of the craftsman. "The machine has replaced the hand, and the businessman has taken the craftsman's place. It would be madness to swim against this current," they admitted in the founding statement of the Wiener Werkstätte, published two years later. "All this notwithstanding, we have founded our workshop. It exists to provide on native soil a point of repose amid the cheerful noise of craftsmanship at work, and to give comfort to all who accept the message of Ruskin and Morris. . . . We wish to establish intimate contact between public, designer and craftsman, and to produce good, simple domestic requisites." Following Morris, they elaborated on their arts and crafts aesthetic: "We start from the purpose in hand, usefulness is our first requirement, and our strength has to lie in good proportions and materials well handled. We will seek to decorate, but without any compulsion to do so, and certainly not at any cost. . . . The worth of artistic work and of inspiration must be recognized and prized once again. The work of the art craftsman is to be measured by the same yardstick as that of the painter and the sculptor."[1]

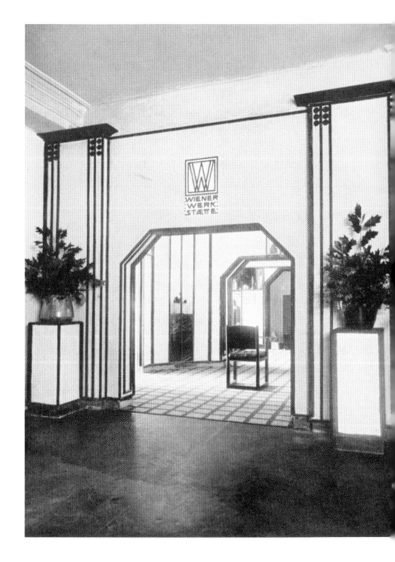

While Hoffmann paid homage, as did many others of his generation (and as many present-day designers still do) to the ideals of William Morris, he showed few hints of having an actual social agenda. He acknowledged the talents and the concerns of the workers who made his products, but he had little real interest in them, especially once he decided that "it will no longer be possible at all to convert the masses" to his vision of modern design. His designs for buildings, objects, interiors, and exhibitions would find favor among those who belonged to the fashionable set in Vienna, and realizing that clients for his type of architecture and design would most certainly come from the privileged classes, he resolved that "it is all the more our duty to bring happiness to the few who turn to us."[2]

The Wiener Werkstätte soon drew this sophisticated following to its showrooms and found itself with scores of employees working in production facilities for leatherwork, bookbinding, metalwork, and wood. Other of its products, such as textiles, ceramics, and glass, were manufactured as collaborative efforts with different Austrian workshops and manufacturers. This prepared the Wiener Werkstätte to meet all the decorating needs of its clients, enabling Hoffmann to realize his concept of the total work of art, or *Gesamtkunstwerk*. "I believe a house should stand as a perfect whole," he wrote, "and that the exterior should reveal the interior. . . . I plead for unity among the rooms. Equally essential is style in every piece of furniture."[3] Perhaps the most complete example of a Viennese *Gesamtkunstwerk* was the Wiener Werkstätte itself. The early installations that Hoffmann and Moser designed for Werkstätte exhibitions (fig. 4) and shops were painted white, with black detailing on the walls and black and white patterns on the floors. The unity of the firm's design is captured well in one critic's description of a visit to the Werkstätte's headquarters in 1905: "The trade mark and name plate by the side of the entrance are original enough to warn one that one is about to enter a world apart. One is directed up the steps by decorative lines drawn by Hoffmann, a black-and-white Ariadne thread which makes all further direction unnecessary. Nor is one left in any doubt about which iron door to open at the top of the steps—it is the black-and-white one with a look all of its own. Black and white continue to predominate as one walks into the reception rooms. . . . Brightness and neatness strike one here, every object is accurately and tastefully placed in its context, so that one is aware of the spirit of the place."[4] This served as a branding device for shoppers, reinforced with a graphic identity that centered on the logo of interlocked Ws, probably designed by Moser. Its thin hand-drawn letters, and the firm's rectilinear graphics, with information often enclosed by black rectangles, were fully coordinated in all its graphic production, down to packaging and stationery. Taking the logic of the system further, each of the workshops was assigned its own color, and the paperwork related to its activities bore this color. The graphic system created a lasting image for the Wiener Werkstätte and is a groundbreaking example of a logical retail identity program.

A reliance on fine handicraft production, and the conviction that products of design must meet the same standards as those by which painting and sculpture are judged, are what made the Wiener Werkstätte so brilliant, and why it must be distanced from designs

4
Josef Hoffmann and Koloman Moser. Exhibition of the Wiener Werkstätte in the Hohenzollern-Kunstgewerbehaus, Berlin, 1904. From *Deutsche Kunst und Dekoration*, 1903–4

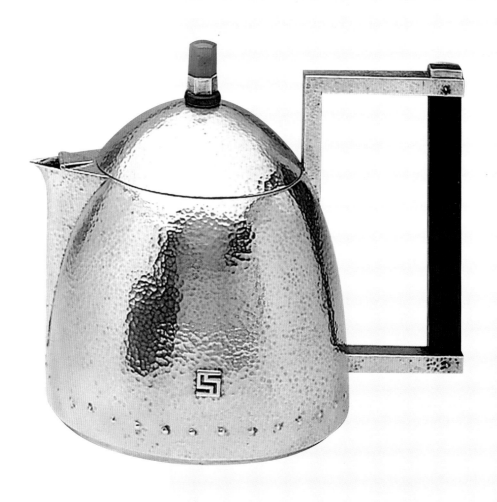

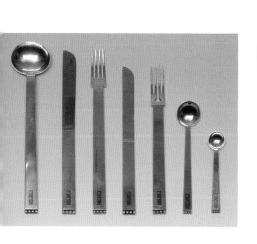

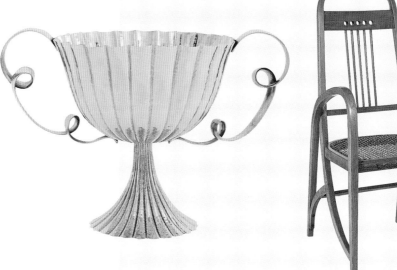

produced by the Bauhaus experiment. The silver teapot Hoffmann created the same year the Werkstätte was founded (fig. 5) may be composed of geometric forms, but it is far from an advanced example of anonymous industrial design. The richly toned vessel, with a rectangular handle seemingly stuck onto the conical shape to assert its equality as an ornamental form, is handmade of expensive materials—silver, ebony, and carnelian (a semi-precious stone)— and is greatly animated by the sensuous surface of hammer marks that reflect light in shimmering patterns and celebrate the hand of the craftsman who made it. Metal was Hoffmann's most brilliant material, and with it he created many different types of objects— trays and teapots, flatware, boxes, lamps, vases, jewelry—in unusual forms. They include pieces with strict geometric outlines and decoration from his reductive period, among them the perforated objects in painted sheet metal and in silver described above and the flatware service he designed in 1904 (fig. 6). Although ascetic in their uninflected surfaces, the utensils are arbitrary and individual- istic in their eccentric shapes and the spherical ornaments at the base of each one. There are a great many more examples, including works with leafy patterns that he did around 1910 and the most elegant of his many metal vessels, beaten baroque centerpieces with fluted antique shapes and flowing ribbonlike handles (fig. 7), which hark back to the classical past. His work in other mediums throughout his career is as convincingly individualistic and idiosyn- cratic, be it in furniture (fig. 8), glassware, ceramics, or textiles and wallpapers (fig. 9). As the Wiener Werkstätte continued into the teens and twenties, his production shows him working in concert with the other designers attached to the workshop, such as Eduard Josef Wimmer, Dagobert Peche, and Joseph Urban, who brought the organization into a decorative mode that was closely tied to the Art Deco movement.

5
Josef Hoffmann. Teapot, 1903. Silver, carnelian, and ebony. Made by the Wiener Werkstätte. Minneapolis Institute of Art. The Modernist Collection, gift of Norwest Bank Minnesota

6
Josef Hoffmann. Cutlery, 1904. Silver. Made by the Wiener Werkstätte. Österreichisches Museum für Angewandte Kunst, Vienna

7
Josef Hoffmann. Centerpiece, 1924-25. Brass. Made by the Wiener Werkstätte. Minneapolis Institute of Art. The Modernist Collection, gift of Norwest Bank Minnesota

8
Josef Hoffmann. Armchair, c. 1908. Beech. Made by Jacob and Josef Kohn. Victoria and Albert Museum, London

9
Josef Hoffmann. Wallpaper, 1913. Printed paper. Austrian Archives, Vienna

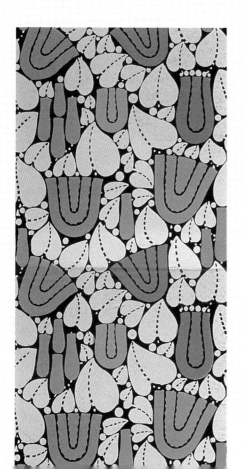

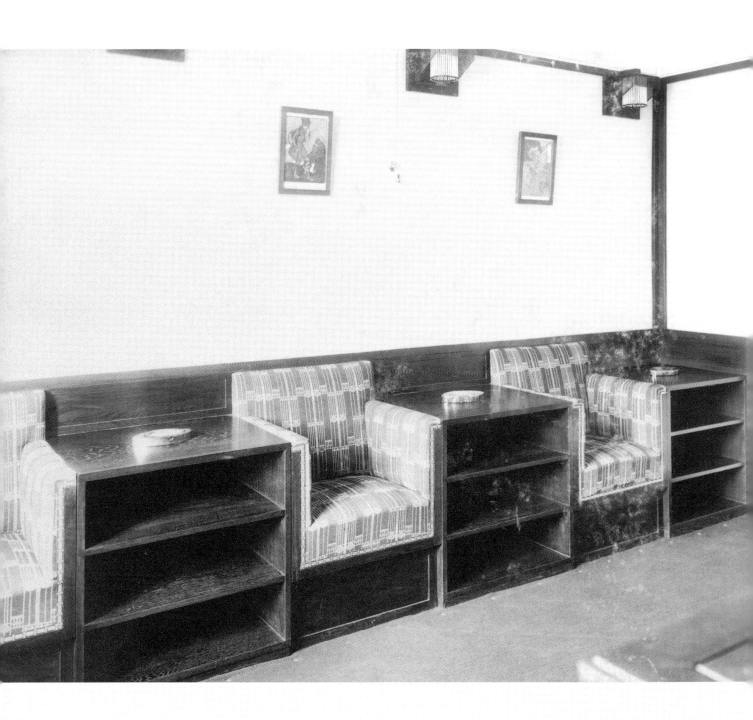

With the founding of the Wiener Werkstätte, Hoffmann combined his architectural practice with that of the new organization, which was called upon to provide interior furnishings for many of his designs. For two of Hoffmann's major building commissions, the Sanatorium at Purkersdorf, near Vienna (1903–6), and the Stoclet house in Brussels (1905–11), the Wiener Werkstätte created or commissioned virtually all the interior furnishings. For the Sanatorium, a luxury rest home and recovery clinic, which he furnished in collaboration with Moser, Hoffmann designed a concrete building of geometric simplicity that was decorated in an understated manner, with ornamental friezes inside and out, black and white geometric tile work, a wide range of built-in cupboards, lighting, gridded metal designs, and Moser's cubic furniture, often upholstered with Hoffmann's fabrics (fig. 10). Hoffmann also created a series of bentwood chairs and tables, unusual in their rounded forms, all with decorative spheres like those on his flatware, at their joints. The frame of his dining chairs (fig. 11) is curved, with small spheres accenting the meeting of the legs and seat and openwork circles in the back panel reinforcing this motif. Hoffmann usually relied on rectilinear forms, according to his doctrinaire belief in the Arts and Crafts principle of appropriate and logical construction. Bentwood was the only material that for him would retain its integrity when constructed with rounded forms, since it was inherent to the process by which it was made. "We also want to avoid the many technical faults," he wrote, following this line of reasoning. "We forget that for every curved constructive part we would have to go into the forest to look for the correctly curved branch, like the peasant who builds his plow or sled. It is, of course, something else with the so-called bentwood where the fiber is artificially bent, and the curve is therefore justified."[5]

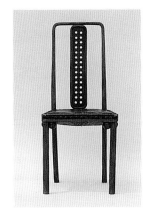

Hoffmann's Stoclet house was the Wiener Werkstätte's most elaborate commission. It was their dual masterpiece, an immense building of great elegance, clad with precious marble inside and out (fig. 12), furnished with luxury goods of the finest materials and craftsmanship, and decorated with specially commissioned examples of new Viennese art and design, including mosaic murals by Gustav Klimt in the dining room. This was the "perfect whole" that Hoffmann had anticipated, and every room was part of the "unity" he pursued. The richness of the conception, repeated in a décor appropriate to each room's purpose, is demonstrated in the ample dining room (fig. 13) with its richly grained marble walls, checkered tile floor, polished marble-topped macassar cabinets, leather chairs with gold tooling, massive inlaid table, and Klimt's mosaics.

The Stoclet house may be fittingly credited as a forerunner of the Art Deco style, which flourished after World War I and had its triumph at the International Exposition of Modern Decorative and Industrial Arts in Paris in 1925, for which Hoffmann designed the Austrian pavilion. This movement channeled a high quality of craftsmanship to create a modern style that was based on the flattening and simplifying of ornament but invited allusions to traditional styles, much like the furnishings of the Stoclet dining room.

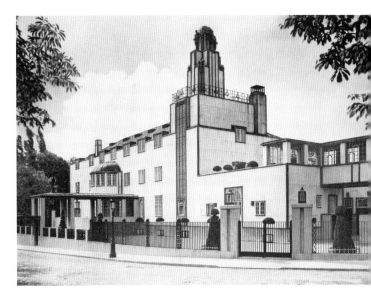

10
Josef Hoffmann and Koloman Moser. Furnishings in the Purkersdorf Sanatorium, near Vienna, 1903–6

11
Josef Hoffmann. Chair, 1904. Beech. Made by Jacob and Josef Kohn. Österreichisches Museum für Angewandte Kunst, Vienna

12
Josef Hoffmann. Stoclet house, 1905–11. From *Moderne Bauform*, 1914. The Stoclet house was the most extensive commission granted to the Vienna Workshop.

Hoffmann's work was critically praised during its own time and continued to be noticed during the 1930s, when the architectural critics who gathered modern design into the International Style found the flat roofs, planar facades, and absence of moldings characteristic of modernism. But at the same time they had to excuse his decorative elements, which appeared to them, as did those of Frank Lloyd Wright, as a "national," not an "international," characteristic. Thus he and Wright were not counted among the leaders of the International Style. Afterwards Hoffmann was demoted, or more truthfully, ignored. He was rediscovered in the 1970s, during the revival of interest in Art Deco, when a group of his furnishings was returned to production (fig. 14) and his legacy once again became fashionable. The postmodern movement of the 1980s gave him another boost, when such architect-designers as Richard Meier and Michael Graves strayed from antique classicism to classic Vienna and borrowed copiously from his ornamental works.

More recently, in a curious and startling about-face, a renewed insistence on functionalist modernism has turned him into a master of that persuasion. Because Hoffmann's chosen vocabulary was geometric, his work has been retrofitted with the austerity of machine modernism. The aesthetic associated with the Wiener Werkstätte has been called "spartan" in the *New York Times*,[6] although it is hard to understand what is spartan about an abundance of precious materials, wanton decorative patterning, and the willful application of ornamental forms to something so simple as a bentwood chair, not to mention the entire program of the Stoclet house. What is most ironic about the suggestion that Hoffmann and the Viennese style were spartan is that he and the Secession were hounded during their own time by the original spokesman for modernist austerity, Adolf Loos. The Viennese architect and author of the essay "Ornament and Crime" (1908) chided Hoffmann for introducing an "artistic" ornamental style and mocked the whole idea of the *Gesamtkunstwerk,* which he thought restricted the freedom of those who lived in such fully designed buildings to be themselves. This fact alone should have alerted the retrofitters that some of their assumptions about Hoffmann's position in the history of design were amiss. In looking at Hoffmann's career as an entirety, we must finally get his aesthetic right. While he may have pared down many of his forms to rectilinear outlines and introduced a reductive geometric vocabulary, his objects were always both decorative and luxurious in their conception, contributing to a style that might be called simple but never spartan.

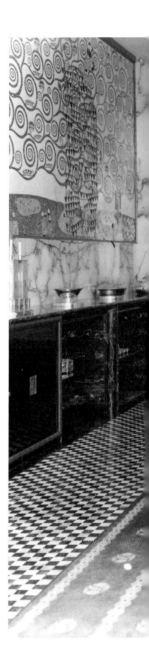

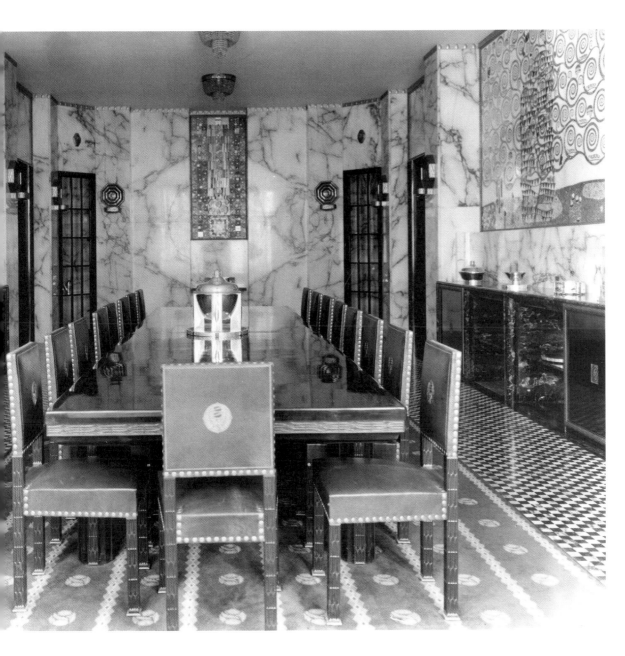

13
Josef Hoffmann.
Dining room of the Stoclet
house, Brussels, 1905–11.
Hoffmann's lavish furnish-
ings are set off by Gustav
Klimt's mosaic murals.

14
"Revival di Hoffmann"
(Hoffmann Revival). From
Casabella, March 1974.
A number of Hoffmann's
works were rescued from
oblivion and returned to
production during the
1970s.

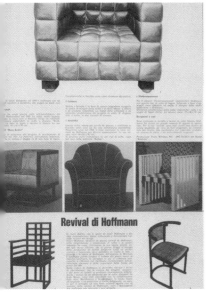

4

Frank Lloyd Wright
Face to face with the machine

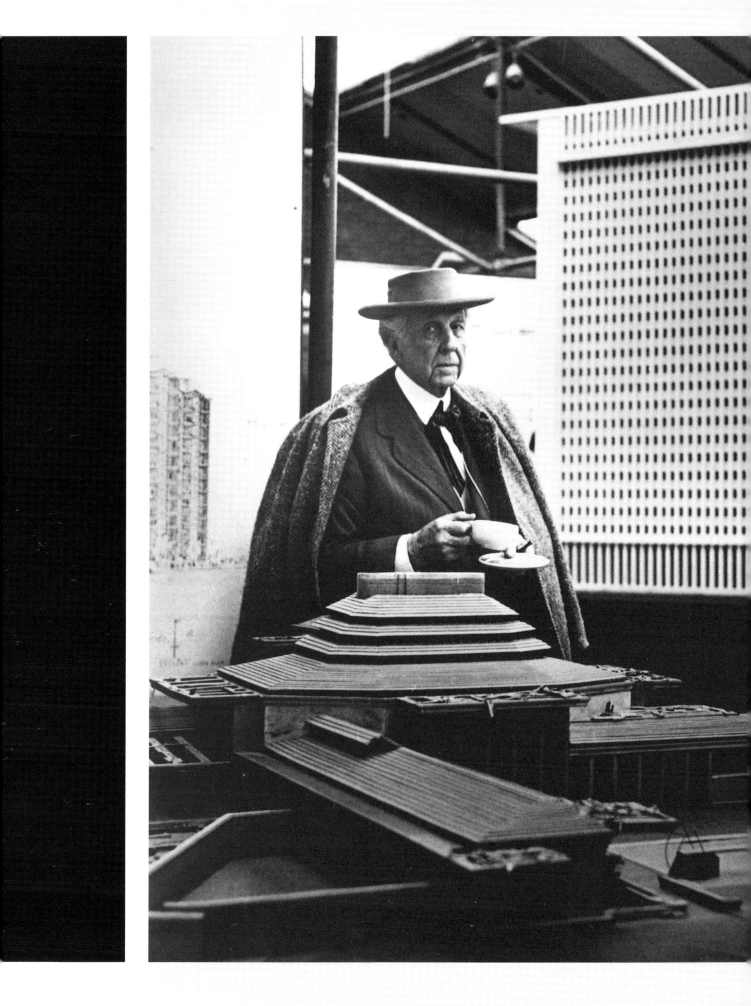

1
Frank Lloyd Wright
taking a break for tea
during an inspection
of his retrospective
exhibition "Sixty Years
of Living Architecture,"
New York, 1953

"All artists love and honor William Morris,"[1] America's greatest architect Frank Lloyd Wright (1867–1959) proclaimed in "The Art and Craft of the Machine," the hopeful lecture he gave at Hull House in Chicago in 1901. A founding member of the Chicago Arts and Crafts Society in 1897, he had probably learned of Morris from issues of *The Studio,* a magazine that was established in London in 1893. Through its pages artists and connoisseurs abroad were introduced to the movement, and it was as avidly read in the artistic circles of the United States as in those of Europe. But he had already been prepared for new aesthetic ideas, having been raised in a home sensitive to the refinements of the reform taste of his time; prints of English cathedrals hung in his bedroom, and his mother was determined, as he wrote in his autobiography, that he was "to build beautiful buildings. . . . Before he was born, she said she intended him to be an Architect."[2] With some engineering training but no architectural education, he left his home in Wisconsin in 1887 for the excitement and unprecedented opportunities of a Chicago that was still rebuilding after its great fire. Wright entered the busy architecture office of Dankmar Adler and Louis Sullivan. One of the creators of the modern skyscraper, Sullivan was the man Wright would always consider his teacher. By 1893 Wright had started his own firm, an almost immediate success, building private houses in Chicago and its suburbs, particularly Oak Park. Self-assured, personable, but arrogant, he would endure several marriages and a series of personal scandals, a host of tragedies, continual professional crises, and financial ups and downs. These did not dim his fervor for his work, and he remains for most Americans the image of the heroic architect, boldly independent, dignified, and persuasive as he defined and redefined a native architecture over his long career.

Wright revered Morris's devotion to artistic craftsmanship and the honesty he demonstrated in his use of materials. The furniture Wright created for his Prairie houses in the early years of the century came closest to Arts and Crafts antecedents; like those of Gustav Stickley, Wright's furnishings were carefully crafted and employed much of the vocabulary found in Morris and Company designs— plain rectilinear shapes, natural oak, slatted sides and backs. In the house he designed for Joseph W. Husser in Chicago at the turn of the century, he introduced a type of grand dining-room furniture, which he would use consistently over the next decade and which would continue to reappear later on. Forming a unified design scheme, the Husser version included three oak tables with overhanging tops that could be used individually or together, accompanied by twenty-four high-back slatted chairs. The chairs, exaggerated in their scale and with slats reaching almost to the floor, were visually tied to the tables through the complementary slatted bases at their ends. By the end of the century's first decade, these had evolved into magnificent ensembles, as in the Meyer May house in Grand Rapids, Michigan (fig. 2). The chairs, with high solid backs, complement the table, with its attached art-glass lamps. With the enveloping screen of chairs, it forms an intimate enclosure that sets off the dining area from the free-flowing space of the rest of the house.

But as much as Wright honored the craft ideals of Morris, he opposed Morris when it came to the machine, for Wright had "a gradually deepening conviction that in the machine lies the only future of art and craft—as I believe, a glorious future; that the machine is, in fact, the metamorphosis of ancient art and craft; that we are at last face to face with the machine—the modern Sphinx—whose riddle the artist must solve."[3] Wright's alliance with the machine might surprise those who know him as America's leading disciple of Morris, but for Wright, this was a different time and a different climate. That Morris "miscalculated the machine does not matter,"[4] he wrote, for across the Atlantic, Wright could see the machine not as Morris's destroyer of a traditional culture rooted in craft but as "the normal tool of our civilization."[5] In the hands of craftsmen trained in its artistic use, it was the means for creating a truly democratic American art form that would supply the needs of a still expanding nation.

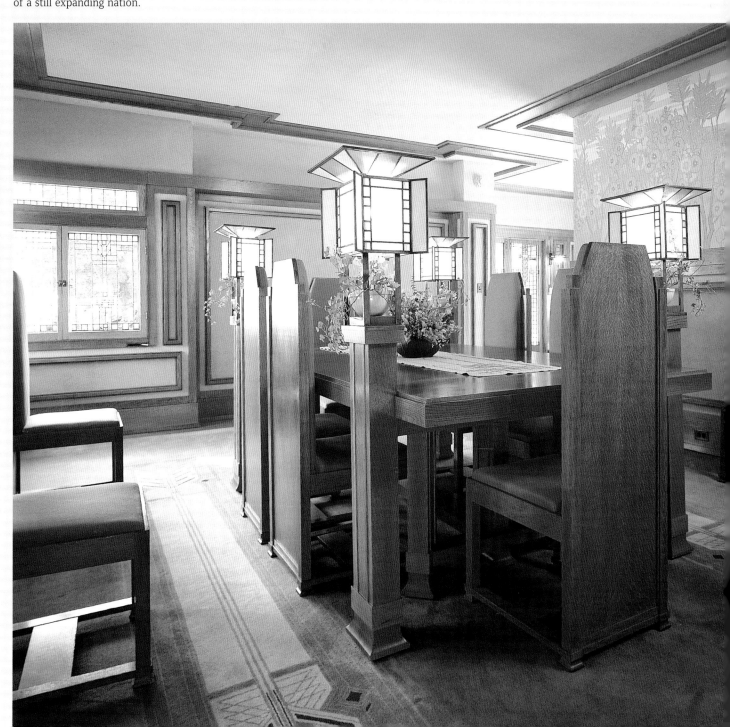

In honoring Morris for preaching the gospel of simplicity, Wright understood him as making way for the core aesthetic of the machine. "The present industrial condition is constantly studied," Wright explained in his article "In the Cause of Architecture" (1908), "and the treatment simplified and arranged to fit modern processes and to utilize to the best advantage the work of the machine. The furniture takes the clean-cut, straight-line forms that the machine can render far better than would be possible by hand. Certain facilities, too, of the machine . . . are taken advantage of and," he added, tying this to the Arts and Crafts aesthetic, "the nature of the materials is usually revealed in the process."[6] He adopted these straight-line forms and simplification as his own aesthetic in the construction of such works as the plain, almost rude, wooden chairs he designed for his studio in Oak Park (fig. 3). The severe rectilinear frame with its apparent mitered joints and the wide oak board that forms its slanted back were well suited to letting the machine do what it does best. The back also boldly displays the fullness and beauty of the grain, which Wright regarded as an added dimension to be achieved by accepting the simplicity of the machine.

In his polemical writing about the machine, Wright never meant to suggest industrial production on a large scale for his furnishings; he wanted to solve the riddle of the machine for individual artistic use. His only significant designs to be factory made were the office furniture he created for the Larkin Company Administration Building in Buffalo (1903) and the Johnson Wax Building in Racine, Wisconsin (1936), and the commercial line of household products he introduced in 1955 in collaboration with a group of American manufacturers. Called the Taliesin ensemble after the names of his two houses and schools, in Wisconsin and Arizona, the line of products included carpets, wallpapers, fabrics (some based on his architectural designs [fig. 4]), furniture, even coordinated paint colors—everything needed for postwar consumers to fashion their own unified Frank Lloyd Wright interiors. But the majority of Wright's furnishings were created individually to fit out the large number of buildings he designed and erected. The scale of his activity is humbling: The catalogue of his work lists 433 completed buildings (much augmented by secondary structures at many of the sites)[7] spanning a career of almost seventy years. It is enough to give architectural historians pause, but for those who chronicle the field of design, the scale is exponentially greater. Virtually every Wright building included an array of furnishings and fixtures that were conceived to harmonize with its decorative scheme, which allows us to multiply the architectural projects by a factor of twenty, thirty, forty, or even more and arrive at a number for his decorative designs that may be in the tens of thousands.

Taking a total approach to design—following through on an architectural and decorative vision that was all-encompassing inside and out—was emblematic of the new architecture of his time, but Wright adhered to it more consistently than most. It was essential to his artistic conception, what he called "organic architecture," for which, as he wrote, "it is quite impossible to consider the building one thing and its furnishings another, its setting and environment still another. In the spirit in which these buildings are conceived, these are all one thing, to be foreseen and provided for in the

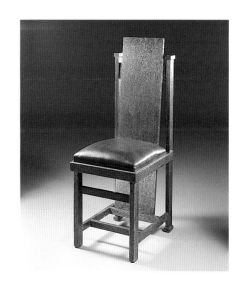

2
Frank Lloyd Wright. Dining room of the Meyer May house, Grand Rapids, Michigan, 1909

3
Frank Lloyd Wright. Chair, 1904. Oak with leather upholstery. Virginia Museum of Fine Arts, Richmond. Gift of the Sydney and Frances Lewis Foundation

4
Frank Lloyd Wright. Fabric from the Taliesin ensemble, 1955. Screen-printed rayon and silk. Made by F. Schumacher & Company. The Art Institute of Chicago. Gift of Brooks Davis. The spherical plans of the houses Wright built for his sons inspired the design of this fabric.

nature of the structure."[8] Whenever possible, he designed all the fittings of his buildings, decorative reliefs, paneling, furniture, stained glass, light fixtures, metalware, china, silver, fabrics, carpets, table linens, and even clothing (as did several other notable designers in the early twentieth century) so that the inhabitants would not mar the organically integrated interiors he conceived. This was "the modern opportunity," Wright continued, "to make of a building, together with its equipment, appurtenances, and environment, an entity which shall constitute a complete work of art."[9]

Underlying the artistic vision of each of his building projects was a broad thematic or structural idea, which he called upon to unify all aspects of its design. During the early years of his career when he was creating his Prairie houses—long, low buildings with overhanging eaves that responded to the open spaces of the great American landscape—he often took nature as his inspiration, using conventionalized interpretations of native weeds and flowers as his unifying motifs. In his simplification of the structure of the plants, he was following the path of Morris and other nineteenth-century architectural designers, including Owen Jones, whose book *The Grammar of Ornament* (1856) recommended an ornament "based upon a geometrical construction"[10] and stated that "flowers or other natural objects should not be used as ornaments, but conventional representations founded upon them sufficiently suggestive to convey the intended image to the mind, without destroying the unity of the object they are employed to decorate."[11] In this flattened geometrical design he deviated from the type of ornament favored by Louis Sullivan, whose buildings were distinguished by their florid, more expressive decoration. But Wright's decorative design, in keeping with Arts and Crafts dictums, was always meant to be integral to the building, "always of the surface, never on it."[12]

For the ornamental design of the Susan Lawrence Dana house in Springfield, Illinois, constructed between 1902 and 1904, Wright followed Jones's advice on decorative abstraction. He chose the sumac plant as his starting point, to which he added other prairie flowers, grasses, and butterflies. Wright explained that "from one basic idea all the formal elements of design are in each case derived and held well together in scale and character . . . its grammar may be deduced from some plant form that has appealed to me, as certain properties in line and form of the sumach were used in the Lawrence house . . . but in every case the motif is adhered to throughout so that it is not too much to say that each building aesthetically is cut from one piece of goods and consistently hangs together with an integrity impossible otherwise. In a fine-art sense, these designs have grown as natural plants grow, the individuality of each is integral and as complete as skill, time, strength, and circumstances would permit."[13] The sumac is recalled in various ways throughout the house, but particularly in the two-story dining room (fig. 5), where it appears naturalistically amid other autumn plants in a painted frieze done by George Niedecken, an artist working in Wright's studio; as decoration, reduced to a conventionalized chevron motif, in the earthy amber, green, and gold geometric patterns of the art-glass windows

5
Frank Lloyd Wright.
Dining room of the Susan
Lawrence Dana house,
Springfield, Illinois, 1902–4

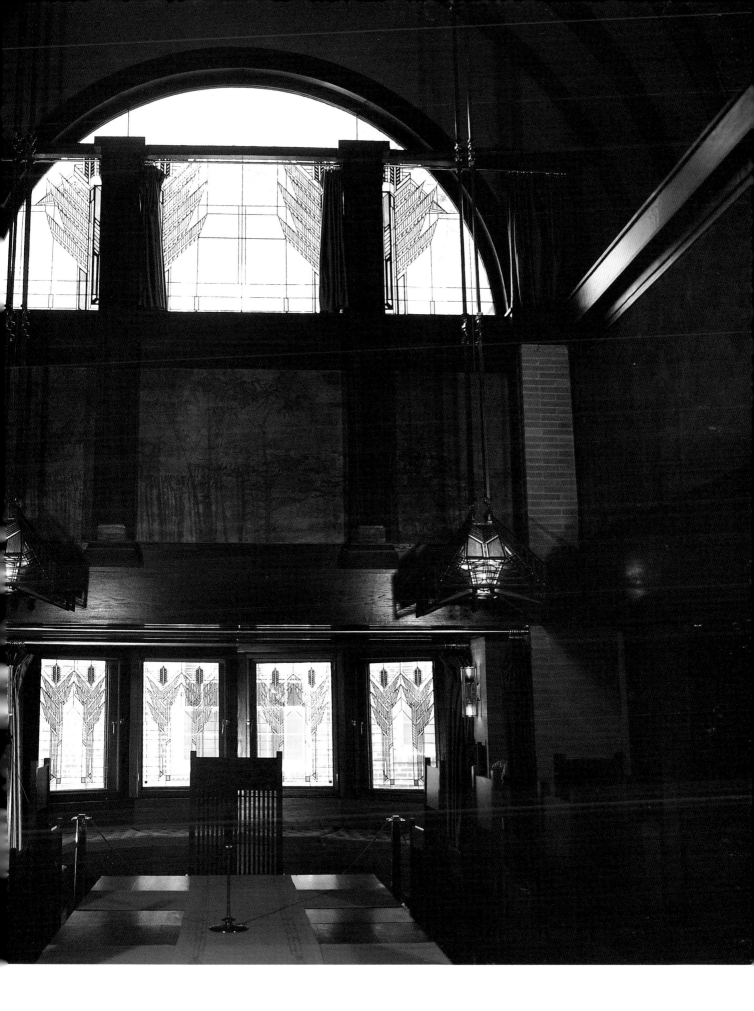

and the hanging "butterfly" lamps; and suggestively, in the autumnal colors of the fabrics and rugs and the warm oak of the furniture. Sumac itself might well have been among the actual plants, wild-flowers, and weed stems that would have been used in the house, set in the various vases and weed holders that Wright designed for this and other of his Prairie houses (fig. 6). This approach to orna-ment and a similar geometric conventionalizing of nature had appeared as early as 1897 in Wright's work. It is seen in the dense and repetitive ornamental motifs he drew in pen and ink for the elabo-ration of a fine, privately printed book titled *The House Beautiful* (fig. 7). The text, by a Unitarian minister, William C. Gannet, draws on the precepts of the Arts and Crafts Movement and Wright designed the volume's lacy ornaments and borders in the tradition of William Morris.

An extreme geometric abstraction of natural forms appears as the theme of the house Wright built in 1920 for Aline Barnsdall in Los Angeles. Known as the Hollyhock House after the flower on which its ornament is based, the concrete structure is decorated inside and out with this motif, which, in this case, came from the client, as Wright recalled: "A bit sentimental withal, Miss Barnsdall had pre-named the house for the Hollyhock she loved for many reasons, all of them good ones, and called upon me to render her favorite flower as a feature of Architecture, how I might."[14] He chose to ren-der the flower in a strictly rectilinear fashion. He ornamented the mansard-like roof with a frieze of his tall, cast-concrete abstracted hollyhocks and repeated them outside on the piers, walls, lamps, and garden urns. Inside, spare stained glass in purple and green dis-plays a variant of the abstracted hollyhock motif, while the dining table and chairs feature another take on the subject. The flowers grow up the center of the high-back chairs in a deeply sculptural motif against a pattern of rectangles forming a sort of trellis (fig. 8), which was repeated on the base of the table and picked up on the walls of the dining room.

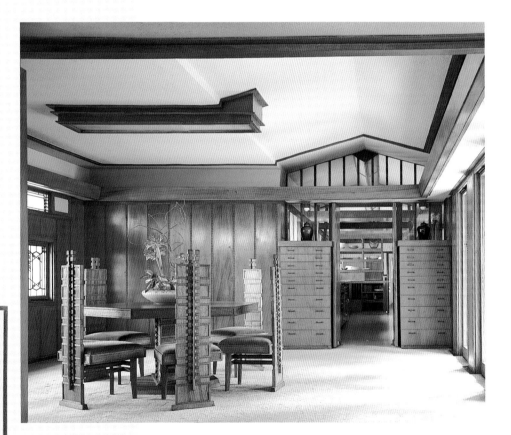

6
Frank Lloyd Wright.
Weed holder, 1895–1900.
Patinated copper.
Minneapolis Institute of Art.
The Modernist Collection,
gift of Norwest Bank
Minnesota. A weed holder
of this type was used in
the dining room of the
Dana house.

7
Frank Lloyd Wright.
"House Furnishing," chapter
heading from *The House
Beautiful* by William C.
Gannett, Auvergne Press,
1897. The Frank Lloyd
Wright Memorial Foundation

8
Frank Lloyd Wright.
Dining room, Hollyhock
House, Los Angeles, 1920

Wright was gradually to outgrow design literally conventionalized from nature. After his first trip to Europe in 1910, to oversee publication of a portfolio of his work in Germany, he began to favor geometry and abstraction as the organizing principles of his buildings. The chair he designed for the Imperial Hotel in Tokyo (1918–22) (fig. 9) combines hexagonal, square, and triangular forms that are equally specific to its commission as a sumac or hollyhock, for the geometry echoed shapes found in the structure and the ornamentation of the building itself. Geometric shapes were also the focus of the extraordinary suite of stained glass created for the Avery Coonley school building (known as the "Playhouse") in Riverside, Illinois, in 1912 (fig. 10). These geometric shapes are not truly abstract, however; in fact, they were meant to be pictorial, for the circles represent the balloons that Wright remembered seeing at a parade, and they are accompanied by squares of confetti and a small American flag that add to the narrative. The parade theme notwithstanding, the stained glass was very likely influenced by early abstract painting, which Wright probably knew from his trip abroad. The arrangement of simplified shapes and the use of primary and secondary colors, which depart from the earth tones of the Prairie houses built only a few years earlier, are unlike anything he had done before.

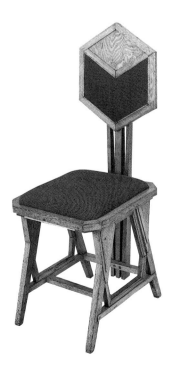

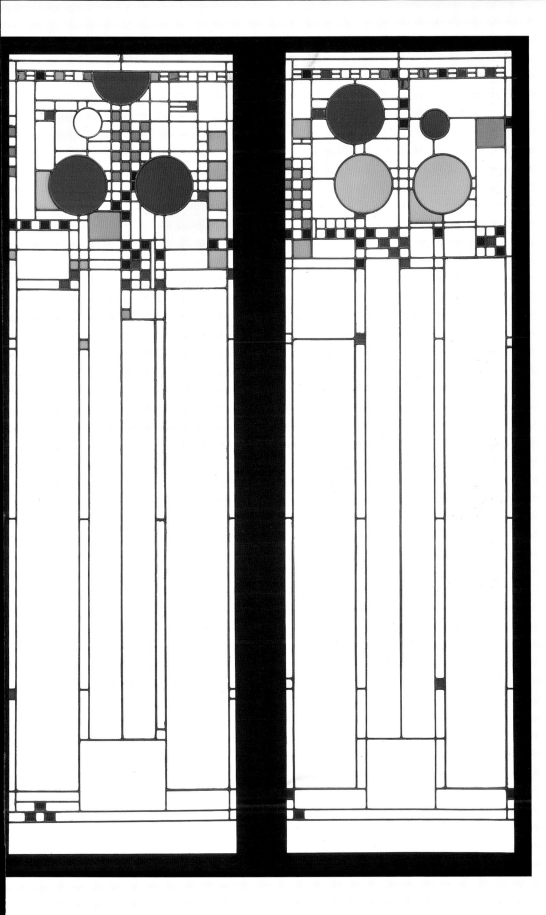

9
Frank Lloyd Wright.
Chair from the Imperial
Hotel, Tokyo, 1918–22.
Oak with upholstery.
Philadelphia Museum of
Art. Gift of the Imperial
Hotel

10
Frank Lloyd Wright.
Windows from the Avery
Coonley Playhouse,
Riverside, Illinois, 1912.
Clear and colored glass.
The Metropolitan Museum
of Art, New York. Purchase,
Edgar J. Kaufmann
Foundation and Edward C.
Moore Jr. gifts

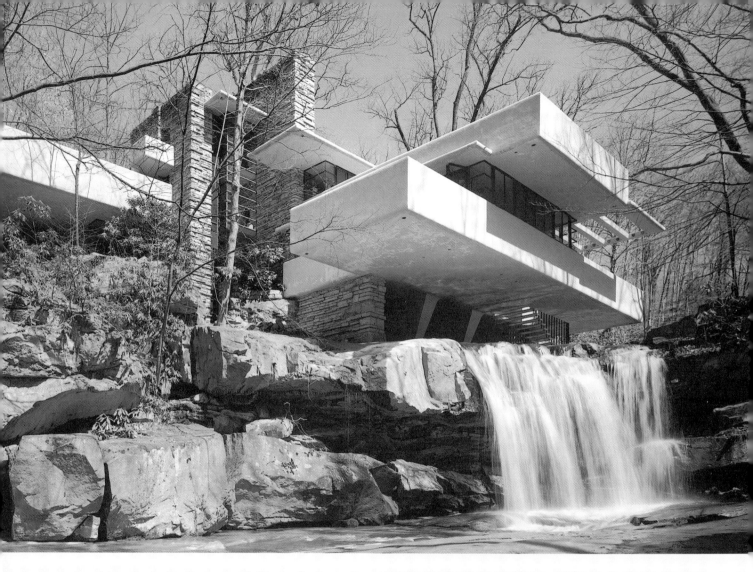

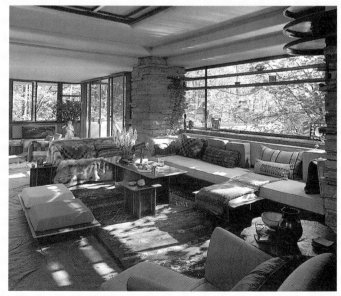

Wright's decorative design would be generalized even beyond the abstraction of geometry to emerge from the essential structures of his buildings. Fallingwater in Bear Run, Pennsylvania (fig. 11), twentieth-century America's domestic architectural masterpiece, designed in 1935, was Wright's challenge to International Style modernism, with its concrete structure responding to the formula of Le Corbusier in France. Its great cantilevered balconies, boldly echoing the rocks on which it sits, are his structural response to "its setting and environment." The design strives to bring surrounding nature into the house: the ever-present sound of the stream and waterfall, the changing patterns of the seasons revealed through the strip windows, and the colors and natural materials of the site. The cantilevered structure of the balconies is repeated in the built-in banquettes, the tables, and the stools and chairs (fig. 12).

Wright's other great response to broader currents in the design of his day was the Johnson Wax Building and its furnishings. He adopted the horizontal linearity and streamlined curves seen in the works of Raymond Loewy and the new American industrial designers (see Loewy, fig. 4) and the popular tubular-metal furniture of designers including Marcel Breuer (see Brandt, fig. 5) and Le Corbusier, Perriand, and Jeanneret (see Le Corbusier, fig. 10). Wright outfitted the entire building with special furniture made of cast-aluminum piping painted a brick color to harmonize with the building and the prairie around it. The office furnishings, designed for utmost efficiency, included several models of desks with cantilevered work surfaces (fig. 13), swinging rather than sliding drawers, built-in lighting tubes, and chairs that came in three- and four-legged versions.

11
Frank Lloyd Wright. Fallingwater, Bear Run, Pennsylvania, 1935

12
Frank Lloyd Wright. Living room, Fallingwater, Bear Run, Pennsylvania, 1935

13
Frank Lloyd Wright. Desk from the Johnson Wax Building, Racine, Wisconsin, 1936. Painted metal and walnut. The Museum of Modern Art, New York

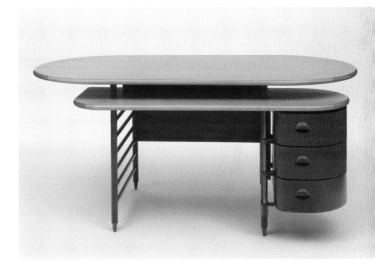

Following through on the details demanded by an all-encompassing approach to construction and decoration took painstaking amounts of consideration and required huge numbers of drawings as Wright strove to make all aspects of his designs part of a unified whole. In the early days of his career, when craftsmen were not yet accustomed to his brand of modern simplicity and his deliberate omission of conventional architectural elements from his works, "special detail drawings were necessary merely to allow the things to be left off or not done."[15] Wright became so proficient at envisioning the interiors of his buildings that he could design furniture on the spot, as he did for the Usonian house (he coined the adjective, hoping it would replace "American") that he erected for his retrospective exhibition in New York in 1953 (fig. 14).[16] For this interior, he designed built-in wall units and matching tables, stools, and dining chairs of broad planes of plywood, joined at right angles, with the supporting geometric structure revealed. Aside from the grain of the wood, which, in the Arts and Crafts tradition, became its formal design feature, Wright's only decorative elements are geometric cutouts in the backs of the dining chairs. Following the format of his earlier work, the chairs create an intimate enclosure in the open space of his design. Much of Wright's later furniture looks as if it had been designed of folded paper, and for

14
Frank Lloyd Wright.
Living-dining room of the
Usonian exhibition house,
New York, 1953

15
Frank Lloyd Wright.
Living room, Taliesin West,
Scottsdale, Arizona, 1937.
The Frank Lloyd Wright
Memorial Foundation

that reason has become known as "origami" furniture (see fig. 15).
Straight cut by machine and assembled with nails and glue rather
than traditional joinery, it could be made quickly, not requiring the
experience of a cabinetmaker but only the skills of a carpenter.

The close ties of Wright's decorative designs to the buildings for
which they were created are the reason why so many of his objects
appear curiously awkward or unresolved when they are removed
from their surroundings and shown in the bright spotlight of an
auction house, gallery, or museum. Because his buildings are often
so unconventional, their furnishings may appear to be oddly deco-
rated, out of scale, or extremely quirky in shape, especially those
done after Wright had left his Prairie houses behind. Wright
followed an all-encompassing approach to design, originating in the
nineteenth century, in which architects created furnishings that
would meld closely with the overall concept and decoration of each
building, generally a costly and time-consuming process. Twentieth-
century modernism took a more efficient approach that sought to
replace design created specifically for each project with universal,
undecorated forms meant to be easily and economically accommo-
dated in any building anywhere.

5

Le Corbusier
Type-objects and type-furniture

"Modern decorative art is not decorated"[1]—a paradox of terminology but a truism as well for Le Corbusier (1887–1965), the twentieth century's most influential architect, who became known for his unique method of building with reinforced concrete and for his polemical book *Towards a New Architecture* (1923). "The paradox lies not in reality, but in the words," he explained. "Why," he asked, "should chairs, bottles, baskets, shoes, which are all objects of utility, all tools, be called decorative art?"[2] Le Corbusier was not just complaining about the conventional term "decorative arts," he was condemning decoration, for he was promoting an alternative concept of design in which the ornamental enrichment of an object's surface would be supplanted by the rich simplicity of standardized functional form. With his insistence on the validity of this new formula, Le Corbusier took the crucial, final step in breaking ties with the past, moving well beyond Art Nouveau's rejection of historic styles at the beginning of the century to a rejection of decorative design itself.

Le Corbusier's arrival at this crossroads was the culmination of a long voyage of architectural and personal awakening that resulted not only in a new approach to design but also in a new persona for the architect. Born Charles-Edouard Jeanneret in the Swiss watch-making center of La Chaux-de-Fonds, he studied engraving (the mainstay skill for the decoration of watch cases) and decorative arts at the school of art there. His formal architectural training was minimal; his extensive travels and his apprenticeship and youthful work in Paris (with Auguste Perret) and Berlin (with Peter Behrens) provided his background in the field. In 1917, after having designed several buildings and interiors with their furnishings in La Chaux-de-Fonds, he left home and moved to Paris. There he took up the life of a painter and, with a fellow artist, Amédée Ozenfant, intro-duced a new post-Cubist movement that they called Purism. At the same time he worked as an architect, opening an office and taking on his cousin Pierre Jeanneret as partner in 1922. It was in Paris that he entirely rethought his architectural ideas and became a modernist builder, repudiating, or at least ignoring, the mildly neoclassical style of his past designs and changing his name to erase any connection with them. "Le Corbusier," a variant of a family name, would be the way he signed all of his future architectural work and much of the critical writing he did for the magazine *L'Esprit Nouveau* (The New Spirit), of which he was a co-founder, but he would continue for almost another decade to use "Jeanneret" to sign the paintings that he created.

The young Jeanneret had observed spare, functional design first-hand when as a student he traveled on a fact-finding trip to study the decorative arts in Germany. He spent several months in 1911 working in the studio of Peter Behrens, whose position as artistic director of the German electric company AEG had been devoted to standardizing the company's production and creating a style that he considered suitable to machine manufacture. In the journal Jeanneret kept of his trip, he wrote that Behrens's products had "been taken to their most simple aspect . . . all the beauty lying in the proportions, and the finish of the material. These severe, ample forms are above all impressive, not pretty, they are neutral, perfectly appropriate to their use."[3] He would call on very similar

terms to described the simple forms that he and Ozenfant depicted in their Purist still-life paintings, common undecorated objects such as bottles, glassware, books, guitars, pipes, and moldings that had slowly become defined and standardized over many decades (fig. 2). Unlike Cubism, which had depicted objects from many viewpoints, suggesting a constantly changing world, Purism showed these banal, invariable, and ubiquitous industrial products in their most recognizable forms and from their most characteristic viewpoints, attempting to capture the essence of an underlying stability and universal harmony.

Le Corbusier called these standard objects "types," describing them in *The Decorative Art of Today* (1925) as products that had evolved slowly over time so that they closely fit the most universal of human requirements, much like the effect of the evolutionary process on our own bodies. Among the type objects he illustrated in this book were commercial glassware, bottles, garden and café furniture (fig. 3), and office furnishings. "They are extensions of our limbs," he explained, "and are adapted to human functions that are type-functions. Type-needs, type-functions, therefore type-objects and type furniture."[4] Each object is a "docile servant";[5] "we sit on them, work on them, make use of them, use them up; when used up, we replace them."[6] In this way, he discarded empathy from design. Not for him John Ruskin's reverence for individual expression, irregularity, and the chance marks that each man's labor left on his products. "Previously every man, creating his work from scratch, was attached to it and loved it as if it were his own offspring," Le Corbusier and Ozenfant wrote in *After Cubism* (1918), their Purist manifesto. But now, they continued, "manufactured products are so perfect that they give labor teams cause for collective pride. A worker who has executed only a single isolated component understands the interest of his labor; the machines covering the factory floor make him perceive power and clarity, make him feel at one with work of such perfection that his mind alone would never have dared even to aspire to it."[7] This clarity of simple forms was the key to a new aesthetic of machine perfection.

2
Le Corbusier.
Still Life, 1920. Oil on
canvas. The Museum of
Modern Art, New York

3
Café tables. Illustration
from Le Corbusier,
*The Decorative Art of
Today,* 1925

Nº 78
Guéridon rond pliant.
Diamètre : 0.50. 0.55, 0.60. 0 70.

Nº 77
Guéridon carre phant.
Côtés : 0 50, 0.55. 0.60.

Le Corbusier translated his idea of machine-made type-objects and type-furniture into the furnishings of the pavilion he erected at the International Exposition of Modern Decorative and Industrial Arts in Paris in 1925 (fig. 4). Chosen for function alone, these furnishings were perfect for the interior of the "machine for living,"[8] as he had famously described the modern house in *Towards a New Architecture*. Presented under the auspices of his magazine, *L'Esprit Nouveau,* this pavilion was not a typical exhibition building at all; it was a model of the standardized living units that he proposed for his new reinforced-concrete apartment blocks, which he hoped would bring to reality his utopian vision of the modern city. Each unit, or apartment home (*immeuble-villa*), would have a two-story living room (fig. 5) and sleeping balcony above, window wall, and terrace (fig. 4), modular fittings, and, of course, type furnishings.

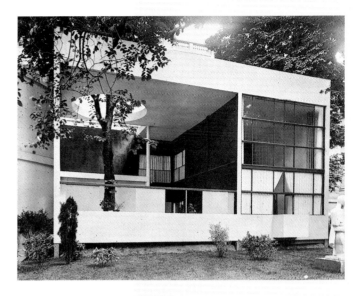

Among the type furnishings that can be seen in photographs of the interior of the Esprit Nouveau pavilion are bentwood chairs, leather easy chairs, simple tables with metal legs, and ceramic and glass accessories. They had all been around for a long time even then. The Austrian manufacturer Thonet had made the cane-seat bentwood armchair he used since about 1902. Le Corbusier described it as "humble" and "certainly the most common as well as the cheapest of armchairs,"[9] and his description of it laid out for the reader his understanding of the evolution of a type: "During the long and scrupulous process of development in the factory, the Thonet chair gradually takes on its final weight and thickness . . . [in a] process of perfecting by almost imperceptible steps."[10] The upholstered leather easy, or club, chair, used in the pavilion was also a type, which had become "attuned to our movements and quick to respond to them."[11] It had been introduced in nineteenth-century England in the salons and libraries of gentlemen's clubs, and Henry James was one observer who had marveled at its comfort: "Such lounges and easy chairs!" he wrote home admiringly in 1877.[12] The metal-legged tables with wooden or metal tops, acquired from hospital suppliers, were also meant as flexible type furnishings for use "as a desk or a tea table, and by putting them together, banquets can be served on them."[13] The small glass and ceramic objects that became vases and planters were also common designs, principally laboratory equipment made to exacting scientific requirements, here appropriated for domestic use because of their unornamented simplicity.

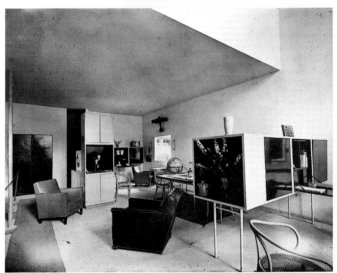

Although the pavilion's storage units (fig. 6) were his own design, Le Corbusier had no problem in considering them type furnishings also. They were used architecturally, to divide and define spaces in the flexible open-plan interiors that he originated. No cabinetry then available could fulfill the function of storage and spatial definition that he required, and he was sure that in time his vision of modular storage pieces, with interiors fitted specifically for their contents with drawers, shelves, and elements for hanging, would inevitably become one of the requisites of modern architectural design. He also based his concept for the storage units on types: the elaborately fitted out steamer trunks made for the convenience of travelers in their cabins during long ocean voyages; and office

4
Le Corbusier.
Esprit Nouveau pavilion,
International Exposition of
Modern Decorative and
Industrial Arts, Paris, 1925

5
Le Corbusier.
Living room of the Esprit
Nouveau pavilion, Paris,
1925

6
Le Corbusier.
Cabinets on the balcony
of the Esprit Nouveau
pavilion, Paris, 1925

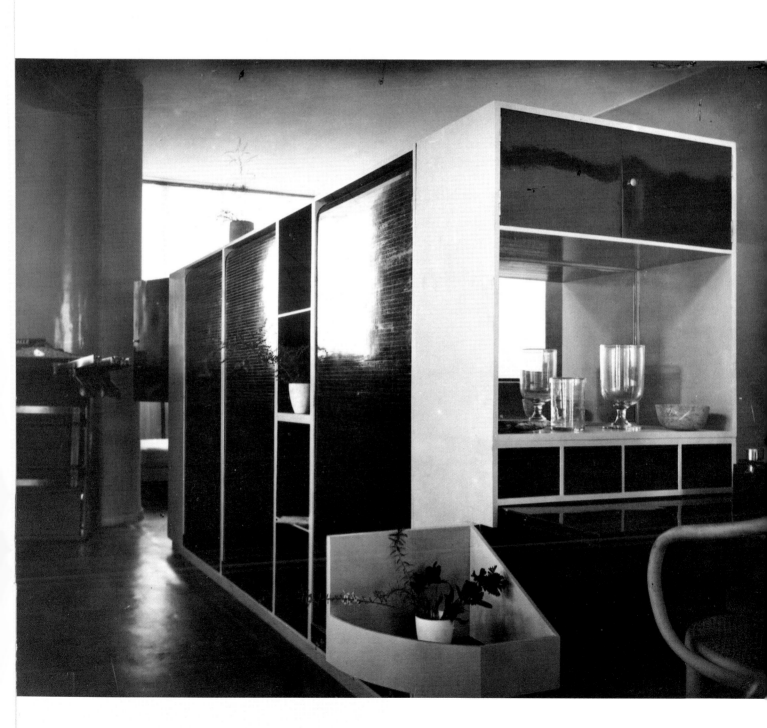

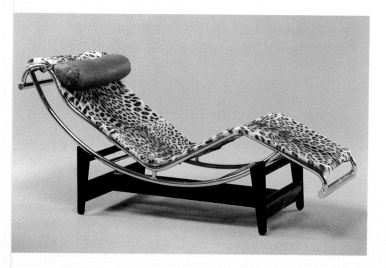

one's activities, depending on the position one takes in a living room (and which we change four or five times in an evening), there are many ways to be seated. One sits 'actively' to work," he explained, illustrating this position at the top left of his drawing. "Chairs are an instrument of torture that keep you awake admirably. I need a chair when I work. I sit down to talk," he continued: "a certain armchair gives me a decent, polite manner," which he drew in the center of the second band of figures. "I tend to a more total relaxation," he went on. "I remember that Noel, the head of the body section at Voisin Automobiles, equipped his 14-horsepower sport with a spring cushion set on the floor; and on it I do five hundred kilometers without a stop, without tiring; I remember it when I furnish my living room," and he drew this position at right in the second band. "But here is the machine for resting," depicting this type in two different positions in the two figures below. "We built it with bicycle tubes and covered it with a magnificent pony skin; it is light enough to be pushed by foot, can be manipulated by a child; I thought of the western cowboy smoking his pipe, his feet up above his head, leaning against a fireplace; complete restfulness. Our chaise longue takes all positions, my weight alone is enough to keep it in the chosen position; no mechanism. It is the true machine for resting."[18]

The "true machine for resting" describes their renowned chaise longue, often sumptuously upholstered with animal skins (fig. 8), an iconic example of modernist design as sculptural form. Its chromed tubular-metal frame sits freely on a painted metal stand and is infinitely adjustable, as Le Corbusier described it: the chaise fosters complete relaxation when it rests in the horizontal position and was said to have health benefits, by allowing the feet to be elevated when the bottom of the frame is raised. The comfortable chair deriving from an automobile seat and corresponding to the pavilion's club chair, was made simply of five leather-covered cushions held in position by a cubic tubular-metal frame (fig. 9). For the chair for conversation, they adapted another type object, but one that had not been part of the Esprit Nouveau pavilion. This was a light folding armchair that had been associated with military campaigns and colonial administration since the nineteenth century, and they replicated its open-frame form and pivoting back closely (fig. 10). For the work chair, which corresponds to the Thonet bentwood chair in the pavilion, they adopted a metal chair with revolving back that Perriand had designed independently at the time she entered Le Corbusier's office (fig. 11).

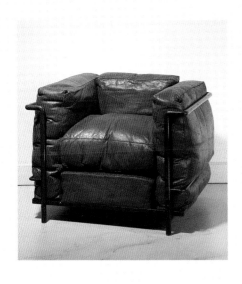

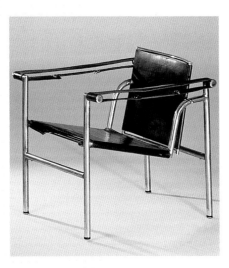

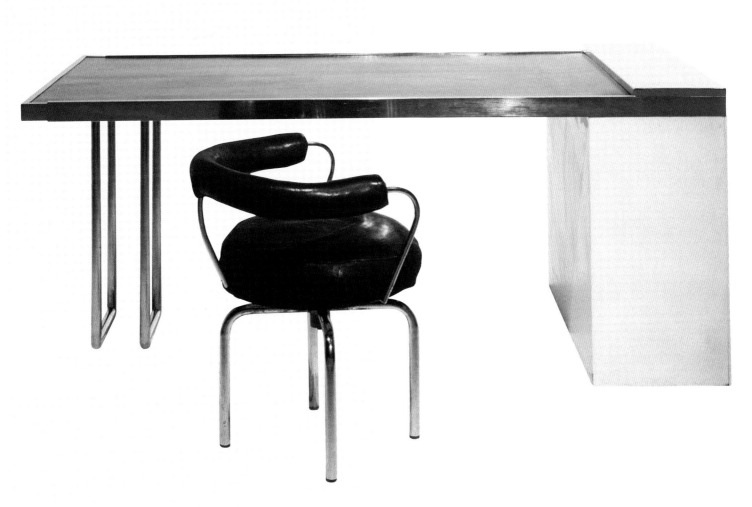

The metal furniture was first shown publicly in the Paris Salon d'Automne of 1929 in an apartment setting, where Le Corbusier referred to it as the "interior equipment of a dwelling" (fig. 12). No longer decorative art, furniture was to be classified as equipment, meant to seem as if it were factory made (although these pieces weren't) just like any appliance or tool necessary for the smooth running of our lives. Perriand was in charge of having these pieces individually fabricated as clients ordered them, and she used them herself in fitting out other interiors, including the office of the administrator of the newspaper *La Semaine à Paris* (fig. 13). By the end of the decade the Thonet firm, which through its French office had sponsored the Salon d'Automne exhibit, had taken on production of their line. Thonet included Perriand's chair with revolving back and the chair with pivoting back on the cover of its 1930–31 tubular-steel furniture catalogue, along with pieces by Marcel Breuer and other designers (fig. 14). Although relatively few examples of this furniture were made and sold by Thonet in the prewar period, it has become very well known today, the result of having been published by Le Corbusier in the serially issued complete catalogue of his works and having been brought back into production when interest in modernist design revived in the 1960s.

The type objects shown in 1925 and the interior equipment of a dwelling of 1928 all shared the modern aesthetic of simplicity. "Simplicity" had assumed many meanings since the term was used to rally the reform of design in the middle of the nineteenth century. Frank Lloyd Wright had praised William Morris for advocating simplicity, but the simplicity of his decorative formats and his Gothic vocabulary was not what we today would call "simple." From Wright's viewpoint, simplicity was also "not simple in the sense that the infant intelligence is simple—nor, for that matter, the side of a barn. . . . A thing to be simple needs only to be true to itself in an organic sense."[19] But for Le Corbusier, simplicity was less complex; above all it meant no decoration and no allusion to historic styles, which he had foresworn ever since he had arrived in Paris.

Unlike the stylistic idioms that made other movements modern but particularized them and associated them with a specific era—the perpendicularity of De Stijl, the strict geometry of the Bauhaus, the decorative angularity of Art Deco—Le Corbusier's aesthetic of simplicity was universal. He replaced a modernity that changed with each successive style and period with a modernity that depended on simplicity alone. He found simplicity all over, absorbing objects from past and present and even from distant cultures that fit his notion of purity and perfection. By defining anything that was simple as modern, regardless of when and where it originated, he made modern timeless. Timeless for his day and timeless for ours. Who has not come upon a piece of chaste Georgian silver, a Wedgwood cup, or a plain Shaker desk in a museum and unthinkingly said "Wow! It's so modern"? While such objects may have been around for a very long time, they are—thanks to Le Corbusier—modern too.

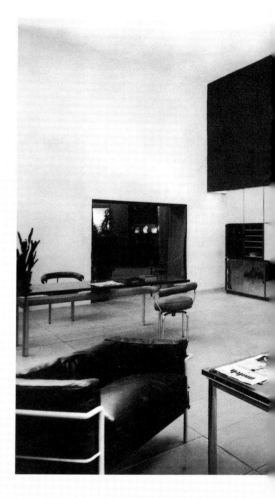

12
Le Corbusier, Charlotte
Perriand, and Pierre
Jeanneret. "Interior
Equipment of a Dwelling,"
installation at the Salon
d'Automne, Paris, 1929.
Shown at the exhibition
was all of the free-standing
furniture designed in 1928,
along with modular metal
cabinets.

13
Le Corbusier, Charlotte
Perriand, and Pierre
Jeanneret. Office of the
Administrator, *La Semaine
à Paris*, Paris, c. 1930.
Charlotte Perriand probably
arranged this interior for
the firm using her chair
with revolving back, the
club chair, and the chair
with pivoting back.

14
Cover of Thonet
Stahlrohrmöbel
(Tubular-Steel Furniture)
catalogue (1930–31).
Bauhaus-Archiv, Berlin.
Perriand's chair with
revolving back joins Marcel
Breuer's typewriter table
on the front cover of the
Thonet steel furniture
catalogue, while the firm's
chair with pivoting back
and Breuer's armchair and
coffee table appear on
the reverse.

6

Marianne Brandt

Art and technology, a new unity!

Marianne Brandt (1893–1983) is the great success story of the Bauhaus, the German school of design that the architect Walter Gropius founded in 1919 by combining and restructuring the school of arts and crafts and the academy of art in Weimar. The Bauhaus is for many the well of industrial modernism, the legendary single source of avant-garde theory and design for the twentieth century. Its avant-garde position rests on the stature of its international artist-teachers, and on its policy of designing for industry, but the school did not start out with factory production as a goal. When Gropius proclaimed in the first program of the Bauhaus, "The ultimate aim of all visual arts is the complete building," his vision of bringing unity to the arts through architecture was based not on the machine but on the workshop precedents of William Morris and the Arts and Crafts Movement. He gave notice to his constituency of architects, sculptors, and painters that "we all must return to the crafts!"[1] and insisted that Bauhaus students gain practical training by learning a trade in the school's workshops.

Bauhaus products are revered as prime examples of functionalist modernism, especially those designed, like Marianne Brandt's metalwork, in the cool machine mode that became the Bauhaus style around 1924. A student, then a teacher, at the Bauhaus, Brandt most closely reflected its changing aspirations as it evolved from a retrogressive craft-based design academy into a forward-looking "laboratory" for the creation of prototypes for industrial production. The handmade coffee and tea services that Brandt wrought as a student in the Bauhaus metal workshop were original and fully mature creations (fig. 2), exemplars of the geometric Bauhaus aesthetic, while her series of factory-made lighting devices (fig. 3), designed with a number of colleagues during the later 1920s after the school had made inroads into industry, had perhaps the broadest commercial distribution of any of the school's products. Her only possible rival would be the Hungarian Marcel Breuer, who also was both Bauhaus student and teacher and whose career similarly mirrors the changing phases of Bauhaus ideology. But his student furniture designs are mere curiosities (fig. 4), highly derivative of the works of the Dutch De Stijl designer Gerrit Rietveld, and while his revolutionary tubular-steel furniture, including his famous armchair (fig. 5), became the best-known designs associated with the Bauhaus (in spite of the fact that

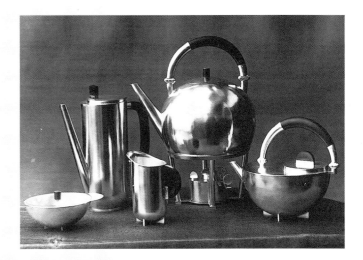

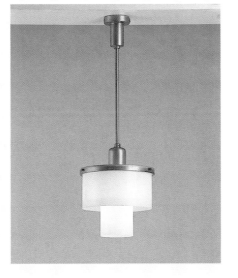

Breuer always insisted that he designed them independently of the school), they did not achieve anywhere near the broad commercial distribution of Brandt's products until well after the Bauhaus closed.

In order to make her mark at the Bauhaus, Marianne Brandt had to overcome the school's inherent sexism, which corralled its large number of female students into a special textile curriculum. Because the young and liberal Weimar Republic guaranteed equal education-al opportunity for women, the Bauhaus administration created a separate women's program so that the large number of female students would not take the places in the other workshops that it wanted for its male students. Brandt had a number of advantages over the other women matriculants that may have allowed her to follow an independent program. Born Marianne Liebe in the city of Chemnitz, southeast of Leipzig, she came to the school at the age of thirty, older than the majority of the students; she was married (to a Norwegian artist, Erik Brandt, although by then they had already separated); and she had had the experience of studying painting at the academy of art in Weimar and of living and working abroad. After visiting the Bauhaus exhibition that was organized in 1923 to demonstrate the strides made by the school during its first four years (see van de Velde, fig. 2), she decided to enroll as a student there. She was apparently taken under the wing of László Moholy-Nagy, the Hungarian designer who had been hired in 1923 to take over the direction of the famous foundation course, which introduced students to problems of form and the use of materials. After Brandt completed the required half-year of preliminary studies under Moholy-Nagy and his assistant Josef Albers, and had taken the artistic design courses taught by the painters Wassily Kandinsky and Paul Klee, Moholy-Nagy ushered her into an apprenticeship in the metal workshop, which he also headed.

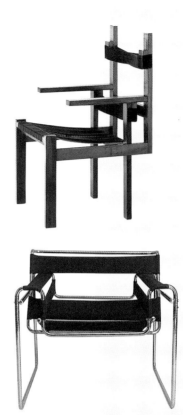

As the only female student in the metal workshop, Brandt was not immediately welcomed by her fellow students. A photograph of the workshop group shows her in the background, barely visible, peeking out from behind the men (fig. 6). A half century later she recalled the problems of her initiation into the group: "At first I was not accepted with pleasure—there was no place for a woman in a metal workshop, they felt. They admitted this to me later on and mean-while expressed their displeasure by giving me all sorts of dull, dreary work. How many little hemispheres did I most patiently hammer out of brittle new silver, thinking that was the way it had to be and all beginnings are hard. Later things settled down, and we got along well together."[2] How important her patience with those hemispheres of silver turned out to be can be seen in the singular designs she created after her disheartening introduction; the tea and coffee services and other tabletop pieces she painstakingly fabricated soon rivaled the work of the other students and the assistants in the metal workshop.

The hemispheres on which Brandt based her designs reflect the Bauhaus's emphasis on geometry, the search for universal and unchanging solutions to the creation of artistic forms through a reliance on Platonic solids. Yet her designs are personal and highly

idiosyncratic, with semicircular handles of metal and wood, or wooden half discs attached with apparent rivets; cylindrical or rectangular knobs; and cross-footed bases—elements not attached in a fully organic fashion but in an additive way, much like the techniques used in the foundation course to create class projects with disparate materials. About a score of these vessels are known, made of gold, silver, copper, or brass, with handles and knobs of ebony, all executed over a short period of time as her skills developed after she became fully integrated into the workshop.

When Brandt began to study at the Bauhaus at the beginning of 1924, Walter Gropius had just introduced a new philosophy for the school, using as his rallying cry the phrase "art and technology, a new unity!"[3] Discarding his initial bias in favor of hand production, he began to direct the school toward the creation of designs for industrial manufacture, and he introduced an aesthetic approach that he felt would evoke machine production. Thus the objects created in the school's workshops began to change in style, away

4
Marcel Breuer.
Armchair, 1924. Stained maple and horsehair. Bauhaus-Archiv, Berlin

5
Marcel Breuer.
Armchair, 1925. Chrome-plated steel and canvas. The Museum of Modern Art, New York. Gift of Herbert Bayer

6
László Moholy-Nagy and the students of the Bauhaus metal workshop, 1924–25. Brandt can be seen peeking out at the rear behind the male students and teachers.

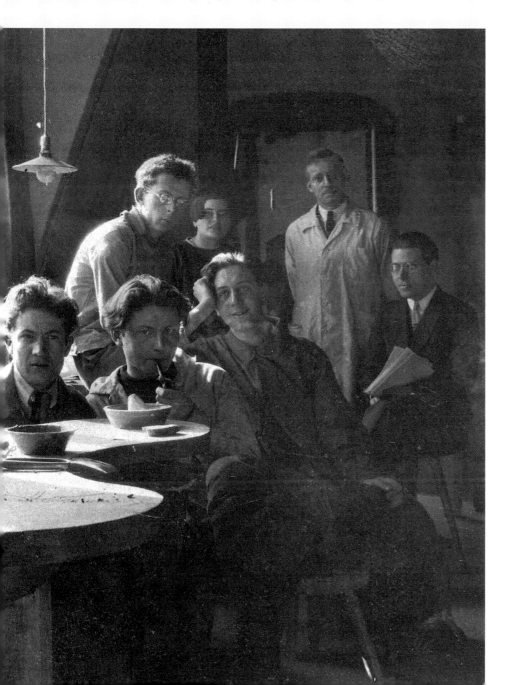

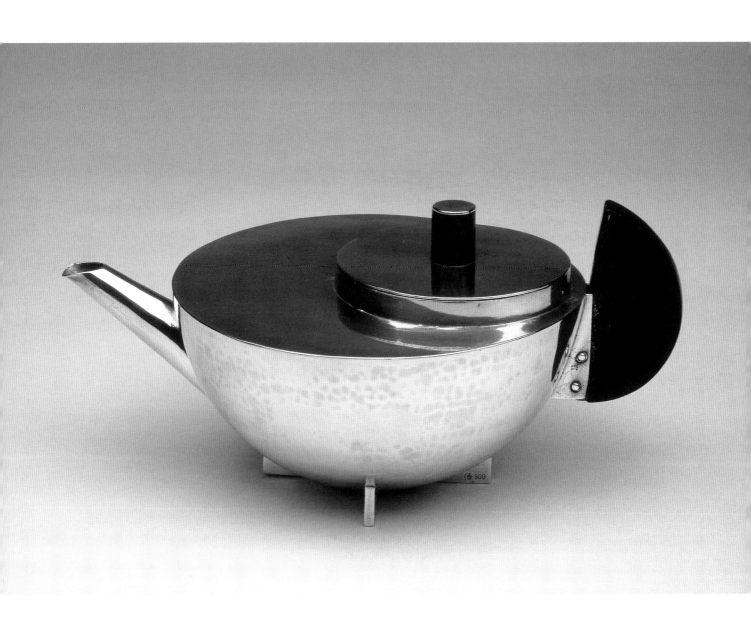

from the rough surfaces and irregular forms associated with the ideals of William Morris and toward a high degree of finish meant to make them look as if they were made by machine. This abrupt aesthetic change is clearly documented in Marianne Brandt's own work. Of all her tea infusers, one stands out as unique (fig. 7); it has an irregular, mottled, unpolished surface that shows all the signs of Brandt's hand "most patiently hammer[ing it] out of brittle new silver." This must be among the earliest of the tea and coffee vessels she executed, for it reflects the initial Bauhaus handicraft approach that she was originally introduced to during her apprenticeship. It looks very different from all her other known tea and coffee vessels from this period, which display the smooth, reflective, highly polished surfaces that Gropius now favored (fig. 8), with not the least indication remaining of the hand of the maker.

When Brandt arrived, fancy tabletop items were still the focus of the metal workshop, but "they had just begun to produce objects capable of being mass-produced though still fully handicrafted," she recalled. "The task was to shape these things in such a way that even if they were to be produced in numbers, making the work lighter, they would satisfy all aesthetic and practical criteria."[4] Making handcrafted products look like machine-made ones, which contradicted in every way Morris's call for honesty in the use of materials and techniques, was consistent with what other designers in the metal workshop were doing, and with other metal products that the Bauhaus was producing about 1924. Wilhelm Wagenfeld, who revised a prototype lamp created by Karl Jakob Jucker to make a glass and metal design that has become one of the most recognizable of Bauhaus products (fig. 9), spoke of the Bauhaus administration's expectations for this new machine aesthetic in the market.

7
Marianne Brandt.
Tea infuser, 1924.
Silver and ebony.
British Museum, London

8
Marianne Brandt.
Tea infuser, 1924. Brass, silver, and ebony.
Bauhaus-Archiv, Berlin.
Gift of Willy Hauswald.
Marianne Brandt's two tea infusers from 1924 demonstrate the change in the aesthetic at the Bauhaus from an approach that emphasized hand craftsmanship to one that simulated the products of machine production.

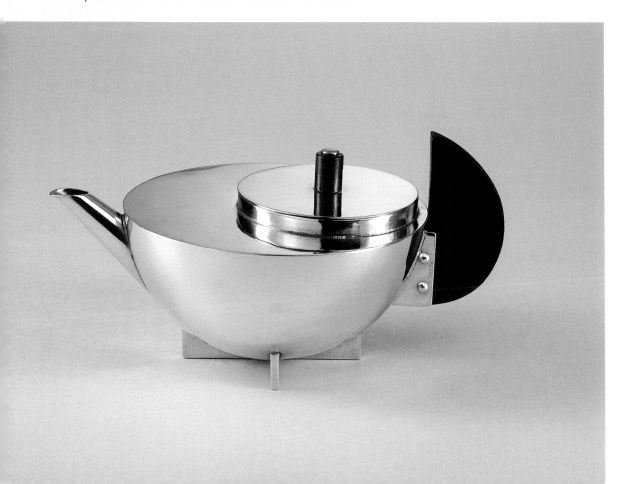

"In our Metal Workshop there was only an obsolescent machine for grinding and polishing and no other machine tools, only the most essential hand tools for our teachers. Under such conditions we nevertheless made a series of 'Bauhaus lamps' for the Leipzig Trade Fair. I myself was sent to the 'Bauhaus Stand' in the Lighting Hall. Autumn 1924. But we had no success. Dealers and manufacturers made fun of our products. Although they looked cheap, as though machine made, they were actually expensively made by hand."[5] Brandt's work, too, was made by hand to look as if it were produced by a machine. She was successful enough in this regard to fool at least one journalist, who described a Brandt tea infuser as "machine made" and mistakenly explained to his readers how the "machine presses out the half-sphere in a single process."[6]

The metal workshop resisted change, however, as Moholy-Nagy recounted in a memoir titled "From Wine Jugs to Lighting Fixtures": "When Gropius appointed me to take over the metal workshop he asked me to reorganize it as a workshop for industrial design. Until my arrival the metal workshop had been a gold and silver workshop where wine jugs, samovars, elaborate jewelry, coffee services, etc., were made. Changing the policy of this workshop involved a revolution, for in their pride the gold- and silversmiths avoided the use of ferrous metals, nickel and chromium plating and abhorred the idea of making models for electrical household appliances or lighting fixtures. It took quite a while to get under way the kind of work which later made the Bauhaus a leader in designing for the lighting fixture industry."[7]

Moholy-Nagy's vision eventually won out. "Far more difficult than electric lamps was the problem of industrially producing our silverware and other tableware," Brandt recollected. "Not many such things were being produced. So to a certain extent we were branded as a lighting department. We furnished whole buildings with our industrially produced lamps and only rarely designed and produced special pieces in our workshop for particular rooms or showrooms."[8] One impetus for the push into industrial lighting was the need to create fixtures for the new buildings that Gropius was constructing in Dessau for the school's move there in 1925. Very little lighting suitable to Gropius's modern style was then available commercially, and Brandt joined others in the metal workshop in creating appropriate designs to fit out the workshops (fig. 10), classrooms, auditorium, and all the other spaces in the new school complex, including the faculty housing that Gropius had also designed. Their previous lighting experience was quite limited, but they rapidly designed a great variety of fixtures to suit the diverse needs of the buildings. The forms of the lamps followed the geometric approach that the metal workshop and the Bauhaus itself had promoted, which is clearly seen in Marianne Brandt's spare hanging light for the Bauhaus building, designed with her colleague Helmut Schulze, consisting of simple concentric two-tone glass cylinders supported with metal mounts (fig. 3).

About the same time, the Bauhaus was undertaking negotiations with a number of manufacturers to collaborate on the factory production

9
Karl Jakob Jucker and
Wilhelm Wagenfeld.
Table lamp, 1923–24.
Nickel-plated brass and
glass. Bauhaus-Archiv,
Berlin. Gift of Herbert
Skrebba

10
Bauhaus weaving
workshop, c. 1927–28,
with adjustable hanging
lamps designed by
Marianne Brandt and
Hans Przyrembel, 1927

of lighting designed by the Bauhaus metal workshop. Examples of its production were readily available in the new Bauhaus buildings. In 1928 the Bauhaus made commercial arrangements with two lighting firms. The first, Schwintzer and Gräff of Berlin, undertook to manufacture and distribute lighting already created by the Bauhaus workshop, including a number of fixtures from the Dessau buildings. The second, Körting and Mathiesen of Leipzig (known by its initials in its English branch as Kandem ["K and em"], a nickname that was then made into its international trademark), moved the Bauhaus lighting project ahead creatively by agreeing to collaborate fully on the introduction of new designs. In return for fees and royalties, the contract gave Kandem the rights to any new products they wanted to manufacture, with the allowance that they could patent them and produce them as their own without giving credit to the Bauhaus or to the individual designers.

Just as this was happening, Walter Gropius resigned from the Bauhaus, and Moholy-Nagy soon left also, with the result that in April 1928 Brandt became temporary head of the metal workshop. Had she been a man, the position would undoubtedly have been awarded on a permanent basis, but until then only the textile workshop was headed by a woman. There, too, relationships with industry were percolating, though at first on a piecemeal basis. In 1928 and 1929, individual textile prototypes and samples were purchased for production by a number of German textile mills and sold as "Bauhaus fabrics." In 1930, however, the Bauhaus and a large manufacturer, Polytextil, signed a contract, not unlike the one made with Körting and Mathiesen, for the production of a "Bauhaus collection." In this case, however, the association with the school was publicized and seen as an important aid to sales.

Brandt held the temporary position of workshop head until July 1929, when she left to join Gropius's office in Berlin. She had been in charge of the considerable duties of keeping the collaboration with the lighting manufacturers going, and she opened up new possibilities for the students to become acquainted with industrial manufacturing techniques through a program of factory visits. Brandt had been tempted to stay at the Bauhaus by an offer to continue working with Kandem and at the same time to "learn photography from the ground up" in the school's newly opened department led by Walter Peterhans.[9] Brandt had adopted Moholy-Nagy's special interest in photography by learning its techniques as she moved from the foundation course into the metal workshop. In particular, she made many self-portraits, some boldly showing the accouterments or symbols of her profession; in one from 1929 she is dressed in her costume for the school's Metallic Fest (fig. 1). She used her self-portraits as well in the collages she began to create in 1926. *Me,* a photocollage included in a portfolio titled 9 *Years of Bauhaus: A Chronicle* (fig. 11), shows how immersed she was in the school's message. Reclining at the left, she rests on a stack of her aluminum light reflectors; standing behind her is her mentor Moholy-Nagy. Views of the Bauhaus building and of her fellow students complete this autobiographical image. Much of her photography responds to the visual qualities of metal, particularly emphasizing the shiny surfaces she created in the workshop (fig. 12) and exploring properties of reflection, distortion, and shadows of all kinds.

11
Marianne Brandt. *Me,* sheet from portfolio 9 *Years of Bauhaus: A Chronicle,* 1928. Photocollage. Bauhaus-Archiv, Berlin. Brandt shows herself reclining at left on her metal reflectors. Moholy-Nagy appears above, along with Gropius's Bauhaus building and other students.

12
Marianne Brandt. Reflections, 1928–29. Photograph. Bauhaus-Archiv, Berlin

Designing for Kandem was a collaborative undertaking, and many of her works were done in association with others in the metal workshop, principally the Austrian Hin Bredendieck, trained as a carpenter and joiner, who had come to the Bauhaus for further study in 1927. Together they were responsible for the Kandem desk and table lamp models, which were the Kandem/Bauhaus designs that achieved the greatest commercial success. The desk lamp (fig. 13) was an earlier Kandem design updated at the request of the company, resolved in a new sleek and elegant form with a base that remained stable, regardless of how the arm was bent. Equally simple was the enameled bedside swivel lamp (fig. 14), conceived for hotel rooms, which had a slanted base that was supposed to provide indirect light when the lamp was turned directly down toward it. It has had a long production history and has been much imitated, with distant versions available even today. Together, Brandt and Bredendieck also created a series of simple ceiling and hanging fixtures, glass and metal designs that were used both domestically and commercially.

Brandt had one final collaboration with industry after she left Gropius's office and before she returned to her home in Chemnitz on the Nazis' accession to power. From 1930 to 1932 she headed the design division of the Ruppelwerk metalware factory in Gotha and was responsible for creating a new system of manufacturing for the bent sheet-metal household products she introduced. Some were in a considerably more popular style than the Bauhaus products had been, colorfully lacquered and decorated with Art Deco–style motifs, while others more closely followed the reductive forms of her previous products (fig. 15). In Chemnitz she worked as an artist until after the war. She then taught in the design schools of Dresden and East Berlin but was cut off by the Iron Curtain from any interaction with Western design.

In spite of the deliberate attempts by the Bauhaus to limit female students' equal access to all the offerings of its curriculum, the school's greatest success in its industrial mission can be attributed directly to the activities of its women. The textile workshop, which had its designs produced by industry, and the metal workshop, with Brandt in charge of the collaborations with Schwintzer and Gräff and Körting and Mathiesen, put women into close contact with manufacturers, bringing to fruition Gropius's vision of a productive collaboration of art and industry.

13
Marianne Brandt and Hin Bredendieck. Kandem desk lamp, 1928. Copper and aluminum. Made by Körting and Mathiesen. Bauhaus-Archiv, Berlin

14
Marianne Brandt and Hin Bredendieck. Kandem bedside lamp, 1928. Enameled steel. Made by Körting and Mathiesen. Bauhaus-Archiv, Berlin

15
Marianne Brandt. Table clock, c. 1930. Painted and chrome-plated metal. Made by Ruppelwerk, Gotha, Germany. The Museum of Modern Art, New York

7

Raymond Loewy

Never leave well enough alone

TWENTY CENTS OCTOBER 31, 1949

TIME

THE WEEKLY NEWSMAGAZINE

Artzybasheff

DESIGNER RAYMOND LOEWY
He streamlines the sales curve.

$5 A YEAR (REG. U.S. PAT. OFF.) VOL. LIV

Raymond Loewy (1893–1986) was the most successful, and the most visible, of American industrial designers. With several offices in the United States, one in London, more than one hundred employees, and clients among the top corporations in the world, he was the designer shown, at mid-career, in 1949 on the cover of *Time* magazine. His portrait is surrounded by an astounding display of his creativity (fig. 1), from the Lucky Strike cigarette package to his Scenicruiser bus for Greyhound, demonstrating the far-reaching impact that his work had had on American life. Loewy, with a handful of other designers, notably Henry Dreyfuss, Norman Bel Geddes, and Walter Dorwin Teague, defined the upstart field of industrial design during the 1930s. With their backgrounds principally in advertising, fashion, and the theater, not architecture or art, they brought the realistic concerns of the marketplace into the modern design equation, rejecting the European emphasis on abstract geometric forms of lasting validity for the commercial advantages of ephemeral styling. While they shared a passion for redesign, each of these designers had his own version of what that meant and how it applied to the appearance of their objects: the streamlined, or teardrop, shapes that became symbolic of the decade justified by Geddes in his book *Horizons* (1932);[1] the less extreme "cleanlined" design favored by Dreyfuss;[2] the formalism espoused by Teague in *Design This Day: The Technique of Order in the Machine Age* (1940);[3] and the expressive shells celebrated by Loewy in his autobiography with its tongue-in-cheek title, *Never Leave Well Enough Alone* (1951).[4] It was in this book that Loewy presented what he called "the perfect functional shape," an egg (also shown at bottom right on the *Time* cover), describing it as "illustrating the skin-tension theory of structural engineering"[5] and providing justification for his controversial shell forms.

At first the industrial designers had to market their merits vigorously, demonstrating to corporations that outside consultants could push up sales figures by redesigning the products that had been put together by their engineers. They used early successes, such as Loewy's legendary redesign of the Gestetner mimeograph machine in 1929, as their models. Loewy had taken an awkwardly assembled duplicating machine with all of its working parts exposed, created only with regard to engineering requirements, and had restyled it for visual impact and ease of customer use (fig. 2), which greatly increased its sales. By using clay instead of wood or steel to model the form of the redesigned duplicating machine—then an untried approach, he claimed[6]—Loewy introduced the fluid forms and rounded edges that would define American streamlined design. "Because Gestetner needed the design so quickly," he later told an interviewer, "there was no way to work in steel. I had to work with my hands, like a sculptor. I kept as close to the skeleton as possible to be efficient. And the end result was a simplified form designed to prevent the oil, ink, and paper from clogging the works, a much easier machine for a secretary to maintain."[7] An ever-growing list of major clients jumped on the bandwagon of American styling when they saw the beneficial effect the application of industrial-design talents was having on sales and marketing, asking designers not only to redesign their products but also to create graphics, build-ings, interiors, and marketing tools for their corporations.

1
Raymond Loewy: He Streamlines the Sales Curve. Time cover, October 31, 1949

2
Raymond Loewy. Duplicating machine, 1929. Made by Gestetner. Victoria and Albert Museum, London. Gift of Gestetner International Ltd. By using clay to model this duplicating machine, Loewy introduced streamlined forms to industrial design.

Loewy's own position in the design controversy was all the more contradictory because he was the most Eurocentric of the American industrial designers, holding aesthetic attitudes very similar to those of many of his critics, which he made clear in his comments on certain approaches to styling. His aesthetic "transgression" stemmed from his practicality; he accepted the realities of the marketplace, recognizing that products had to be designed so that they could be sold, and he followed his own philosophy of design to achieve this. He theorized that there was a point beyond which large numbers of consumers would not go, and he tried to bring his designs as close to that point as possible: "Our desire is naturally to give the buying public the most advanced product that research can develop and technology can produce," he explained. "Unfortunately, it has been proved time and time again that such a product does not always sell well. There seems to be for each individual product (or service, or store, or package, etc.) a critical area at which the consumer's desire for novelty reaches what I might call the shock-zone. At that point the urge to buy reaches a plateau, and sometimes evolves into a resistance to buying. It is a sort of tug of war between the attraction to the new and fear of the unfamiliar. The adult public's taste is not necessarily ready to accept the logical solutions to their requirements if this solution implies too vast a departure from what they have been conditioned into accepting as the norm. In other words, they will only go so far. . . . At this point, a design has reached what I call the MAYA (Most Advanced Yet Acceptable) stage."[12] This careful balancing act is what kept Loewy at the top of his field for over three decades, although he was berated for this by Peter Blake, then associate editor of *Architectural Forum,* in a review of his autobiography: Loewy "knows better than most," he wrote, "that such alibis for compromise do not hold water and that American advertising can sell a really good design as quickly as it can a phony bit of packaging. . . . He knows that no designer of esthetic integrity can produce a beautiful post-war car one year and then endow it with a jet-propulsion nose the next, that no consistent artist can design the best-looking radio on the market today, a model of pure Machine Art, and at the same time turn out a pregnant porcelain bubble for his refrigerator clients."[13]

Loewy had adopted the "jet-propulsion nose" for his 1950 Studebaker Commander (fig. 8), as he had for his ignominious pencil sharpener, and although the car also received disparaging notices for the excesses of its bullet shape and use of chrome, *Time* reported soon after its release that "Studebaker sold more cars in September than any month in its history."[14] But Loewy completely disarmed the critics in 1953, when his Studebaker Commander V-8 Regal Starlight coupe was unveiled (fig. 9). European in its styling, the low, lean coupe was almost devoid of chrome and had large expanses of glass. It was shown at The Museum of Modern Art in the exhibition "Ten Automobiles," for which all of the autos were chosen, according to the exhibition's curator, Arthur Drexler, "primarily for their excellence as works of art."[15] When its "gleaming undecorated"[16] hub cap was chosen for the cover of the catalogue, this isolated piece of chrome put Loewy's design squarely in the camp of "Machine Art,"

The New Studebaker for 1950

953 STUDEBAKER COMMANDER V-8 REGAL STARLIGHT COUPE FOR 5

8
Raymond Loewy.
Commander Convertible,
1950. Made by Studebaker.
Printed brochure

9
Raymond Loewy.
Commander V-8 Regal
Starlight Coupe, 1953.
Made by Studebaker.
Advertisement

MoMA's own aesthetic confection. In a further reversal, Loewy spoke out shortly afterward in an *Atlantic Monthly* article, "Jukebox on Wheels," against the "dreamboat," a "vehicle that's too big for most people, too expensive, too costly to manufacture, and too gaudy."[17] He criticized the American automobile industry for the same attitude to styling for which he himself had been criticized. "Is it responsible," he asked, "to camouflage one of America's most remarkable machines as a piece of gaudy merchandise? . . . Form, which should be the clean-cut expression of mechanic excellence, has become sensuous and organic."[18] Loewy continued to create his own sensuous and organic forms in such objects as the dinnerware he designed for Rosenthal, with its archetypal Fifties-style hour-glass-shaped coffee-pot (fig. 10), but not for mechanical products such as cars. By the time Loewy designed his own jukebox just a few years later, in 1958 (fig. 11), his sensuous and organic design had been left behind.

With his commissions for advertising, corporate identity, and packaging, Loewy was naturally immune to the criticism of commercialism that his industrial products had received. His work in these areas became equally, and more lastingly, familiar to Americans than his products, most fallen victim to the fickleness of merchandising. Some of his graphic solutions are still in use today, however, among them the red and white triangle logo created for Nabisco in the 1950s and updated in the 1970s; the LU biscuit package from 1957 (created by his French office, Compagnie de l'Esthétique Industrielle, founded in 1952); and the identity program, including logo, for Exxon (fig. 12), unveiled in 1972. Loewy's first packaging sensation was for Lucky Strike in 1941 and 1942. For his redesign, which he had printed on the back as well as the front, he did no more than change the type and color, bringing greatly increased sales to the brand. His simple two-color logo for the farm machinery firm International Harvester, from 1945, is a uniquely brilliant referential concept in which the bold block letter forms of the firm's initials suggest a farmer on his tractor (fig. 13). He took on a huge program for the company, restyling its equipment, designing its packaging and advertising, and providing a standardized format for its salesrooms.

Loewy's architecture and interior planning, especially for retail spaces, has received less notice than his products and graphics, but it was the most profitable postwar activity of the firm. Loewy and Snaith were at the forefront of postwar shopping mall development. Their suburban stores for Lord and Taylor, signaling the opening of the suburbs to stores from the American downtown, were in a style Loewy dubbed Colonial Modern, using bricks and stone to soften a rectilinear modernist concept. The firm also undertook a major study for supermarket planning, financed by the industry's Super Market Institute. The firm's report, *Super Markets of the Sixties,* recommended many of the features with which we are familiar in supermarkets today. They suggested individualizing the different departments; emphasizing fresh items, produce, bakery, fish and meat, and flowers, rather than the boxed and canned goods that then occupied the larger part of the stores; and including nonfood items, which provided retailers with merchandise for which the markups were higher.

10
Raymond Loewy. "Model 2000" coffee pot, creamer, sugar bowl, cup and saucer. 1955–1960. Porcelain. Made by Rosenthal. Newark Museum

11
Raymond Loewy. UPB-100 Jukebox, 1958. Made by United Music Corporation. Hagley Museum and Library, Wilmington, Delaware

12
Raymond Loewy. Studies for Exxon logo, 1966. Felt-tip-pen on paper. Library of Congress, Washington, D.C.

13
Raymond Loewy. Logo for International Harvester, c. 1945. Hagley Museum and Library, Wilmington, Delaware

One of the firm's last major projects, which Loewy called the most exciting, was its work for NASA on the Skylab Space Station, beginning in 1967 (fig. 14). The brief was to humanize the bleak interior of the spacecraft that NASA engineers had designed. Habitability studies were done and Loewy suggested ways to make the tight spaces more comfortable and to better satisfy basic daily needs. But he was most persuasive when he insisted that regardless of difficulty, a window must be included in the cabin area, showing his concern for the psychological as well as the physical well-being of the astronauts. This project, begun when he was seventy-five, was the culmination of Loewy's career. It demonstrated his mastery of problem solving, a facet of his design that has often been overlooked. The research phase of his projects, according to Loewy, was sometimes anecdotal and rudimentary, sometimes technically exacting, but he always started out asking more important questions than what the form of the product ought to be. Flashy and self-serving he may have been, but he also was extremely thoughtful and knew that to succeed in industrial design, one had first to satisfy basic needs; the outer shells would come later.

EXTRA-VEHICULAR ACTIVITY

14
Raymond Loewy and
William Snaith. Saturn Five
Space Station Habitability
Study, c. 1972. Lithograph.
Hagley Museum and Library,
Wilmington, Delaware

E.V.A

SATURN, FIVE SPACE STATION
HABITABILITY STUDY
RAYMOND LOEWY / WILLIAM SNAITH Inc.

NASA HQ

8

Charles and Ray Eames
A method of action

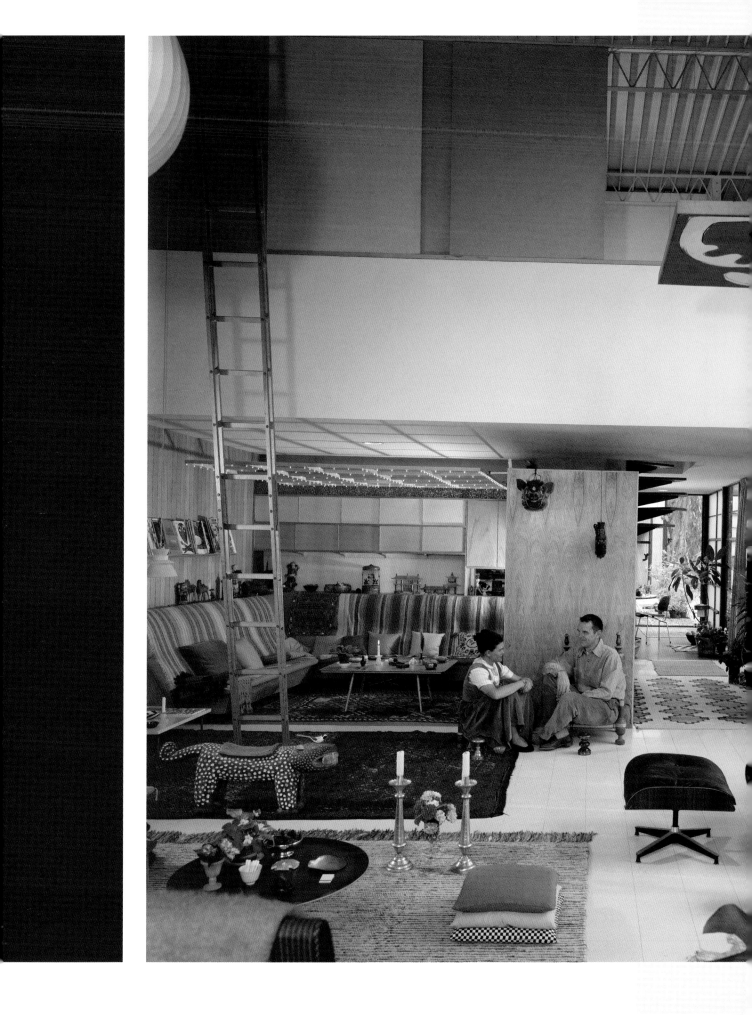

Charles Eames (1907–1978) brought extraordinary vision to mid-century modern design. He exploited developing technologies to create landmark furniture and he introduced revolutionary techniques for film and multimedia presentations, exploring a multiplicity of ways that images could be made to communicate ideas. His working premise was always a balance of opposites: "action"—his definition of the method of design—and "constraints"—the limitations of design,[1] which he recognized but never stopped pushing against. By his side (fig. 1) was his lifelong partner, Ray Kaiser Eames (1912–1988), the artist he married in 1941, whose advice and aesthetic vision colored all of his work in the years afterwards. Charles had trained as an architect at Washington University in St. Louis, Ray had studied painting with the abstractionist Hans Hofmann in New York, and with their divergent backgrounds and experience they became an enduring, successful team (although Ray was not sufficiently credited for her role in their endeavors). They, and the multitalented staff in their office, not only pushed design in new directions but also greatly broadened its definition, steering the emphasis away from form and function and toward the practical process of problem solving and communication.

First came their furniture, the great postwar triumph for American design. Their unexpected forms in plywood, metal, and plastic drew on the experimental work in bent plywood that Charles had done with the architect Eero Saarinen in the late 1930s. Looking to Saarinen's Finnish heritage, they had taken Alvar Aalto's elegant laminated-birch furniture as inspiration for their first project together, seating for the Kleinhans music hall in Buffalo, but when they decided to enter the "Organic Design in Home Furnishings" competition organized by The Museum of Modern Art in 1940, they sought to take bentwood beyond Aalto's use of this material. Whereas Aalto's plywood had been bent along a single plane to offer a flat surface for seating, Eames and Saarinen wanted a one-piece plywood shell that was curved in several directions at the same time so that it would conform more closely to the human body. Although their designs for plywood chairs won first prize in the museum competition, they were never successfully manufactured. Eames and Saarinen's goal of creating one-piece bent-plywood shells had not taken into account the constraints of the material; regardless of how much they tried, the plywood cracked when it was bent in the way they had envisioned, and the chairs had to be covered with a fabric upholstery in order to be marketed at all (fig. 2).

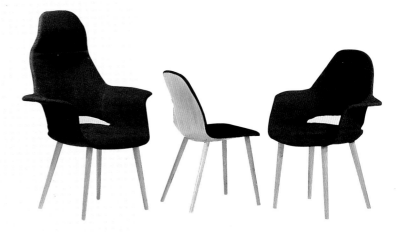

As the Second World War began, Saarinen went out on his own and Charles and Ray, now married and partners living in California, devoted the greater part of their energies to plywood products for the war effort. The museum competition had brought commissions for molded-plywood glider and aircraft parts for military contractors and leg and arm splints for the United States Navy, of which some 150,000 were manufactured by the end of the war. Not yet ready to give up on the original idea for one-piece seating shells, however, they continued to work toward this goal by experimenting with plywood bending and molding processes on their own. While the extremely tedious work of gluing and heat bonding with a rudimentary home-made hydraulic mold brought them the desired results, successful commercial production did not ensue. When the manufacturer attempted to replicate their work industrially in order to fabricate seats and backs of a single piece of bent plywood, once again the wood split and cracked. In the end, they had to settle for a two-piece design; their chairs were molded in the compound curves they sought but they had to have separate seats and backs (figs. 3, 4). These were then epoxied to their spindly metal or bent plywood frames with rubber shock mounts, a legacy of wartime technological advances. The two-piece compromise notwithstanding, the years of experimentation had paid off. Their plywood seating, along with storage units, tables, and an undulating plywood screen, were put into production and sold in considerable numbers, first by the Venice (California)–based Molded Plywood Division of Evans Product Company, of which Charles had become director of research, and then by the long-established furniture manufacturer Herman Miller of Zeeland, Michigan.

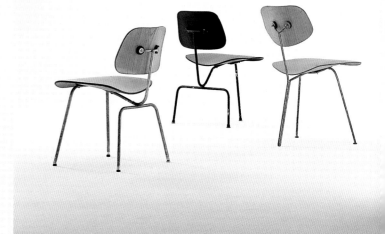

The plywood designs produced by Evans were soon shown in an exhibition at The Museum of Modern Art in 1946, "New Furniture Designed by Charles Eames," and it brought them a shower of publicity. What might seem surprising to us today is how fast the Eames furniture caught on with critics and consumers, who were willing to accept the modern aesthetic of simplicity and functionality and adopt new and unusual materials and a bold and quirky contemporary look for their homes. As early as November 1946, one of their plywood child's chairs appeared on the cover of *House and Garden,* and by 1950 *Time* magazine could recognize the ubiquity of the plywood side chair, calling it "a sort of model T in modern furniture," which "can be found under the rumps of connoisseurs across the nation."[2]

The "International Competition for Low-Cost Furniture Design" at The Museum of Modern Art in 1948 allowed for further submissions of innovative designs, this time chairs with seats of metal and plastic. An awkward "minimum" chair made of tubular metal screwed together rudimentarily, with a wire mesh seat and back, was their exercise in finding the most minimal means of creating a comfortable chair. This eventually led to the production of their bent and welded metal-mesh chairs, which were introduced by Herman Miller during the 1950s (fig. 5). They also submitted chairs with shaped-metal seating shells following their experiments in plywood. These proved to be too expensive for commercial factory production, but

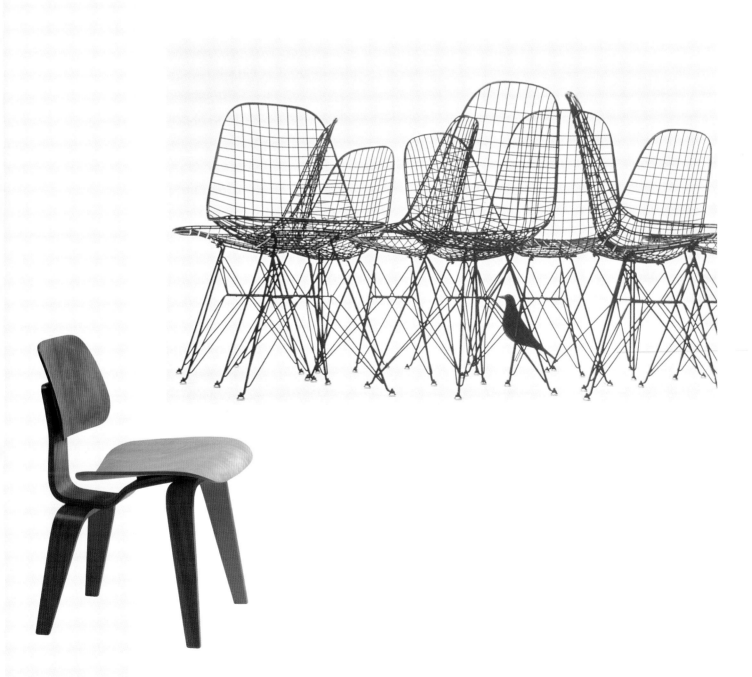

they led to a line of similar seat forms molded in a newly available material, fiberglass, which had been used widely during the war. These chairs with shells made of glass fibers embedded in molded plastic were brought into production by Herman Miller in 1950 (fig. 6), sold in large numbers, and have been universally copied.

The Eameses' chair was not the first to be successfully made of fiberglass, however. Eero Saarinen's molded-plastic Womb chair of 1948 had already been mass-produced (by Hans Knoll Associates, the other major postwar manufacturer of modern furniture), but it was padded and covered with upholstery. The Eameses revealed the seating shell, testifying to their faith in this new material. "Perhaps the greatest advantage of this chair," wrote Edgar Kaufmann, Jr., in the volume cataloguing the achievement of the "Low-Cost Furniture" competition, "is the extraordinary lustre and soft, smooth surface of the plastic. . . . Never before used in furniture, this airplane plastic is virtually indestructible and withstands stains and mars. Both to the eye and to the touch this plastic is a most desirable addition to the gamut of materials available for modern rooms."[3] Another "Low-Cost" competition entry was for an eccentrically shaped lounge chair in fiberglass known as "La Chaise" (see fig. 14), but it was not put into production during their lifetimes.

Eames products were held up as essential examples of Good Design, the modern aesthetic of economy and simplicity that then prevailed critically around the world, and popularly too, although to a lesser extent. For the postwar era this was a way to forget the failures of the European past and to embrace new American design as a fresh start, in housing, in furnishings, and in one's lifestyle. Good Design took its outlook from many of the modernist design elements that had been explored over the past century, and its tenets were generally summed up in the criteria used by The Museum of Modern Art in selecting works for its Good Design exhibitions (1950–55): "eye-appeal, function, construction and price, with emphasis on the first."[4] But Good Design also had a moral dimension, with the

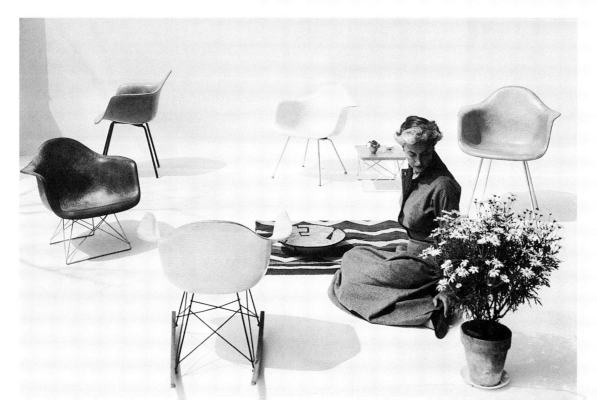

principle of "good" reaching back to the nineteenth century, when John Ruskin, William Morris, and other reformers had sought paternalistically to improve the lives of the people through economical, utilitarian, and tasteful design.

For Charles and Ray Eames, Good Design meant a unity of those elements listed in the museum's definition, but not in the museum's order. For them design was not first and foremost an artistic expression; appearance was meant to seem effortless, an afterthought, as if the form of their products had emerged naturally from their purpose and their technology, and it remained tied to the precepts of fine craftsmanship promoted by William Morris. Least of all did they expect design to respond to a "self-conscious urge to be original."[5] They detested the artistic exclusiveness associated with the design object as a work of art. For them, as for Le Corbusier, the best design was to be found in universal everyday, or type, forms, those objects that had evolved out of need over long periods of time. These were the kinds of objects they collected and the kind that they celebrated in their films, from toy tops to traditional breads baked around the world. There is no better consideration of the type object than the Eameses' reflection on a common Indian metal household vessel called a *lota* (fig. 7), published in their "India Report." Their description of the *lota* was part of their assessment of the elements to be considered when starting in on any design problem; it set the stage for their recommendations for the creation of an Indian design school, which they hoped would "hasten the production of the 'Lotas' of our time." This report, which had been commissioned by the government of India, was written in 1958 after they had traveled extensively on the Indian subcontinent.

"Of all the objects we have seen and admired during our visit to India," they wrote, "the Lota, that simple vessel of everyday use, stands out as perhaps the greatest, the most beautiful." But how, they continued,

6
Charles and Ray Eames. Chairs, 1950–53. Advertising photograph by Charles Eames. Library of Congress, Washington, D.C. The plastic chairs could be bought with the various bases shown here.

7
Common Indian vessels, or *lotas,* photographed by Charles Eames during a trip to India in 1958.

would one go about designing a Lota? First one would have to shut out all
 preconceived ideas on the subject and begin to consider factor after factor:
The optimum amount of liquid to be fetched, carried, poured, and stored in a
 prescribed set of circumstances. The size and strength and gender of the
 hands (if hands) that would manipulate it.
The way it is to be transported—head, hip, hand, basket, or cart.
The balance, the center of gravity, when empty, when full, its balance when
 rotated for pouring.
The fluid dynamics of the problem not only when pouring, but when filling
 and cleaning, and under the complicated motions of head carrying—slow
 and fast.
Its sculpture as it fits the palm of the hand, the curve of the hip.
Its sculpture as complement to the rhythmic motion of walking or a static pose
 at the well. . . .
How pleasant does it feel, eyes closed, eyes open?
How pleasant does it sound when it strikes another vessel, is set down on
 ground or stone, empty or full—or being poured into?
What is the possible material?
What is its cost in terms of working?
What is its cost in terms of ultimate service? . . .
How will it look as the sun reflects off its surface?
How does it feel to possess it, to sell it, to give it?[6]

Design was to address itself "to the need,"[7] in Charles's words, and the solution was to be found in a "preoccupation with structure which comes from looking at all problems as architectural ones."[8] They were literally preoccupied with architectural structure when they designed their own house and studio (figs. 1, 8), built in Pacific Palisades between 1945 and 1949. This was begun as part of the Case Study House initiative of *Arts & Architecture* magazine, an undertaking meant to demonstrate how industrial means could contribute to solving the postwar housing shortage in a way that would be accessible to the middle-class consumer. Twenty-three houses were built under this experimental program. The Eameses designed their house using standardized prefabricated elements such as steel framing, metal windows, and plywood panels that could be ordered from builder catalogues, again following a path prescribed by Le Corbusier in his plans for modular construction and industrially made housing. But in truth, while they used off-the-rack elements to satisfy the economical building concept they were advocating, many modifications were made by the Eames office to these standardized components in order to reach the level of refinement that the Eameses demanded.

The house and studio stand as prime examples of logical construction using standardized materials; the two rectangular glass and steel structures served as flexible shells for the changing activities of their daily life and work and as a showcase for their extensive collection of common objects, folk art, and natural materials, much of it gathered during their travels or camping trips in the desert. Their captivation with the commonplace, and love of such objects as toy trains, led them to use their collections as inspiration for their photographs and films, as elements in their graphics and product advertisements, and in the playthings and construction toys they also designed. Their House of Cards, a building toy of slotted cards made in several versions and sizes (fig. 9), brought a strong aesthetic attitude to the world of play, with their choices of all-over patterns for the faces of one set and, for another, their photographs of an imaginative array of objects, including spools of thread, folk toys, rulers, a crab, and a cookie—all styled with the sensitivity of Ray's special vision. These endeavors expressed the approach to fun, with purpose, that colored all of their undertakings as they set out to explore the always exciting aspects of the world around them. Although a strong belief in modernism infused the time they lived in, they refused to be bound by its strictures, as they celebrated decorative patterns and introduced elements from the past into their designs, be they historic objects or images, or examples of traditional typography.

By the mid-1950s, the housing shortage in America had begun to be ameliorated, and luxuries were becoming more accessible and more desired, leaving behind the Good Design authority of simplicity that scarcity had given to austerity. At the same time, a strong corporate design market was emerging as some of the most important companies in the United States built new headquarters and needed new furnishings to fill them. The Eameses turned to designing contract furnishings for commercial spaces, corporate headquarters, and such

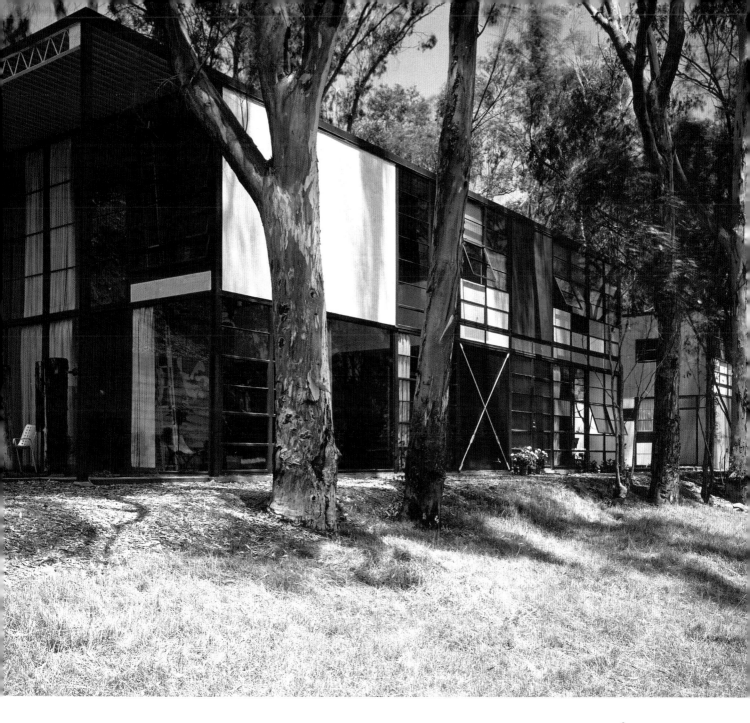

8
Charles and Ray Eames.
House, 1949. Pacific
Palisades, California

9
Charles and Ray Eames.
House of Cards, 1952.
Advertising photograph by
Charles Eames

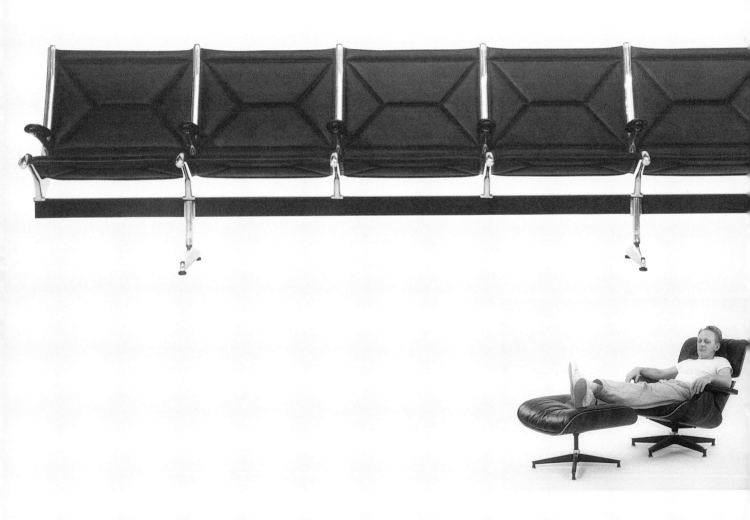

large public undertakings as schools, train stations, and airports. Their aluminum Tandem seating in sling form was used in major American airports, from O'Hare in Chicago to Dulles in Washington, D.C. (fig. 10). Their most famous chair, the lounge chair and ottoman designed in 1956, was also destined for the corporate world, not the low-cost market of Good Design. Although it follows the technology of their earlier plywood furniture molded in several parts, it was made of expensive materials, exotic rosewood plywood and leather upholstery, with cast-aluminum back braces and swivel pedestal, and would have been out of reach of those for whom the first plywood chairs had been conceived. Even though it has a unique form, it began as a type concept, with Eames, like Le Corbusier, wanting to "make an updated version of the old English club chair."[9] The lounge chair was the subject of a short film, inspired by an invitation to discuss their furniture design on television's "Today Show" one morning. Made in a single weekend and ready for broadcast that week, the film depicts each of the components of the chair and shows how it is designed for easy assembly. In this amusing vignette, a lackadaisical workman shown in sped-up motion puts the elements together so quickly that he has a moment to lounge in the chair and fall into a romantic reverie (fig. 11). He then wakes up, takes it apart, and packs it in a carton ready for shipping.

From very early in his career as a designer, Charles had considered film as a medium that would help him communicate his ideas. "Putting an idea on film," he explained in an interview with the producer Paul Schrader, "provides the ideal discipline for whittling that idea down to size."[10] Relying on gut instinct, but with little experience, the office entered the world of motion pictures in the early 1950s. Their first film to be shown in public was *Blacktop*, completed in 1952, eleven minutes capturing the abstract patterns made by soap bubbles as water from a hose was run on a macadam surface, edited in synchronization with a soundtrack of selections from Bach's *Goldberg Variations*. They went on to make some eighty films, pieces for their own pleasure that played with their collections, ones that present mathematical and scientific ideas and concepts, and ones commissioned by corporations, institutions, and the government. Their evocative set piece *Tops* (1969) (fig. 12), using a great variety of these toys from across the globe, has a cyclical structure, showing the toys starting to spin, revolving at full speed, beginning to wobble precariously, and then falling down. The toy films depend heavily on their finely crafted scores, many written by the Hollywood composer Elmer Bernstein. *Powers of Ten* (1977), their most frequently shown film, takes us on a journey to the outer reaches of the universe and then to the inner reaches of the atom in fast-moving action, making the concepts of large numbers and exponential series seem easily accessible. Today the Eames films are not well known, orphans in the academic world of film studies where they seem to fit no critical category and thus have been overlooked.

10
Charles and Ray Eames.
Tandem Sling Seating, 1962.
Aluminum and Naugahyde.
Made by Herman Miller

11
Charles and Ray Eames.
Film frame, *Eames Lounge Chair*, 1956

12
Charles and Ray Eames.
Film frame, *Tops*, 1969

By the early 1970s the Eames office had also become engaged in the
creation of museum and gallery exhibitions, many sponsored by its
client IBM, using films and other innovative graphic techniques as
devices for communication. The major attraction in their IBM pres-
entation at the New York World's Fair in 1964 was a film that related
ordinary problem solving to the processing function of the computer.
This was shown at a huge scale as a multiscreen presentation, bor-
rowing a format that they had introduced to wide acclaim in Moscow
in 1959 at the first major Cold War cultural exchange. Thousands of
photographic images were projected simultaneously on seven large
screens in that multimedia presentation, which sympathetically
depicted the universality of man through images of the United States
(fig. 13). Their most complex exhibition was "The World of Franklin
and Jefferson" (1975–77), which traveled throughout Europe and
North America; its extensive complement of text, image, and object
exemplified the Eames educational philosophy of information over-
load in which the audience can choose what is of interest from a
large, sometimes overwhelming, number of possibilities.

Charles Eames took many of the photographs used in the slide and
multimedia presentations and films that the Eames office originated.
He was an obsessive photographer, and the offspring of his passion
(shared with many of his associates) forms an enormous body of
material that can greatly enlarge our understanding of the genius of
the Eames design team. Photography was a unifying factor in all of
their work; it was used as a research tool, and it often morphed into
the content of their projects, for example, the poignant slide images
that make up the film of their home, *House—After Five Years of
Living* (1955). Photography was used for documenting the stages of
the creation of their designs and for marketing them as well (figs. 5,
6, 9); it recorded life in their office (nothing, for example, was com-
pleted in the Eames studio without a group portrait of those who had
worked on it); it was self-expression and artistic exploration (fig. 14);
and it was used to create a repository of their personal memories
and to celebrate their extraordinary achievements in design.

13
Charles and Ray Eames.
Installation view with film
Glimpses of the U.S.A.
projected on seven screens
in a pavilion designed by
R. Buckminster Fuller for
the American National
Exhibition, Moscow, 1959.
This was the public debut
of the multiscreen film
presentation.

14
Charles Eames. Mold for La
Chaise with shadows, 1948.
Photograph

9

Achille Castiglioni
The formal qualities of the industrial product

For the postwar generation, the only name in lighting was Castiglioni, belonging to three brothers, Achille (1918–2002) (fig. 1), Livio (1911–1979), and Pier Giacomo (1913–1968). The name is attached to some of the most innovative designs of the past century, demonstrating the willingness of these Italian designers to disregard precedents as they started afresh with each project and discovered intriguing possibilities in every new material and method that came their way. "I'd like each of my designs today to look as if it had been done by a different person," Achille explained, "because the paths a design takes are always different, case by case, if possible without any preconceptions about form."[1] Achille was the best known, most inventive, and longest-lived of the brothers. Like his elder siblings, he studied architecture, following Livio and Pier Giacomo to the Politecnico in Milan, and he joined their design office after completing his degree in 1944. The three continued to work together until 1952, when Livio left to establish his own independent consultancy, specializing in the design of electronics and appliances in addition to lighting. Achille and Pier Giacomo remained together, working as partners on virtually every project undertaken by their office until the latter's death in 1968.

Although they were known throughout the world for their lighting, the Castiglionis' work was actually much more varied, comprising many aspects of industrial design, including furniture, appliances and electronics, plastics, and tableware. Equally significant and extensive, and a constant focus of their activity, was the design of exhibitions—trade-fair pavilions and installations for organizations and industry. The brothers also became deeply involved with installations for their own field, industrial design, creating settings for the Milan Triennale exhibitions and Compasso d'Oro prize presentations as well as exhibition stands and showrooms for many of the firms that manufactured their products. Their work, whether products or presentations, seesawed between the poles of formal abstraction and semantic complexity. Their project for the industrial-design section of the Milan Triennale in 1954 (fig. 2), a collaborative work with several other Italian designers, was a spare formalist installation in keeping with the functionalist interpretation given to the objects

1
Achille Castiglioni, 1960s

2
Achille and Pier Giacomo Castiglioni and others. Installation for the Industrial Design Section, Tenth Triennale, Milan, 1954

of modern design displayed there. Huge circles of fabric set in a darkened space and suspended above white and black pedestals dominated the interior. Both natural daylight and artificial light after dark were diffused by the thin circles, demonstrating how lighting effects can define and unify an exhibition. But their 1958 pavilion for RAI, the Italian radio and television broadcasting agency (fig. 3), took an opposite path. In the tradition of pavilion designs that act as storyboards, the building displayed a narrative rooftop composition that announced the exhibit within. A group of colorful transmitting towers and receiving antennas suggested its theme, the technology and history of international television transmission in Europe, which was then in its infancy.

Castiglioni was a formalist at heart, although his critical reputation rests on the way he exploited technology and on his intriguing solutions to functional problems. He defined industrial design as "the discipline that determines the formal qualities of the industrial product,"[2] and it is obvious that his designs have been most widely appreciated for their aesthetic solutions, which were always based on functional logic and an underlying simplicity. In "my objects," he wrote, I "try to unite form with function, but I have to say that also in my design work I've always seen function as the principal component. I've tried to find that point where the chosen value of the function can effectively be identified with a true expressive form."[3] The very first commercial lamp he designed in 1949 with Pier Giacomo was first and foremost an expressive form (fig. 4), although the impetus for its creation was their fascination with how a new technology, a thin fluorescent tube that had just been introduced in Italy by General Electric, could be used. Realizing that this thin light bulb would be perfect for a desk lamp, they adroitly joined it with an enameled metal tube of the same thickness, which they extended into a single elongated form that bends and turns in several planes. Bulb and frame create a continuous base and arm, resulting in a design for wall or desk that flows like a coherent calligraphic statement. In a much later design, his Brera lamp of 1992 (fig. 5), formal qualities are equally the point. His inspiration for this seemingly perfect etched-glass form was the image of a wondrous ostrich egg suspended by a golden chain in the *Altarpiece of the Virgin and Child Enthroned,* painted by the Renaissance artist Piero della Francesca and now in the Brera Gallery in Milan. While Raymond Loewy considered the egg the greatest of engineering forms, Castiglioni admired it for its formal perfection. But to make his egg shape work as a lamp, he had to crack it, to permit air to circulate, to avoid overheating, and to allow for changing the bulb.

3
Achille and Pier Giacomo
Castiglioni. Installation for
the Italian radio and
television agency pavilion,
Milan Trade Fair, 1958

4
Achille and Pier Giacomo
Castiglioni. Tubino table
lamp, 1949. Enameled
metal. Made by Arredoluce

The Arco (Arc) lamp of 1962 (fig. 6) is the most celebrated Castiglioni lighting design. The lamp's reflector is held in mid air by a perfect arc of shiny stainless steel, which springs audaciously from a block of marble that functions as a counterweight. As much as we may admire it as the isolated focal point of a living room, a bold graphic statement that so many interior designers have used it to create, this was not the original design concept. Castiglioni rejected the kind of design that produced the showpiece, or "designer object," which for him was "an expectation of design, but of image instead of substance."[4] Like so many of the Castiglionis' other lamps, Arco was meant to fulfill a very specific, practical need: to focus useful light in a room with no ceiling fixture, over a dining table, for example. In this setting, the exquisite isolated refinement of the full extent of the lamp would not be so evident as the three-part arc swooped overhead and gracefully supported the adjustable reflector over the table. Their Taccia, or Touch, table lamp, produced the same year (fig. 7), also responded to the problem of directing light. Here the user simply adjusts the loose reflector by hand to throw the light where it is needed. The bulb is hidden in the flanged cylindrical base, which evolved as a means for keeping the lamp from overheating. Unintentionally, however, and considerably in advance of the postmodernist return to classical forms, it resembles the shaft of a fluted column.

Castiglioni espoused the lasting values championed by formalist modernism as he disavowed the popular, ephemeral aesthetic that was much in evidence in Italian goods of the immediate postwar era. He strictly adhered to an orthodox interpretation of Good Design, whereby, although a product may have been carefully created to accommodate a specific use, it was judged first for its "eye appeal."[5] For Achille and his brothers, design had to have "a coherent formal vocabulary that completely excludes concession to the 'taste of the day,'" as they explained in an article published in 1953.[6] Castiglioni's entire career was a delicate dance around the demands of "manufacturers, who from lack of a proper training and education, or because of a confused idea of the aesthetic sense of our time, are mistakenly concerned with satisfying what they call the 'taste of the public'" rather than the public, which "has shown it is ready to set the correct value on the beautiful form of an industrial object rationally conceived."[7] His faith in the public seems to have been justified in at least some instances, for he was "proudest," he said, of a design for which he was least known, a plastic electrical switch created in 1968 (fig. 8). It was used all over the world, an example of the acceptance by the public of an anonymous utilitarian object that functioned well and had become a type. The switch "was produced in large numbers and bought for its formal qualities, but no one in the shops selling electrical materials knows who did the design. It fits snugly in the hand and goes click very nicely."[8] Here is an enduring object of his own creation, easy to use even in the dark, over fifteen million of which have been sold.

5
Achille Castiglioni. Brera hanging lamp, 1992. Etched glass and metal. Made by Flos

6
Achille and Pier Giacomo Castiglioni. Arco (Arc) floor lamp, 1962. Stainless steel and marble. Made by Flos

7
Achille and Pier Giacomo Castiglioni. Taccia (Touch) table lamp, 1962. Metal and glass. Made by Arredoluce

8
Achille and Pier Giacomo Castiglioni. Electrical switch, 1968. Plastic. Made by Vlm

Castiglioni thought often about accommodating the public, especially with regard to packaging products so that they could be sold cheaply and carried home by the consumer. His Frisbi hanging lamp of 1978 is made of components that come disassembled in a compact package (fig. 9). The Frisbi was created to answer the question, "Can a single lamp provide direct, soft and reflected light all at the same time?"[9] He achieved this simply, but after much research and the arrival of another new light bulb, which could provide bright light and illumination over a large area. By cutting a circular hole in a large disc, he allowed for direct light, while the translucent disc permits soft light to penetrate downward as additional ambient light is reflected onto the surrounding walls.

Following the criticism of styling that was mounted to challenge American industrial design around mid-century, Castiglioni was especially hard on redesign, "whose only object is to boost sales. In this case," he said, "one of the fundamental features of design is lacking, namely the rigorous logic that combines form with a content chosen or created by the designer."[10] Yet he himself engaged in redesign more than once, and he could justify his involvement in such projects when technology or function, for example, demanded it and turned it into "just another case of design."[11] How this extends to his redesign of a simple historic form, such as his Cumano table of 1977 (fig. 10), is not quite clear. Admittedly modeled on one of the most ubiquitous café tables used in France since the nineteenth century, it is a dead ringer for a type object illustrated in the pages of Le Corbusier's *Decorative Art of Today* (see Le Corbusier, fig. 3), nor was this the only time he tackled the redesign of an object that was so well known. The table was not updated in its overall form, and only subtly in its materials and construction. It was made in several bright colors, a feature added as a selling point, and he included a hole in the enameled metal top so that it could be hung on a special peg sold with the table, for storage or display.

9
Achille Castiglioni.
Frisbi hanging lamp, 1978.
Metal and plastic. Made
by Flos

10
Achille Castiglioni.
Cumano table, 1977.
Enameled metal. Made
by Zanotta

In the design of the Sanluca armchair of 1960 (fig. 11), the brothers recast the classic comfortable chair. Their touchstone was not the type object of Le Corbusier's rectilinear nineteenth-century easy chair, however, but a more ornate eighteenth-century prototype with an organic, curvilinear profile. Its format was unusual, with none of the springs, stuffing, and structural elements found in traditional upholstered furniture. The armchair is composed of three separate elements, seat, back, and headrest, made of pressed-metal forms covered with foam and then upholstered with fabric or leather. With its wavelike back and freely curved frame, this bold referential work was a blow against modernist orthodoxy (several of their compatriots were similarly using referential forms, which were then considered to be a revival of Art Nouveau).

Throughout his career, Achille reveled in technology, repeatedly inviting new challenges to which he responded with unusual formal solutions. Unlike Charles and Ray Eames, who mastered new technologies and introduced them into large-scale manufacture, he took a more opportunistic approach to technological engagement: He undertook to figure out ways to adopt for his designs emerging technology, such as newly developed bulbs, only after they were commercially available. Like a hobbyist in a hardware store, he selected novel components—switches, transformers, bulbs—that he could use to solve the narrowly defined design problems that he set himself. He came up with highly imaginative solutions that used them to great advantage, working out new means, for example, to combat heat build-up or to direct light in specific ways. His Gibigiana table lamp of 1980 (fig. 12) is perhaps the most complex outcome of this approach, offering an extremely sophisticated solution to a common but perplexing problem—directing light onto a particular spot for a narrowly defined activity, such as reading in bed when one's partner wants to sleep. Numerous other designers had explored ways to solve this age-old problem, such as individual wall sconces, clip-on lamps, and light sources on articulated, movable arms. Castiglioni started afresh in proposing a design that was totally divorced from any conventional approach to domestic lighting. In this lamp, the light from a halogen bulb embedded in a tall, tapering aluminum tube shines on an adjustable mirror at its top, which directs the light where it is needed. "Gibigiana" is the Milanese term for "flicker," an apt name for the reflective action of this complicated mirror and light design. The mechanics are regulated by two thumb controls, one a dimmer, the other to adjust the angle of the mirror. But the complexities of this mechanical gem are hidden, and its public success has rested on its formal appearance, a simple, sexy, colored enamel cone that speaks of robotics and mechanistic design. One may wonder how often Gibigiana has actually been used for the special purpose for which it was designed, and how often it stands instead as a trophy design in a more public place in the home.

It could only have been disingenuous on Castiglioni's part when he told an interviewer that "lighting equipment can be considered correctly designed only when one rejects any temptation to design an object,"[12] for whether he intended it or not, his fixtures are what we look at and remember; we can't take our eyes off them. Either

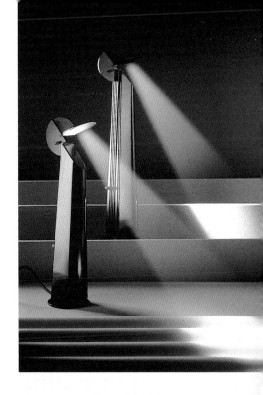

11
Achille and Pier Giacomo Castiglioni. Sanluca armchair, 1960. Leather, metal, and wood. Made by Gavina

12
Achille Castiglioni. Gibigiana table lamp, 1980. Enameled aluminum. Made by Flos

we are absorbed by their simple formal beauty or mesmerized by their complex, ambiguous architecture. In accepting complexity, the brothers shared a unique willingness to give up the unity of modernism, replacing it by an additive approach that introduced a variety of disparate elements assembled according to functional requirements alone. Their Mezzadro, or "Sharecropper," stool was made of a tractor seat, a bent steel bar, and a wooden stabilizer, held together with a large wing nut (fig. 13), an assemblage in the Duchampian tradition of the found object. Its witty name, Mezzadro, was meant to take on a new meaning when this agricultural artifact was insinuated into a domestic environment. Their Toio floor lamp of 1962 (fig. 14) is a similarly additive assemblage of found objects that remain distinguishable when the design is assembled. For this glaring creation they coyly selected the mechanical elements required to make an automobile headlight function as an adjustable floor lamp, employing a steel pedestal, holding the required transformer, as a stabilizing weight, and adding fishing rod rings to keep the electric wire in place.

Castiglioni stood apart from the design movements of his day, although his work resonates with the issues current during his time. True innovation was his overarching goal as he refused to acknowledge the MAYA principle established by Raymond Loewy. "I believe," he wrote, "that the quality of a design, above all its social value, is proportionate to its innovative force. . . . It is this attitude that some semiologist has called 'a deviation from the norm.' In other words, the design always tends to go beyond the threshold of expectation of both client and market."[13] Most clearly he can be seen as inspiring the High-Tech movement of the 1970s, where industrial objects and elements were taken into the domestic environment without being disguised, a throwback to Corbusian principles and once again the focus of such British designers as Tom Dixon and Jasper Morrison. He did not produce the type of Pop art–inspired objects that many other Italian designers did during the later 1960s—over-scale appropriations of familiar objects used for new purposes such as De Pas, D'Urbino, Lomazzi's renowned baseball mitt sofa—but his Mezzadro chair can stand as an inspiration for and an alternative to them. Nor did he protest with them as they relinquished design for demonstrations and dialectics. Postmodernism passed him by in many ways, too, but he readily suggested classical forms or used historical references when he felt they would be expressive of his own vision. With no other agenda than the seamless marriage of form and function, he could be a model for the many designers of his time who looked to him for inspiration, whether those who continued to work in a simple, formal mode or those who chose complexity or irony and commentary as their field of action.

13
Achille and Pier Giacomo Castiglioni. Mezzadro (Sharecropper) stool, 1962. Enameled metal, tractor seat, metal, and wood. The Museum of Modern Art, New York

14
Achille and Pier Giacomo Castiglioni. Toio floor lamp, 1962. Enameled metal and steel. Made by Flos

10

Ettore Sottsass, Jr.
A way of discussing life, sociality, politics, food, even design

Ettore Sottsass, Jr. (born 1917), artist as well as designer, found himself a celebrity on the home pages of international newspapers in 1981 when the press created an uproar over the outrageous creations that his newly formed Memphis group introduced at the Milan furniture show that year. Their unexpected shapes and their colorful patterned surfaces ignored every tenet of Good Design, by then a bankrupt aesthetic of elitist taste that many who wrote publicly about design had yet to relinquish. With this single event, fashion became an acknowledged factor in design, and Sottsass saw "nothing surprising" in it. "All the people who work at Memphis," he wrote in his introduction to the group's second catalogue, "are people who are not in pursuit of a metaphysical, aesthetic idea, of an absolute, or still less, of eternity." Repudiating this holdover from the functionalist ideals of "eternal" design, he saw that today, "everything we do is consumed. Everything we do is dedicated to life and not eternity."[1]

Sottsass has consistently been an alternative force in Italian design, and early on he took steps to define his own rules; he focused not simply on the aesthetic form of individual objects but on the way they fit in with users' various needs, and he introduced a linguistic content to his work. "To me," he has said, "doing design doesn't mean giving form to a more or less stupid product for a more or less sophisticated industry. Design for me is a way of discussing life, sociality, politics, food, and even design."[2] Sottsass showed that Memphis, with its new vocabulary of forms, could still fulfill the traditional purposes of design, and he recognized the symbolic content of useful objects, which had not been acknowledged by modernism. Even the Memphis name was a send-up, borrowed from Bob Dylan's lyric "stuck inside of Mobile with the Memphis blues again," which had played incessantly on a phonograph at the time the group was being organized.

The inaugural Memphis collection included furniture (fig. 2), ceramics, and lamps by Sottsass and a number of younger designers in Milan, among them Andrea Branzi, Michele De Lucchi, George Sowden, Matteo Thun, and Marco Zanini. A second collection introduced the next year expanded Memphis's offerings to embrace textiles by Nathalie du Pasquier, glass blown in Murano, and objects of silver (fig. 3). Also participating in the initial collection was Alessandro Mendini, an influential figure in Milanese design circles whose experimental Studio Alchimia had been an inspiration for this

1
Ettore Sottsass, Jr., 1974

2
Ettore Sottsass, Jr.
Casablanca sideboard, 1981.
Wood and plastic laminate.
Made by Memphis.
Philadelphia Museum of
Art. Gift of Collab and
Abet Laminati

3
Memphis catalogue, 1982
(detail). A unified Memphis
aesthetic seems to present
itself despite the diversity
of these products of many
different designers.

new undertaking. In 1979 and 1980 Sottsass had joined forces with Mendini on work for Alchimia exhibitions; he showed his anti-modernist furniture prototypes in Alchimia's archly named Bau.Haus and Bau.Haus Side Two collections. But he broke with Mendini when he realized that Alchimia's purpose was purely polemical, not directed toward achieving distribution for the group's creations, and he went on to found Memphis. The new group, which had the backing of several Italian manufacturers, was determined to make furniture for the market, not ideological statements, but its success exceeded all expectations as this experiment with a new language of design generated publicity worldwide.

Sottsass himself designed several large pieces of furniture for the initial Memphis collection: three sideboards, a table, and a bookcase, all at a slant, with odd forms and uncertain functionality. His Casablanca sideboard had boldly outstretched shelves, some set at vertiginous angles, a form with no precedent in the history of design (fig. 2); if anything, it could be connected with some vague romantic notion of the exotic. Its wooden structure was sheathed with red, white, and black laminated plastic in the sponge pattern that he had designed several years before for Abet, a Milanese firm, and which he had used in some of his own earlier designs for Alchimia (fig. 4). Most of Memphis's products were made of Abet's plastic laminates, taking advantage of their ability to carry strong, even colors and

decorative patterns. But the material's association with cheap construction and crass design, left over from the fifties, made for commentary on the way we value materials in our society and also an uneasy contradiction, because so many of Memphis's products were costly owing to the time required to assemble them by hand.

In order to live up to the subtitle that had been chosen for Memphis, "The New International Style"—a challenge to those who still worshipped at the altar of what remained of International Style modernism—a number of foreign designers were invited to join the Italian cadre and submit works to the collection: Hans Hollein from Austria; Terry Jones from England; Shiro Kuramata (see Kuramata, fig. 5), Arata Isozaki, and Masanori Umeda from Japan; Javier Mariscal from Spain; and Peter Shire and Michael Graves from the United States. Their designs for Memphis were not as stylistically cohesive as the indigenous ones—Graves created an elegant, Art Deco-inspired dressing table, while Umeda's conception of cushioned seating was placed inside a boldly striped boxing ring—but all the invitees shared a willingness to look to new directions for the syntax in which they were working.

While "postmodern" seemed to many the perfect adjective for these radical works, which subverted modernism's most cherished principles, Memphis rejected this pat designation (although they could never free themselves of it). Memphis, they said, had nothing to do with the Western canon of columns, pediments, and arches that European postmodern design was then reintroducing. Instead, the group looked to more distant sources, especially third world cultures, for its ornamental inspiration, and to the undervalued expression of the Fifties for its palette and its materials. The impact of Memphis was immediate, seen in the pastel and acid colors, jazzy typefaces, and bizarre patterns that seeped into graphic design and in the watered-down Memphis forms that were introduced in commercial lines issued by the American furniture industry. It had a revitalizing impact on the burgeoning craft revival, where the bromidic aesthetic that valued the signs of the hand and the colors of the earth was turned around by this new approach. But the Memphis experience had its most generative effect at Sottsass Associati, the firm founded in 1980 by Sottsass, with Zanini and several young designers. Believing in the Memphis vision, which the firm had spearheaded, they let its eccentricities and its lessons color many of the group's endeavors. It was in the area of commercial interiors and corporate identity that Memphis seemed to make the most sense as a design approach. Its strange aesthetic was perfectly at home in the world of boutiques, where its novelty could be counted on to bring in customers. Sottsass Associati designed clothing shops for Fiorucci and Esprit (fig. 5) in major European cities during the 1980s. Their interiors were built with a Memphis sensibility using multiple patterns, Memphis furniture, and a narrative type of space planning that animated their concepts.

Sottsass also used the Memphis experience as a spur for his own return to architectural work. Although he had studied architecture, it was only when he was in his late sixties that it became his principal focus, and he used color, reawakened by Memphis, to give his buildings an immediate impact. Sottsass felt a special bond with Le

4
Ettore Sottsass, Jr. Seggiolina da Pranzo (Little Dining Chair), 1979. Plastic laminate and metal. Made by Alchimia

5
Sottsass Associati. Esprit showroom, Zurich, 1985–86

Corbusier as an artist who had colored the interiors of his buildings in a sophisticated range of tones to accentuate their spatial experience. But Sottsass responded to an aspect of the architect's work that has been little discussed, his "sensuality . . . the tactile quality of things and the pleasure taken by the eye in certain forms and colours."[3] For his Wolf House in Ridgeway, Colorado (1985–89) (fig. 6), designed soon after he left Memphis, Sottsass combined a pleasurable, celebratory use of decisive color with the additive method he employed in his furniture. He left nothing in a single plane; boxes are added onto boxes, jutting back and forth, some projecting precariously, creating strong shadows that provide a sense of solidity for a structure so sensuously painted.

By the time Memphis had come and gone, Sottsass had a full resume behind him. Born in Austria, he studied architecture in Turin before the Second World War, but barely continued with it. His work instead was a mixture of curating exhibits for the Milan Triennale, writing for design magazines such as *Domus,* and creating installations; simultaneously he was involved with art, drawing inspiration from abstraction, De Stijl, and Surrealism, particularly the haunting works of Giorgio de Chirico. In 1956 he traveled to the United States, where he spent three months in the office of George Nelson, experiencing at first hand the role of the American consulting industrial designer. Soon after his return to Italy he began to collaborate with the business-machine manufacturer Olivetti, but his relationship with Olivetti, as enlightened a firm as could be found in Italy and comparable in its design savvy to IBM under Thomas Watson, Jr., evolved in a unique way. The firm created an independent design studio under his direction, allowing him to continue working for other companies, and all the designers were encouraged to freelance, if they so desired, in an effort to keep their design energy at a peak. Among his earliest designs for Olivetti was his rationalized organization for the room-size Elea 9002 electronic computer, released in 1959 (fig. 7); he visually unified the components by a series of modular elements at human scale in coded colors. Sottsass created a number of business machines and several workplace systems for the corporation, but his most individualistic design for Olivetti was the smallest and most contradictory: the brilliant red plastic Valentine portable typewriter of 1969, which came with a red plastic slipcase (fig. 8). It was contradictory because it rejected the focus on "business" that was Olivetti's bread and butter. Instead, Sottsass wrote rhapsodically, the shiny Valentine was "for use any place except in an office, so as not to remind anyone of monotonous working hours, but rather to keep amateur poets company on quiet Sundays in the country or to provide a highly colored object on a table in a studio apartment. An anti-machine built around the commonest mass-produced mechanism, the works inside any typewriter, it may also seem to be an unpretentious toy."[4] Sottsass perhaps had in mind the typically cool Italian spaces that one could see reproduced in the magazines *Domus* and *Abitare,* which needed the punch of an indisputable red object to wake them up out of their still-modernist complacency. His musings about how and where the Valentine typewriter would be used is an example of the

6
Ettore Sottsass, Jr.
Wolf house, Ridgeway,
Colorado, 1985–89

7
Ettore Sottsass, Jr.
Elea 9002 computer, 1959.
Made by Olivetti

8
Ettore Sottsass, Jr.
Valentine portable
typewriter, 1969. Plastic and
metal. Made by Olivetti

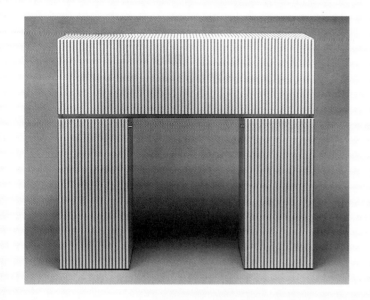

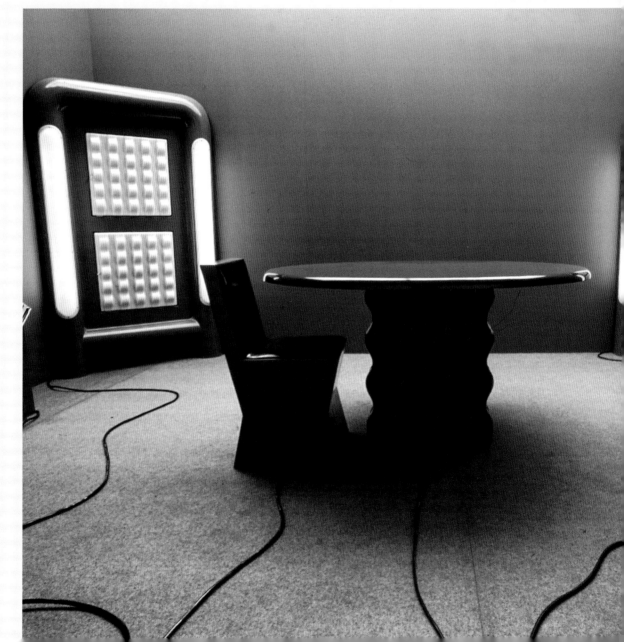

kind of situational thinking that Italian designers were engaged in as they questioned the need for conventional consumer products and began to leave behind the myopic emphasis on functionalist designs suited for use anywhere, anytime.

Parallel to his involvement with Olivetti, Sottsass was working with Poltronova on the design of furniture, at a time when Pop art and Minimalism co-existed. His so-called Superboxes, prototypes of desks and wardrobes that he began to work on in 1966 (fig. 9), were clad with plastic laminate, introduced more than a decade before Memphis. These pieces had striped patterns like color-field paintings on their outer surfaces and were treated as more than anonymous containers. Meant to be placed not against the wall but in the center of a room, some set on pedestals, they were his response to the shock of Minimalist sculpture. His so-called Gray Furniture followed, neutral molded-fiberglass constructions with organic shapes, some incorporating neon lights, that were the complete opposite of his geometric boxes (fig. 10). Often they were shown as casual objects in relaxed settings inhabited by nude models, suggesting the free spirit of the new psychedelic age they seemed to represent.

9
Ettore Sottsass, Jr. Nefertiti desk, 1969. Plywood and plastic laminate. Made by Abet. Philadelphia Museum of Art. Gift of Abet Laminati

10
Ettore Sottsass, Jr. Table, chairs, and lamps, 1970. Fiberglass. Made by Poltronova

The protests of 1968 radically affected Italian society, and in reaction Italian design went underground in many ways during the 1970s. The retrospective exhibition "Italy: The New Domestic Landscape" at The Museum of Modern Art in New York in 1972 marked the end of the boom era that had placed heavy emphasis on consumer goods. The show could make sense at that time only because a group of alternative proposals for approaches to design were included in it. Radical groups such as Superstudio and Global Tools contemplated how architecture and design might better serve the public and a future that could operate on different terms, and many reverted to language in order to achieve this. Sottsass, one of the group of architects and designers who founded Global Tools, proposed his own futuristic environment for the exhibition: linked, movable, accordion-sided fiberglass units that would organize all of the needs of habitation into one consistent and efficient system (fig. 11). He offered a new vision of how our lives at home might be differently composed, standardizing our mundane activities by confining them in modular units but opening up our living space for any other activities we might like to pursue. Sottsass also retreated from designing products into his own artistic and intellectual pursuits. He was hopeful that "it may occur to someone working in design to produce objects that are of no use to industrial civilization as it is set up at present but that serve to release creative energies, to suggest possibilities, to stimulate awareness, to bring people's feet back onto the planet."[5] His own effort to release creative energies and suggest possibilities emerged in several alternative projects. One was a series of photographs taken of his minimalist interventions in natural settings, which included thoughtful, compassionate, some-times ironic, captions (fig 12). A second series was more fantastic, consisting of watercolors made into lithographs on the theme of "The Planet as Festival." In these he imagined gigantic engineering feats created for a post-consumer society, for example, huge buildings made to look like a table and three chairs straddling a river or megalithic stadiums sunk into the cliffs, to which the possibilities of extremes of pleasure brought people great distances across a barren countryside.

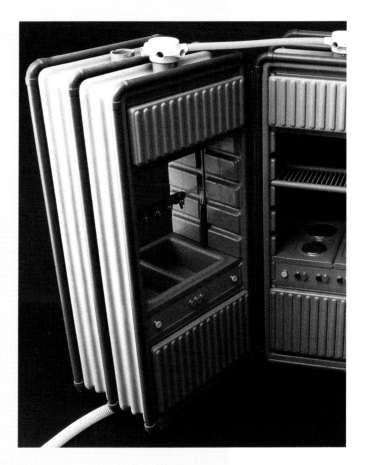

Everything Sottsass has done incorporates an introspection most clearly spelled out in his less well-known endeavors such as ceramics and photography. His own private delight is ceramics, which he has been designing since the 1950s. When he was first asked to do a series of modern-style ceramics for an American furniture retailer, he fought the complacency of making the luxury products that were commissioned, which would simply have added to the catalogue of collectible objects. "It seemed to me," he wrote in summing up his experiences, "that it might be possible to find some kind of arche-typal forms—not essential forms proposing an ideal metaphysical state but forms that were found by man a very long time ago, forms so deeply linked to history that they are now part of human nature and cannot be dispensed with."[6] The first ceramics he exhibited, in Milan in 1958, responded to this quest with simple, boldly colored archetypal forms that looked like they could be remains of an ancient civilization. He continued to make ceramics, many relating

11
Ettore Sottsass, Jr.
Environment for "Italy: The
New Domestic Landscape,"
The Museum of Modern
Art, New York, 1972.
Fiberglass. Made by Kartell

12
Ettore Sottsass, Jr.
*Design of a Very Beautiful
Vase: Not Everybody Has
Rice to Put in It,* 1972–74.
Photograph

distinctly to his life situation. His black-ground "ceramics of darkness" were produced after he suffered a grave illness, and a second series, plates with mystical cosmic signs dedicated to the Indian god Shiva, were made in thanks for his recovery. These were completed after he had traveled in India and come under the sway of Eastern philosophy. Other life experiences were alluded to in his "Totem" series of glossy ceramic seven-foot-high colored pillars, which he exhibited in 1967 under the title "Menhir, Ziggurat, Stupas, Hydrants and Gas Pumps." Elemental forms have also taken over his more recent furniture (fig. 13), although their individual parts may still be assembled additively, at dizzying angles. Geometry brings his compartments, shelves, and drawers of stained woods into check. Here, the extremes of Memphis expressionism are tempered by sculptural minimalism, the polar opposites of his long career in design.

13
Ettore Sottsass, Jr.
Cabinet No. 50, 2003.
Stained woods. The
Gallery Mourmans

11

Shiro Kuramata

I don't propose anything or
try to instruct

Shiro Kuramata (1943–1991) was a highly successful and much sought-after designer in Japan during the 1970s and 1980s, but his international reputation rests on only a few objects, which are now viewed mostly as museum pieces. He is best known for his striking use of unorthodox materials such as industrial wire mesh in the construction of furniture and the design of interiors, and for his quest for transparency and lightness, an anti-gravitational pull based in surrealistic imaginings that he acknowledged time and again. His most impressive legacy is his expanded-wire-mesh chair of 1986, named How High the Moon (fig. 2), which is undoubtedly among the icons of twentieth-century design. This is Kuramata's contribution to the recurrent redesign of the club chair, the arche-type of comfort that everyone from Le Corbusier to Charles Eames and Philippe Starck has tackled. Modernist in its strong, simple forms, and ample in its proportions, it is, ironically, a transparent void, made even more ambiguous by its material; instead of the soft, comfortable upholstery that we expect on a chair of its type, How High the Moon is made of hard, if somewhat yielding, steel mesh, beautifully put together so that the welded seams are not apparent. That a simple, minimalist object could have such great poetic beauty owes as much to its transparent, light-filtering form, which encapsulates the lyrical spirit of its name, as to its elegant cell-like surface, which Kuramata called his "own style of decora-tion,"[1] realizing its antimodernist implications.

Kuramata was, however, more than a late-twentieth-century designer wrestling with the enigmas of modernism and postmod-ernism, with the age-old conflict between form, function, and ornament. He was also a student of Western art, who explained that "Surrealism and Dadaism were very influential on my whole design approach."[2] If we take him at his word when he said, "I have been influenced by many people, many things, and many friends, but it is Marcel Duchamp who has been most interesting to me,"[3] then this designer pursuing a fertile exploration of material and meaning should be seen, like the French Dadaist, as artist and provocateur. We should give as serious consideration to his artistic borrowings and conceptual explorations as to his formal concerns if we are not to lose sight of Kuramata as a multidimensional figure, who, as he approached the end of his life in 1991, at the age of fifty-six, was adding more and more layers of historical reference and narrative content to his furniture, products, and commercial interior designs.

What most interested Kuramata about Duchamp must have been his iconoclasm and his intriguing sense of humor, elements that contribute to the special character of Kuramata's own work. His career is punctuated by examples of ironic humor, his early Clock with Seven Hands (1967), each moving independently and at its own pace, being an object that would readily qualify as Duchampian. We can find a number of direct allusions to Duchamp in Kuramata's designs—most spectacularly the long wall of deliberately cracked glass that bisected his Issey Miyake boutique in Kobe. This was Kuramata's reference to the accidentally shattered glass of Duchamp's masterpiece, The Large Glass, in the Philadelphia Museum of Art. Kuramata also had his moments of rebellion against the conventions of the past, including a sometimes irreverent regard for the relics of modern design history. In Duchampian terms, his Homage to Josef

1
Shiro Kuramata with his Red Cabinet, designed in 1970

2
Shiro Kuramata. How High the Moon armchair, 1986. Steel mesh. Victoria and Albert Museum, London

Hoffmann Vol. 2 of 1986 (fig. 3) might be seen as an "assisted readymade," a found, or already existing, object to which something is added to move it to a higher level of existence. Here Kuramata altered an upholstered easy chair designed by Josef Hoffmann in 1911, which had been brought back into production in the 1970s with the revival of interest in the Viennese designer's work and was being distributed internationally (see Hoffmann, fig. 14). He replaced the white piping that outlined the dark, plushly upholstered forms of the armchair with strips of tiny light bulbs, creating a heightened version of the chair that becomes a jazzy, disembodied Art Deco-like object.

If Kuramata found Marcel Duchamp most interesting, he found Ettore Sottsass, Jr., most inspiring. For Kuramata, Sottsass was the master, their bond forming instantly when they met during the early Memphis years. It was not the Postmodern stylist, however, but the sensitive poet and the humanitarian soul in Sottsass that Kuramata responded to and that had a great impact on his work: "My concept of design is beginning to undergo great changes, perhaps because I've had hidden doubts about the ideology that has made the jet fighter the extreme symbol of functional beauty,"[4] he wrote in 1981, around the time he met Sottsass. Under his influence, Kuramata relinquished that aspect of his being that he considered "intellectualistic."[5] "Animals react instinctively to changes in their environment," he explained; "humans perhaps detect the direction in which they should move, reacting with their sensitivity rather than instinct. Man's superior sensitivity will save functional beauty, which has been dominated by rationality and has come to a dead end."[6] Sottsass, in turn, came to admire him as well, as the creator of complex, sensitive boutique and restaurant interiors (most lost to the capriciousness of today's commercial climate), "those places sunk in the silence, in the mystery and darkness, those rooms built by a complicated system of reflection and shadow, those spaces designed not for substance, but for allusions, those surfaces crossed and worn away by flashes of bright neon, those orders scanned by ambiguous rituals."[7]

Ambiguous rituals also surrounded the genesis of another unique borrowing from the past, again from Hoffmann, which he entitled Homage to Josef Hoffmann, Begin the Beguine (fig. 4). In 1985 Kuramata took a bentwood chair that had been designed by Hoffmann and was still being manufactured by Thonet and wrapped it in flat steel rods, crisscrossing the entire piece with this strong material. He then set the wooden chair on fire, for him an act of reverence, which he initiated with a prayer. When the chair was completely burned away and the cooled steel given an enameled finish, a glittery, ghostly version of Hoffmann's design remained. Arising phoenix-like out of the flames, this chair has its own rhythmic integrity as it expresses a sense of renewal, implying that artifacts of the past can have a distinctive value for the present, even if they appear in completely altered forms.

3
Shiro Kuramata. Homage to
Josef Hoffmann Vol. 2,
1986. Recycled chair, wood,
cloth, and light bulbs

4
Shiro Kuramata. Homage to
Josef Hoffmann, Begin the
Beguine, 1985. Steel. The
steel-rod form remained
after a bentwood chair by
Josef Hoffmann, around
which the rods were
wrapped, was set on fire.

It is no surprise that Kuramata found his master abroad, for in 1956, at the time he graduated from the Kuwasawa Design Institute and first saw illustrations of Italian design in a copy of *Domus,* he knew that his future as a designer lay in an international milieu. And it happened just as he might have expected. He participated in the first Memphis exhibition in 1981, where he showed several pieces including his series of narrow Imperial storage units and his Ritz writing desk (fig. 5), a squat piece with fat green lacquered legs, roll-top storage compartment, and bleached-oak writing surface and back. Although it was oddly proportioned and eccentrically painted, the Ritz desk was one of the most sedate of the objects presented in this landmark explosion of color, pattern, and idiosyncratic form (see Sottsass, figs. 2 and 3). His inclusion in the Memphis circle and its exhibitions brought him immediate attention in Italian and French magazines, and his first interview published outside Japan appeared in the pages of *Domus* itself, in 1984. There, in an "indirect conversation," he described his relation to the West: "The main Western influence on my work is Bauhaus and subsequent design," he said. "I started in design because I could see myself reflected in this ideology. But then looking in this mirror, I started to have doubts about my unilateral interpretation of functionality and rationality, and I started to put the problem in personal terms (what was a chair for me? A table? A lamp?). Even today I don't approach a project in terms of a product for others; in this sense, I don't propose anything or try to instruct."[8] Although other Japanese designers had also exhibited with Memphis, and their products had been taken up by foreign manufacturers, Kuramata was the only one at that time who was able to free himself of the still subtle inhibitions of the Japanese aesthetic vocabulary and move so easily in an international sphere in the 1980s.

Kuramata's career emerged with the romance of Good Design, the modern, moralistic aesthetic that spread to Japan during the post-war reconstruction period, when American industrial designers such as Raymond Loewy visited the country and helped to set design (and exports) on the right track, much as European modernist designers, such as Charlotte Perriand and the German architect Bruno Taut, had done before the war. Biomorphic mid-century modern furnishings by American and Scandinavian designers were used in some of Kuramata's earliest interior designs. Soon, however, he adopted a rigorously reductive approach originating in American Minimalist art (notably the pared-down work of the sculptors Larry Bell, Dan Flavin, and Donald Judd, which he had seen in a 1967 exhibition in Tokyo), which Sottsass also had been responding to at about the same time in his Superboxes (see Sottsass, fig. 9). But Kuramata's new direction also emerged from his exposure to sophis-ticated European modern art and design, which he much admired.

His minimalist vision can be seen in the extended series he created on the theme of "Furniture with Drawers." He believed that "a chest of drawers is the kind of furniture that most strongly communicates with man, even psychologically. . . [with] a secrecy that is not found

SCRITTOIO RITZ
WRITING DESK

Shiro Kuramata Tokyo

W.	D.	H.
100	80	150

Tavolo scrittoio con armadietto a serranda, struttura in legno laccato verde, piano in rovere sbiancato. Writing desk with small cupboard. Structure in green painted wood, top in bleached oak.

20T04

in a chair."[9] His meditation on the uses of containers and the rituals of organizing our material possessions found its underlying form in abstraction, which recalled the clear acrylic cubes and crisp rectilinear forms of the American Minimalist sculptors. Kuramata's fascination with drawers and compartments aligned naturally with his arrangement of display and storage space in the new type of open boutique he was designing in this early period of his career. One of his earliest furniture designs, from 1968, was a transparent acrylic pyramid on casters, with seemingly free-floating black drawers of descending size that both revealed and hid their contents. He went on to explore this theme in many different ways (see fig. 1). In a number of variations in black and white from 1970, he played on modular arrangements outlined in black. He alternated cool modernist pieces with much-celebrated antimodernist statements, cabinets with delightful serpentine silhouettes (fig. 6), which first brought him to international attention as a renegade designer throwing off the dutiful adherence to rational form that was to be expected in one who claimed his origins in the Bauhaus. He invented cabinets with drawers that revolve around a central upright; drawers in floating checkerboard arrangements; and large cabinets that pay homage to the paintings of Piet Mondrian, with their drawers in asymmetrical black-outlined forms, some faced with primary colors.

The transparency and translucency of solids, and an ancillary exploration of light passing through, was Kuramata's lifelong theme, stretching from his early work to the time of his death. He explored luminous acrylic surfaces to create furniture and shelving and manipulated acrylic for sophisticated lighting. Kuramata made his most significant statements about transparency in 1976 with his glass furniture—shelves, a table, and a chair (fig. 7). Constructed of thick glass sheets, the chair depends on the considerable strength of a new bonding glue that made it possible to create a stable, strong structure from pieces of glass assembled on edge at right angles. A monumental one-off piece that challenges modernist monuments of the past, it knowingly references the geometry of the famous tubular-steel armchairs of Le Corbusier (see Le Corbusier, fig. 10) and Marcel Breuer (see Brandt, fig. 5). While the earlier steel compositions seem unstable as one sits on flexible strips of leather or cloth in an open metal form, Kuramata's transparent and visually unsubstantial chair is, paradoxically, both solid and supportive.

Using acrylic or glass to achieve transparency is a given; it is not so easy with steel, although Kuramata was able to achieve it in mesh form. The series of mesh works was his most memorable achievement. He began simply, with cone-shaped rollup mesh legs in his triangular glass-top Twilight Time table (1985), and he used expanded steel mesh for a series of upright chairs with steel mesh seats. His magisterial works in expanded iron mesh, used customarily as a construction material but not meant to be seen, are his How High the Moon armchair (fig. 2) and the Issey Miyake men's boutique, built in 1987 in the Shibuya Seiku department store in Tokyo. There he used steel mesh for everything. A steel-mesh cage with a barrel-vaulted top supported by mesh columns took over from the sterile solidity of architecture to create an inner space of dynamic expressiveness, featuring lighting tracks, display shelves, and other fittings of this material (fig. 8).

The next year, when Kuramata created his Miss Blanche armchair (fig. 9), he introduced a figurative and emotional element into his sequence of transparent voids. Its name alluded to the source of its inspiration, the affecting character Blanche du Bois in the 1951 movie of Tennessee Williams's *Streetcar Named Desire*. Miss Blanche incorporates a sprinkling of gaudy red plastic flowers, suspended motionless and forever in a thick, awkward, knife-edged acrylic form, which is set on purple anodized-aluminum legs. Once again the notion of transparency is questioned; his coy design stops us from seeing through the object as we focus on the unexpected and arresting floral display.

7
Shiro Kuramata. Chair, 1976. Glass

8
Shiro Kuramata. Issey Miyake boutique, Seiku department store, Shibuya, Tokyo, 1987

9
Shiro Kuramata. Miss Blanche chair, 1988. Acrylic, artificial roses, and stained aluminum. The Museum of Modern Art, New York

As Kuramata moved into the 1990s, he began to tread further into narrative and literary content, moving in a direction similar to that of Philippe Starck. His Laputa restaurant in Tokyo included a melange of elements, Venetian-style chandeliers, colored acrylic, and one-armed chairs with unusually high backs, as well as his Laputa bed (fig. 10). This curious single-width but double-length bed (used as a sofa) with pillows at each end, has double headboards of stained aluminum based on a common type of metal hospital bed. It is covered in silk upholstery ambiguously printed with a pattern of terrazzo. (Sottsass had experimented with terrazzo during the 1970s, and it had surfaced in Kuramata's work in 1983 when he used it for his Kyoto table for Memphis and for the construction of several of his boutique interiors). As photographed at the edge of the sea, the setting he preferred for the presentation of his works, the Laputa bed is a Magritte-like dream image that affirms the dualities in Kuramata's work: the clarity of modernist design and the ambiguity of postmodernism, the simple formality of functionalism and the complex essence of expressionism.

10
Shiro Kuramata. Laputa
seating bed, 1991. Stained
aluminum and printed silk

12

Philippe Starck
To open the gates to people's
imagination

Philippe Starck (born 1949) bounds down the path blazed by Raymond Loewy as he giddily takes on the task of redesigning the planet. Now, however, as the latter-day industrial designer puts his particular stamp on everything from toothbrushes to train interiors, he questions the need for what he is doing as well as the means by which he is doing it. Reflecting the late twentieth-century emergence of a pressing planetary awareness, Starck does more than just reconfigure the skin of the objects he designs or redesigns: he wants to make them respond to the encyclopedia of concerns that his profession addresses today, from safeguarding the environment to acknowledging the symbolic meanings that are inherent in everyday products. But Starck takes these concerns even further: he insists that we must recognize the moral dimension in design, and the fervor with which he voices his opinions on such issues has not been heard in design discourse since the time of William Morris. Starck is more than willing to let us in on the thought processes behind his design adventure, and the lengthy explanations that he gives are embedded with these beliefs.[1] He invites you to get under his skin, and you can't truly understand his work without doing so. But his eagerness to tell you what is on his mind can be more than embarrassing. He appears ingenuous, like a child who tells all, only to be baffled when you criticize or punish him for it. All this is magnified by his zany antics, publicity images (fig. 1), and whimsical interior designs, and a casual observer of the Starck phenomenon would not be faulted in questioning how seriously he addresses the important issues facing design in the twenty-first century.

Starck's international acclaim came initially with his design of interiors and their furnishings. Public anticipation of his soon-to-be star status was aroused when in 1983 he was one of several up-and-coming French designers commissioned to redecorate the private apartments of President François Mitterand and his wife in the Elysée Palace. His contribution included several pieces of furniture that would later enter production, including his metal-and-glass Président M. table, a version of the three-legged chair that would be used in his Café Costes the next year, and his Richard III leather armchair. His design of the Café Costes, a brilliant new incarnation of a Paris café in a prominent location near the Centre Pompidou, then becoming the cultural focus of the city, solidified his renown. The café proved to be a truly grand public debut as patrons flocked to this dramatic and ambiguous gathering place densely furnished with subtly disconcerting three-legged chairs and featuring a central staircase leading up to a gargantuan clock face with only eight signifying marks (fig. 2). The restrooms, many visitors discovered, looked like none they had ever seen, with transparent sinks, hidden controls, and urinals made of broad expanses of illuminated glass, which seemed more like decorative fountains than sanitary fixtures.

The hotels that Starck soon began to refurbish, starting in 1988 with the Royalton in New York, followed this imaginative line and furthered his bid for fame as each new commission inspired greater leaps of fantasy and brought him more rounds of publicity. The Royalton was his first collaboration with Ian Schrager, a hip American club owner turned hotelier, whose initial approach to Starck was instigated by the brilliance of his Café Costes. Starck's decoration played with the most unexpected juxtapositions—of scale, material,

period, and style—reaching an extreme in the Hotel Saint Martin's Lane in London, completed in 1999. The surreal lobby (fig. 3) is an amalgam of styles and objects that have no apparent relation to one another—an immense vase and flowers, Starck's Gold Tooth stools, Arne Jacobson's organic Egg chair from the 1950s, baroque armchairs, African stools, and huge errant chess pieces—an ensemble deliberately designed to disorient visitors and transport them to worlds they had not yet experienced. He intends his hotels "to arouse, to open the gates to people's imagination, to offer them fertile surprises"[2] far from the mundane experiences of the homes they've left behind.

Interior design, which Starck studied at the Ecole Camondo in Paris, led to his foray into products, at first to furnish the spaces he was commissioned to design. But equal recognition did not come easily for his objects. He thought that he would only be admitted to the magisterial company of the era's renowned designers by creating a "masterpiece," an extraordinary sculptural work of design that demonstrated the extent of his talents. His idols were Michael Graves and Richard Sapper, whose teapots for the Italian housewares firm Alessi had brought them international recognition and unexpected success in the marketplace. Thus in 1987 he undertook what he hoped would be his masterpiece, his Hot Bertaa teapot for Alessi (fig. 4). Rhetorical in its objective, the teapot has a dynamic, aggressive, asymmetrical form expressing his theory of "immobile aerodynamism."[3] The teapot was supposed to seem like it was in motion even though it was immobile, recalling the streamlined products of the 1930s. But Hot Bertaa, which, with its complex construction and complicated system of valves, took five years to reach completion, soured for him, and in retrospect he repudiated it. It is, he confesses, among "the worst"[4] objects he ever made, although it did in fact admit him to the company of Graves and Sapper.

Although Starck coyly states, "I hope there is no such thing as a 'Starck style,'"[5] he has become thoroughly identified with a defining emblematic form, a distinctive tapering, bulbous solid, which he has repeated and reinterpreted in a variety of ways and at very different scales. The handheld Olympic torch he designed along with a number of other ceremonial objects for the 1992 Winter Olympic Games in Albertville is one of them, as is the gigantic mesmerizing golden motif atop the skyscraper headquarters of the Asahi brewery in Tokyo, completed in 1989. Versions of it, including those that morphed into more regular hornlike shapes, began to be used for furniture legs, lamps, appliances, and other objects during the early years of the 1990s. Starck has also favored a more elegant organicism. His toothbrushes for Fluocaril and Alessi (fig. 5), for example, are minute abstract sculptures on circus pedestals, much indebted to Brancusi's lofty modernist impressions of birds in flight. These are part of Starck's insistence on the gains to be had from meeting beauty in ordinary objects. "I thought that if, first thing in the morning, you had something bright and cheerful sitting on the shelf waiting for you" Starck has explained, "it would be like opening the bathroom window onto a summer landscape every day."[6]

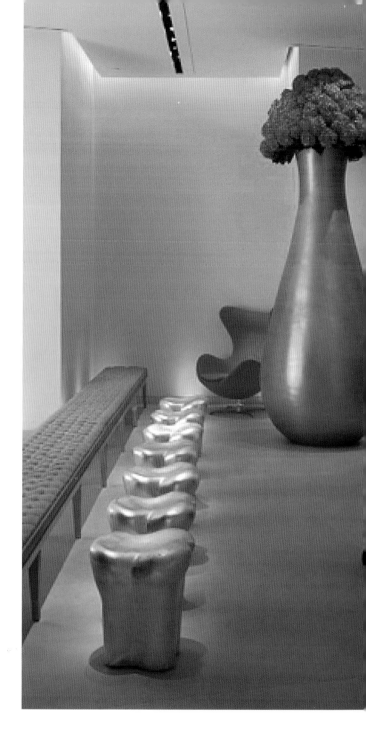

3
Philippe Starck. Lobby of
Hotel Saint Martins Lane,
London, 1999

4
Philippe Starck. Hot Bertaa
teapot, 1987–91. Aluminum
and plastic. Made by Alessi

5
Philippe Starck. Dr. Kiss
toothbrush and holder,
1998. Plastic. Made by
Alessi

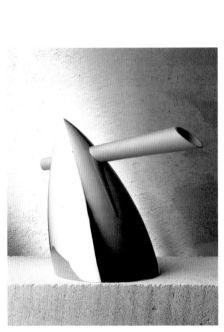

While the story of his Juicy Salif may be one of the most exaggerated examples of how he focuses on the human side of design—and a far cry from the simple situational musings of Ettore Sottsass describing the poetics of his Valentine typewriter—it demonstrates how Starck thinks beyond the physicality of his objects to consider, from his own skewed point of view, the psychological ambience in which they will exist. He tries to be cognizant of the symbolic meaning that consumers will read into his works, be they purchasers of his products or guests in his hotels and restaurants. He also plays with adding his own referential values as he addresses human issues. His appropriation of ordinary garden gnomes, which gained a useful purpose when he recast them as stools and a table (named Napoleon, Attila, and Holy Ghost; fig. 8), was written off by critics as one more publicity stunt. But for Starck they were not just lawn ornaments; produced when ethnic conflicts were tearing apart Eastern Europe, they were meant as a comment on intolerance, a narrow view of the world, the ways that knee-jerk reactions can fan prejudices, whether in politics or design. His Dr. Skud flyswatter (fig. 9), standing up on its own three feet, makes its own comment, looking askance at us with its dour perforated face each time we take an insect's life. Starck has ventured into every area of domestic life with narrative objects that may question our beliefs or bring pleasure to tedious chores. With products such as Dr. Skud, he has literally put design on a pedestal. He has raised—or perhaps lowered—the bar for design, making the kitchen, the bathroom, the laundry, broom closet, and garden as fertile areas for design invention today as the table top and the living room were a century ago.

When Starck decided to come to terms with modernism, he followed a path of reduction almost to minimalist exhaustion. In 1990 he introduced his Miss Sissi lamp (fig. 10) to create an ordinary no-nonsense object, one that had been virtually an archetype but was no longer available. Starck fabricated a "common-place" item, "a work based on collective memory,"[9] maintaining once again that it was designed not by him but "by all of us, and for our great happiness. Finally, and in making it in an ultramodern fashion, in injected plastic, it costs less, and comes in many colors. I had never ever wanted to impose my own taste, a particular aesthetic, on it; it was rather truly a service I performed."[10] In these terms, designing his simple La Marie chair (fig. 11), based on the form of a standard wooden type, was also a service he performed, especially since he considers it "almost perfect"—truly anonymous, without age or style, with "extreme honesty, profound modernity, the almost ideal object."[11] It exists to serve you, he announces. When made in clear or tinted plastic, it is hardly noticed; it is economical, and, like Le Corbusier's servant type-objects, when you are finished with it you can throw it away.

Starck has considered other type furniture also. As early as 1984, he was thinking in terms of types, albeit tortured ones, when he designed the Richard III armchair for the private apartments in the Elysée Palace. From the front it looks like a "bourgeois" leather club chair, ample, comfortable, inviting, but it sits on Starck's trademark,

Cognizant of the Symbolic meaning

Starck's designs are imbued with a sense of playfullness—does it add value?

Yes - people ~~realize the~~ appreciate the object from a new perspective

Perhaps lacking in Dresser's work? Investigate.

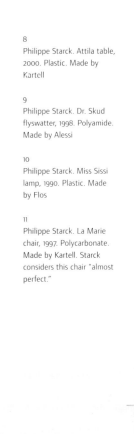

8
Philippe Starck. Attila table, 2000. Plastic. Made by Kartell

9
Philippe Starck. Dr. Skud flyswatter, 1998. Polyamide. Made by Alessi

10
Philippe Starck. Miss Sissi lamp, 1990. Plastic. Made by Flos

11
Philippe Starck. La Marie chair, 1997. Polycarbonate. Made by Kartell. Starck considers this chair "almost perfect."

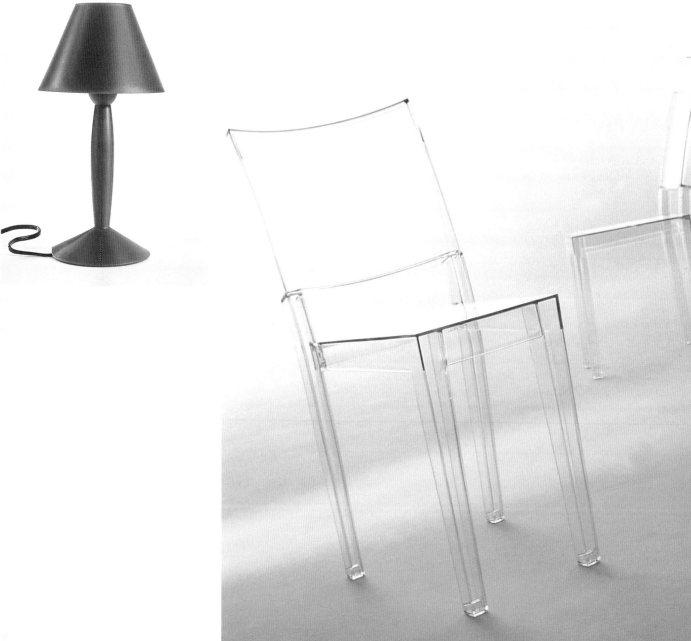

Credits

8
Philippe Starck. Attila table,
2000. Plastic. Made by
Kartell

9
Philippe Starck. Dr. Skud
flyswatter, 1998. Polyamide.
Made by Alessi

10
Philippe Starck. Miss Sissi
lamp, 1990. Plastic. Made
by Flos

11
Philippe Starck. La Marie
chair, 1997. Polycarbonate.
Made by Kartell. Starck
considers this chair "almost
perfect."

possibly unstable, three legs. Reminiscent of Achille Castiglioni's
Sanluca armchair (see Castiglioni, fig. 12), its back is unexpectedly a
void, revealing the underlying metal frame to which the unorthodox
upholstery is molded. In 2000 he returned to the club chair, but in a
more sympathetic design. His brightly colored plastic Bubble Club
armchair and sofa (fig. 12), made for outdoor use, are truly revelato-
ry creations as they challenge our convictions about the kinds of
objects that are appropriate to different situations. Starck gives us a
new option for our gardens as we turn a lawn into a true outdoor
living space.

His clear plastic Louis Ghost armchair (fig. 13) must also be accepted
as a type, a recognition that there are many simple, well-considered,
and long-used objects in non-modern styles that have also become
standardized. Reduced to an almost graphic presentation of the
curved motifs of its eighteenth-century rococo antecedents, and
fabricated with twenty-first-century materials and technology, this
is pure sign, presented without even a touch of the irony that was
the hallmark of postmodernism. Starck's Louis Ghost chair is a dead
serious design for today, a rococo chair brought up to date, with no
loss of integrity on either side. Philippe Starck alone has been able
to arrange a conciliation between modernism and postmodernism
and a true marriage of past and present.

*Extremely
Important
'Quote'!*

Starck's simple and potent hybrid Louis Ghost chair finally allows
modernism to come to terms with the past. But its act of binding
together the past and present is possible only because the Louis
Ghost chair does not actually complete the job, for it remains free
of the ornamental details of its eighteenth-century prototype. The
idiom of modernism is form, the idiom of decorative design was
surface, which is why the historic aspects of the Louis Ghost chair
can be accepted today, and why, regardless of all the eccentricities
that may have appeared in design over the past quarter century, the
underlying structure of design after modernism is still modernist.
By accepting the referential forms introduced by postmodernism,
modernism precariously hangs on; it will only be subverted when
contemporary design embraces ornament and pattern. But not even
a designer as prestigious as Starck has been able to do this with
sufficient verve to make a difference. Were ornament to be accept-
ed, form and decoration would be brought into balance once more
(reaffirming the unity of design that was present before the
machine gained the high ground), and the chapter on the divisive
twentieth-century style that was modern would finally be closed.

*Dresser's design
lacked ornamentation
(some)
early beginnings of
Modernism?*

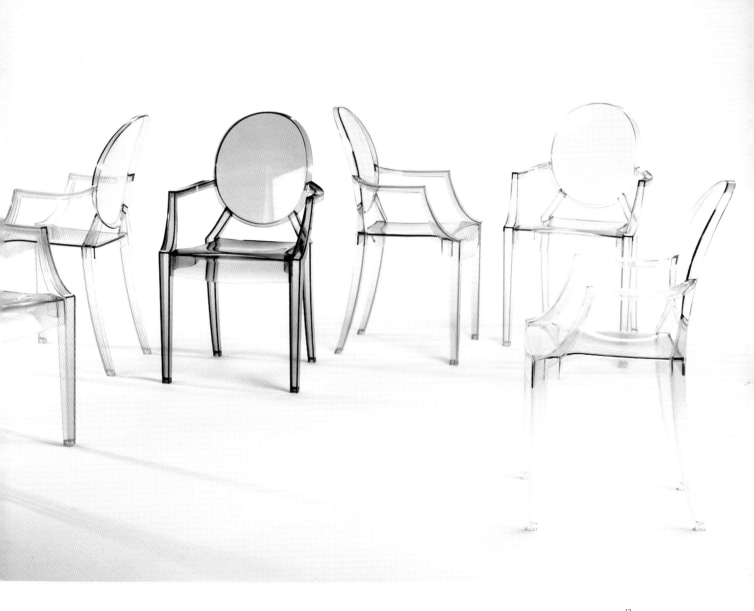

12
Philippe Starck. Bubble
Club sofa, 2000.
Polyethylene. Made by
Kartell

13
Philippe Starck. Louis
Ghost armchair, 2002.
Polycarbonate. Made by
Kartell

Notes

Preface

1. Nikolaus Pevsner, *Pioneers of the Modern Movement: From William Morris to Walter Gropius* (London: Faber & Faber, 1936), p. 41. This was reissued in several editions under the title *Pioneers of Modern Design*; see rev. ed. (Harmondsworth, England: Penguin Books, 1986), p. 38.

William Morris

1. William Morris, "The Lesser Arts" [1887], in *The Collected Works of William Morris*, vol. 22 (London: Longmans Green and Company, 1914), p. 22.
2. William Morris, "Beauty of Life" [1880], in *Collected Works*, vol. 22, p. 76.
3. William Morris, "Some Hints on Pattern-Designing" [1881], in *Collected Works*, vol. 22, p. 177.
4. Morris, "Beauty of Life," p. 73.
5. William Morris, Preface to "The Nature of Gothic," in John Ruskin, *The Works of John Ruskin*, ed. E. T. Cook and Alexander Wedderburn, vol. 10 (London: George Allen, 1904), Appendix 14, p. 460.
6. John Ruskin, "The Nature of Gothic," in *Works of John Ruskin*, vol. 10, p. 196.
7. Morris, "Pattern-Designing," p. 181.
8. Morris and Company catalogue, quoted in Oliver Fairclough and Emmeline Leary, *Textiles by William Morris and Morris & Co., 1861–1940* (London: Thames and Hudson, 1981), p. 34.
9. William Morris, "Art and the Beauty of the Earth" [1881], in *Collected Works*, vol. 22, p. 169.

Henry van de Velde

1. Pevsner, *Pioneers of Modern Design*, p. 101; see also p. 228, n. 13.
2. Walter Gropius, "The Theory and Organization of the Bauhaus" [1923], in *Bauhaus: 1919–1928*, ed. Herbert Bayer, Walter Gropius, and Ise Gropius (New York: The Museum of Modern Art, 1938), p. 24.
3. Henry van de Velde to Gropius, April 11, 1915, and July 8, 1915, in Hans M. Wingler, *The Bauhaus: Weimar Dessau Berlin Chicago* (Cambridge, Mass.: The MIT Press, 1969), p. 21.
4. Henry van de Velde, "A Chapter on the Design and Construction of Modern Furniture" [1897], in *Form and Function: A Source Book for the History of Architecture and Design 1890–1939*, ed. Tim and Charlotte Benton (London: Crosby Lockwood Staples in association with the Open University Press, 1975), p. 18.
5. Henry van de Velde, "William Morris: Artisan et socialiste," *L'Avenir Social*, 1898, p. 69.
6. Morris, "Beauty of Life," p. 76.
7. Henry van de Velde, "Extracts from His Memoirs: 1891–1901," *Architectural Review*, vol. 112 (September 1952), p. 153.
8. Camille Mauclair, "Choses d'Art," *Mercure de France*, February 1896, p. 268.
9. Van de Velde, "Extracts from His Memoirs," p. 146.
10. Henry van de Velde, quoted in Klaus-Jürgen Sembach, *Henry van de Velde* (New York: Rizzoli, 1989), p. 49.
11. Ibid.
12. Ibid., p. 48.

Josef Hoffmann

1. Josef Hoffmann and Koloman Moser, "Working Programme" [1905], in Werner J. Schweiger, *Wiener Werkstätte: Design in Vienna, 1903–1932* (New York: Abbeville Press, 1984), p. 42.
2. Josef Hoffmann, "Simple Furniture" [1901], in Eduard Sekler, *Josef Hoffmann: The Architectural Work* (Princeton: Princeton University Press, 1985), p. 484.
3. Ibid.
4. Ludwig Hevesi, quoted in Schweiger, *Wiener Werkstätte*, p. 44.
5. Hoffmann, "Simple Furniture," 484.
6. Herbert Muschamp, *New York Times*, October 17, 2002.

Frank Lloyd Wright

1. Frank Lloyd Wright, "The Art and Craft of the Machine" [1901], in *Collected Writings*, ed. Bruce Brooks Pfeiffer (New York: Rizzoli, 1992), vol. 1, p. 59.
2. Frank Lloyd Wright, *An Autobiography* (New York: Duell, Sloan and Pearce, 1943), p. 11.
3. Wright, "Art and Craft of the Machine," p. 59.
4. Ibid., pp. 64–65.
5. Frank Lloyd Wright, "In the Cause of Architecture" [1908], in *Collected Writings*, vol. 1, p. 88.
6. Ibid., p. 97.
7. William Allin Storrer, *The Architecture of Frank Lloyd Wright: A Complete Catalog*, 3rd ed. (Chicago: The University of Chicago Press, 2002).
8. Frank Lloyd Wright, Preface, *Ausgeführte Bauten und Entwürfe* [1910], in *Collected Writings*, vol. 1, p. 112.
9. Wright, "In the Cause of Architecture," p. 97.
10. Owen Jones, *The Grammar of Ornament* [1856]; reprint, London: Dorling Kindersley, 2001, p. 24.
11. Ibid., p. 25.
12. Wright, "In the Cause of Architecture," p. 95.
13. Ibid.
14. Wright, *Autobiography*, p. 226.
15. Wright, "In the Cause of Architecture," p. 90.
16. See Pedro E. Guerrero: *Picturing Wright: An Album from Frank Lloyd Wright's Photographer* (San Francisco: Pomegranate Books, 1994), p. 151.

Le Corbusier

1. Le Corbusier, *The Decorative Art of Today* (Cambridge, Mass.: The MIT Press, 1987), p. 84.
2. Ibid.
3. Le Corbusier: *Les Voyages d'Allemagne, Carnets*, ed. Giuliano Gresleri (New York: The Monacelli Press, 1995), Carnet 1, pp. 42-43; transcription, p. 38.
4. Le Corbusier, *Decorative Art*, pp. 77, 79.
5. Ibid., p. 79
6. Ibid., p. xxi.
7. Amédée Ozenfant and Edouard Jeanneret [Le Corbusier], "After Cubism," in Carol S. Eliel, *L'Esprit Nouveau: Purism in Paris, 1918–1925* (Los Angeles: Los Angeles County Museum of Art in association with Harry N. Abrams, 2001), p. 142.
8. Le Corbusier, *Towards a New Architecture* (London: John Rodker Publisher, 1927), p. 89.
9. Le Corbusier *Almanach d'architecture moderne* (Paris: Les Editions G. Crès et Cie, 1926), p. 145.
10. Le Corbusier, *Decorative Art*, p. 76 n.
11. Ibid.
12. Henry James, in Leon Edel, *Henry James*, vol. 2 (New York: Avon Books, 1978), p. 283.
13. Le Corbusier, *Almanach*, p. 145.
14. Le Corbusier, *Decorative Art*, p. 77.
15. Adolf Loos, "Interiors: A Prelude" [1898], in *Spoken into the Void: Collected Essays 1897–1900* (Cambridge, Mass.: The MIT Press, 1982), p. 19.
16. Adolf Loos, "Interiors in the Rotonda" [1898], in *Spoken into the Void*, p. 24.
17. Le Corbusier, *Journey to the East* (Cambridge, Mass.: The MIT Press, 1989), p. 16.
18. Le Corbusier, *Precisions on the Present State of Architecture and City Planning . . .* [1930]; reprint, Cambridge, Mass., and London: MIT Press, 1991, pp. 117–18.
19. Wright, "Art and Craft of the Machine," p. 64.

Marianne Brandt

1. Walter Gropius, "Program of the Staatliche Bauhaus im Weimar" [1919], in Wingler, *Bauhaus*, p. 31.
2. Marianne Brandt, "Letter to the Younger Generation," in *Bauhaus and Bauhaus People*, ed. Eckhard Neumann (New York: Van Nostrand Reinhold Company, 1970), p. 97.
3. Walter Gropius, "Bauhaus Members Breviary" [1924], in Wingler, *Bauhaus*, p. 76.
4. Brandt, "Letter," p. 97.
5. Wilhelm Wagenfeld, in Frank Whitford, *The Bauhaus: Masters & Students by Themselves* (Woodstock, New York: The Overlook Press, 1993), p. 171.
6. F. K. Fuchs, *Deutsche Goldschmiede-Zeitung* [1926], in Whitford, *The Bauhaus: Masters & Students*, p. 222.

7. László Moholy-Nagy, "Metal Workshop: From Wine Jugs to Lighting Fixtures," in *Bauhaus: 1919–1928*, p. 136.
8. Brandt, "Letter," p. 98.
9. Ibid., p. 99.

Raymond Loewy
1. Norman Bel Geddes, *Horizons* (New York: Random House, 1932).
2. Henry Dreyfuss, "An Industrial Designer Thinks about His Job," in *Art Directors' 18th Annual of Advertising Art* (New York: Longmans Green, 1939), p. 170.
3. Walter Dorwin Teague, *Design This Day: The Technique of Order in the Machine Age* (New York: Harcourt Brace and Co., 1940).
4. Raymond Loewy, *Never Leave Well Enough Alone* (New York: Simon and Schuster, 1951).
5. Ibid., p. 201.
6. Raymond Loewy, *Industrial Design: Raymond Loewy* (Woodstock, New York: The Overlook Press, 1979), p. 13.
7. Ibid.,
8. Stephen Bayley, "Public Relations or Industrial Design?" in Angela Schönberger, ed., *Raymond Loewy: Pioneer of American Industrial Design* (Munich: Prestel, 1990), p. 232.
9. Serge Chermayeff and René d'Harnoncourt, "Design for Use," in *Art in Progess* (New York: The Museum of Modern Art, 1944), p. 195.
10. Loewy, *Industrial Design,* p. 13.
11. Loewy, *Never Leave Well Enough Alone,* p. 219.
12. Ibid., pp. 277–78.
13. Peter Blake, "Mr. Loewy and the Egg," *New York Times Book Review*, March 4, 1951, p. 6.
14. *Time*, October 31, 1949, p. 49.
15. Arthur Drexler, *Ten Automobiles* (New York: The Museum of Modern Art, 1953), p. 1.
16. Ibid., p. 10.
17. Raymond Loewy, "Jukebox on Wheels," *The Atlantic Monthly*, vol. 195 (April 1955), p. 36.
18. Ibid., p. 37.

Charles and Ray Eames
1. Charles Eames, interview, "What Is Design?" in John Neuhart, Marilyn Neuhart, and Ray Eames, *Eames Design: The Work of the Office of Charles and Ray Eames* (New York: Harry N. Abrams, 1989), p. 14.
2. *Time,* July 10, 1950, pp. 45–56.
3. Edgar Kaufmann, Jr., *Prize Designs for Modern Furniture from the International Competition for Low-Cost Furniture Design* (New York: The Museum of Modern Art, 1950), pp. 19–20.
4. The Museum of Modern Art, New York, *An Exhibition of Home Furnishings Selected by The Museum of Modern Art, New York, for the Merchandise Mart, Chicago* (1953), inside cover.
5. Charles and Ray Eames, "India Report—1958," in UNIDO-ICSID INDIA 79, Design for Development (Ahmedabad, India, National Institute of Design, January 14–24, 1979), n.p., Library of Congress, Manuscript Division, Eames Archives, Box 45, folder 4.
6. Ibid.
7. Eames, "What is Design?" p. 14.
8. Ibid.
9. Recalled by Don Albinson, in Eames Demetrios, *An Eames Primer* (New York: Universe, 2001), p. 170.
10. Charles Eames, interview, in Paul Schrader, "Poetry of Ideas: The Films of Charles Eames," *Film Quarterly*, Spring 1970, p. 14.

Achille Castiglioni
1. Achille Castiglioni, "Design and Research" [1989], in Sergio Polano, *Achille Castiglioni: Complete Works* (Milan: Électa Architecture, 2001), p. 456.
2. Achille Castiglioni, "The Formal Qualities of Industrial Products" [1961], in Polano, *Castiglioni,* p. 447.
3. Achille Castiglioni, "Design and Production" [1980], in Polano, *Castiglioni,* p. 451.
4. Ibid.
5. The Museum of Modern Art, *Exhibition of Home Furnishings,* inside cover.
6. Achille, Livio, and Pier Giacomo Castiglioni, "Italian Industrial Design" [1953], in Polano, *Castiglioni,* p. 447.
7. Ibid.
8. Achille Castiglioni, in Polano, *Castiglioni,* p. 252.

9. Castiglioni, in Polano, Castiglioni, p. 310.
10. Achille Castiglioni, "Design Survey" [1965], in Polano, *Castiglioni,* pp. 447–48.
11. Castiglioni, in Polano, *Castiglioni,* p. 448.
12. Paolo Portoghesi, in Polano, *Castiglioni,* p. 174.
13. Achille Castiglioni, "Lighting for the Home" [1983], in Polano, *Castiglioni,* p. 453.
14. Achille Castiglioni, "The Poetic of Design" [1983], in Polano, *Castiglioni,* p. 453.

Ettore Sottsass, Jr.
1. Ettore Sottsass, Jr., "Memphis 1982," in *Memphis* [catalogue] (Milan: Memphis, 1982), n.p.
2. Barbara Radice, ed., *Memphis: The New International Style* (Milan, 1981), p. 173.
3. Ettore Sottsass, Jr., in Hans Höger, *Ettore Sottsass Jun.: Designer Artist Architect* (Tübingen and Berlin: Wasmuth, 1993), p. 15.
4. Ettore Sottsass, Jr., in *Design Process: Olivetti, 1908–1978,* exh. cat. (Los Angeles: Frederick S. Wight Art Gallery, University of California, 1979), p. 120.
5. Ettore Sottsass, Jr., *Design Metaphors*, ed. Barbara Radice (New York: Rizzoli, 1988), p. 9.
6. Ettore Sottsass, Jr., "Experience with Ceramics" [1969], in *Ettore Sottsass: Ceramics*, ed. Bruno Bischofberger (San Francisco: Chronicle Books, 1996), p. 9.

Shiro Kuramata
1. Shiro Kuramata, in *Shiro Kuramata: 1934–1991* (Hara Museum of Contemporary Art, 1996), p. 181.
2. Shiro Kuramata, Patrizia Scarzella, and Kazuko Sato, "Indirect Conversation," *Domus,* no. 649 (April 1984), p. 60.
3. Kuramata, in *Shiro Kuramata: 1934–1991,* p. 209.
4. Kuramata, in *Shiro Kuramata: 1934–1991,* p. 160.
5. Kuramata, "Indirect Conversation."
6. Ibid.
7. Ettore Sottsass, Jr., "Text for Shiro Kuramata," in *Shiro Kuramata: 1934–1991,* p. 136.
8. Kuramata, "Indirect Conversation."
9. Kuramata, in *Shiro Kuramata: 1934–1991,* p. 136.

Philippe Starck
1. See Philippe Starck, "Texte intégral de l'exposition," in *Starck Explications* (Paris: Centre Pompidou, 2003).
2. Ibid., p. 85.
3. Ibid., p. 62.
4. Ibid.
5. Philippe Starck, in Conway Lloyd Morgan, *Starck* (New York: Universe, 1999), p. 23.
6. Ibid., p. 11.
7. Ibid., p. 19.
8. Ibid., p. 9.
9. Philippe Starck, in *Starck* (Cologne: Taschen, 2000), p. 150.
10. Ibid.
11. Ibid., p. 191.

For further reading

William Morris

Fiona MacCarthy. *William Morris: A Life for Our Time.* New York: Alfred A. Knopf, 1995.

Linda Parry, ed. *William Morris.* New York: Abrams, 1996.

Diane Waggoner, ed. *"The Beauty of Life": William Morris and the Art of Design.* New York: Thames and Hudson, 2003.

Henry van de Velde

Klaus-Jürgen Sembach. *Henry van de Velde.* New York: Rizzoli, 1989.

Klaus-Jürgen Sembach and Birgit Schulte, eds. *Henry van de Velde: Ein Europäischer Künstler Seiner Zeit.* Cologne: Wienand, 1992.

Josef Hoffmann

Werner J. Schweiger. *Wiener Werkstätte: Design in Vienna, 1903–1932.* New York: Abbeville Press, 1984.

Peter Noever, ed. *Josef Hoffmann Designs.* Munich: Prestel, 1992.

Maria Rennhofer. *Koloman Moser: Master of Viennese Modernism.* New York: Thames and Hudson, 2002.

Frank Lloyd Wright

David A. Hanks. *The Decorative Designs of Frank Lloyd Wright.* New York: Dutton, 1979.

Julie L. Sloan. *Light Screens: The Leaded Glass of Frank Lloyd Wright.* New York: Rizzoli, 2001.

Penny Fowler. *Frank Lloyd Wright: Graphic Artist.* San Francisco: Pomegranate, 2002.

Le Corbusier

George H. Marcus. *Le Corbusier: Inside the Machine for Living.* New York: The Monacelli Press, 2001.

Mary McLeod, ed. *Charlotte Perriand: An Art of Living.* New York: Harry N. Abrams in association with The Architectural League of New York, 2003.

Marianne Brandt

Magdalena Droste. *Bauhaus: 1919–1933.* Berlin: Bauhaus Archiv/Benedikt Taschen, 1993.

Justus A. Binroth and others. *Bauhaus Lighting? Kandem Light!: The Collaboration of the Bauhaus with the Leipzig Company Kandem.* Stuttgart: Arnoldsche, 2002.

Raymond Loewy

Angela Schönberger, ed. *Raymond Loewy: Pioneer of American Industrial Design.* Munich: Prestel, 1990.

Glenn Porter. *Raymond Loewy: Designs for a Consumer Culture.* Wilmington, Delaware: Hagley Museum and Library, 2002.

Charles and Ray Eames

John Neuhart, Marilyn Neuhart, and Ray Eames. *Eames Design: The Work of the Office of Charles and Ray Eames.* New York: Harry N. Abrams, 1989.

Pat Kirkham. *Charles and Ray Eames: Designers of the Twentieth Century.* Cambridge, Mass.: The MIT Press, 1995.

Eames Demetrios. *An Eames Primer.* New York: Universe, 2001.

Achille Castiglioni

Paola Antonelli and Steven Guarnaccia. *Achille Castiglioni.* Mantua: Corraini Editore, 2000.

Sergio Polano. *Achille Castiglioni: Complete Works.* Milan: Electa Architecture, 2001.

Shiro Kuramata

Shiro Kuramata: 1987–1987. Tokyo: Parco, 1988.

Shiro Kuramata: 1934–1991. Tokyo: Hara Museum of Contemporary Art, 1996.

Ettore Sottsass, Jr.

Hans Höger. *Ettore Sottsass, Jun.: Designer, Artist, Architect.* Tübingen: Wasmuth, 1993.

Barbara Radice. *Ettore Sottsass: A Critical Biography.* New York: Rizzoli, 1993.

Andrea Branzi and others. *The Work of Ettore Sottsass and Associates.* New York: Universe, 1999.

Philippe Starck

Conway Lloyd Morgan. *Starck.* New York: Universe, 1999.

Starck. Cologne: Taschen, 2000.

Index

Page numbers in italics refer to illustrations.

Aalto, Alvar, 107
Abet, 136
Abitare, 138
accessories (Brandt), 79
Academy of Art, entrance to (van de Velde), *25*
adjustable hanging lamps (Brandt and Przyrembel), *89*
Adler, Dankmar, 49
After Cubism (Le Corbusier and Ozenfant), 66
Albers, Josef, 80
Alessi, 162
American Moderne style, 95–97
Angels Watch (van de Velde), 30–32, *31*
antimodernism, 149, 153
apartment home (*immeuble-villa*), 68
Arco (Arc) lamp (A. and P. G. Castiglioni), 125, *125*
armchair (Breuer), 79, *81*
armchair (Hoffmann), *41*
Armoury, St. James's Palace, 16
"Art and Craft of the Machine, The" (Wright), 49
Art Deco, 41, 43–44, 74, 89, 137, 150
Art Nouveau, 25–27, 32, 37–38, 65, 71, 128
Art Nouveau, L', 29, *29*
Arts & Architecture, 112
Arts and Crafts Exhibition Society, 21
Arts and Crafts Movement, 27, 38, 43, 51–52, 54, 60, 79
Asahi brewery, golden motif on (Starck), 162
Ashbee, Charles Robert, 21, 38
Attila table (Starck), 166, *167*
Austrian pavilion (Hoffmann), 43
Avery Coonley school building (Playhouse) (Wright), 56, *57*

Baptism of Christ in Jordan, The (Burne-Jones), *15*
Barbizon painters, 30
Barnsdall, Aline, 54
Bauhaus, 25–26, *25*, 37, 41, 74, 77–89, 94, 152, 153
 collection, 87
 fabrics, 87
 lighting fixtures of, 84–87
 metal workshop of, 80, *81*, 84, 87
 Metallic Fest, 79, 87
 sexism in, 80, 87, 89
 silverware and tableware of, 84
 weaving workshop, *85*
Bayley, Stephen, 94
Behrens, Peter, 65
Bell, Larry, 152
bentwood, 43
Bernstein, Elmer, 114
Bing, Siegfried, 29, *29*
Blacktop (C. and R. Eames), 115
Blake, Peter, 98
Bloemenwerf (Haven of Flowers) (van de Velde), 25, 27–28, *27*, 32
 decor of, 27–29
 dining room at, *27*, 29
Bodenhausen, Eberhard von, 32
Book of Verse, A (W. Morris), 11
Brandt, Erik, 80
Brandt, Marianne Liebe, 77–89
 lighting devices of, 79, *79*, *83*, 84, *85*, 87, *89*
 and photography, 87
 self-portraits of, 87
Branzi, Andrea, 135
Bredendieck, Hin, 89, *89*
Brera lamp (A. Castiglioni), 122, *125*
Breuer, Marcel, 58, 71, 74, 75, 79–80, *81*, 155
Brown, Ford Madox, 15
Bubble Club chair and sofa (Starck), 168, *169*
Burne-Jones, Edward, 12, 13, 15, *15*, 16, *17*, 19, 21

Cabinet No. 50 (Sottsass), *145*
cabinet on stand (W. Morris and Webb), *15*
cabinets (Le Corbusier), *69*
Café Costes (Starck), 161, *161*

café tables (Le Corbusier), *67*
candelabrum (van de Velde), 32, *33*
Casabella, 45
Casablanca sideboard, *134*, 136
Case Study House initiative, of *Arts & Architecture*, 112
Castiglioni, Achille, 119–31, *121*, *123*, 127, 129, 131
 desk lamps of, 122, *125*
 and problem of directing light, 125–26, 129
Castiglioni, Livio, 121
Castiglioni, Pier Giacomo, 121–30, *123*, 129, 131
centerpiece (Hoffmann), *41*
"ceramics of darkness" (Sottsass), 145
chair (Hoffmann), *43*
chair (Kuramata), *155*
chair (Perriand), *73*
chair (Wright), *51*, *57*
chairs (C. Eames and Saarinen), plywood and upholstery, *107*
chairs (Le Corbusier, Perriand, and Jeanneret), 72, *73*
chairs (van de Velde), *29*
chair with pivoting back (Le Corbusier, Perriand, and Jeanneret), *73*
chair with revolving back (Perriand), *73*
Chaise, La (C. and R. Eames), 110
 mold for, *117*
chaise longue (Le Corbusier, Perriand, and Jeanneret), 72, *73*
clock (Brandt), *88*, 89
clock (Starck), 161
Clock with Seven Hands (Kuramata), 149
club chair (Kuramata), 149
club chair (Le Corbusier, Perriand, and Jeanneret), *73*
coffee and tea service (Brandt), 79, *79*
Coldspot refrigerator (Loewy), 97, *97*
Colonial Modern, 101
commercial design, 112–15
Compasso d'Oro prize presentations, 121
computers, 116, 138, *139*
"Contemporary American Industrial Art," 94, *95*
Craftsman Workshops, 21
Chicago Arts and Crafts Society, 49
craftsmanship:
 in Wiener Werkstätte, 38, 41
 in William Morris, 11, 19
Cray textile (W. Morris), 17–18, *17*
cruet stand (Moser), *37*
Cubism, 65–66, 71
Cumano table (A. Castiglioni), 126, *127*
cutlery (Hoffmann), *41*

Dadaism, 71, 149
de Chirico, Giorgio, 138
De Lucchi, Michele, 135
Decorative Art of Today, The (Le Corbusier), 66, *67*, 126
De Stijl, 74, 79, 138
Design This Day: The Technique of Order in the Machine Age (Teague), 93
Design of a Very Beautiful Vase: Not Everybody Has Rice to Put in It (Sottsass), *143*
desk (van de Velde), *31*
desk (Wright), *59*
Dessau building, 87
Dixon, Tom, 131
Domus, 138, 152
Dr. Skud flyswatter (Starck), 166, *167*
Dress, velvet (van de Velde), *29*
Drexler, Arthur, 98
Dreyfuss, Henry, 93
du Pasquier, Nathalie, 135
Duchamp, Marcel, 71, 130, 149, 150
Dylan, Bob, 135

Eames, Charles, 105–17, 140
 "action" and "constraints" in design of, 107
 plywood chairs of, 106, *107*
Eames, Charles and Ray, 105–17, *107*, 115, *117*, 129
 films of, 111, 112, 115, *115*, 116, *117*
 house and studio of, 112, *113*, 116
 photographs of, 112, 116
 plywood chairs of, 107, *109*

toys in design of, 112, *113*, 115
 use of standardized materials by, 112
Eames, Ray Kaiser, 105–17
Ecole Camondo, 162
eggs:
 in design of Achille Castiglioni, 122, *125*
 in design of Raymond Loewy, 93, 122
Egg chair (Jacobson), 162
Elea 9002 computer (Sottsass), 138, *139*
electrical switch (A. and P. G. Castiglioni), 124, *125*
Elysée Palace, 161, 166
Endell, August, 25
Entrance to the Academy of Art, Weimar (van de Velde), *25*
Esprit Nouveau, L' (The New Spirit), 65, *65*
Esprit Nouveau pavilion (Le Corbusier), 68, *69*, 72
Esprit showroom (Sottsass Associati), 137, *137*
extendable table (Perriand), *73*
Exxon logo, studies for (Loewy), *101*

Fallingwater (Wright), 59, *59*
Faulkner, Charles, 15
Fiorucci showroom (Sottsass), 137
Flavin, Dan, 152
flower holder, design for (Hoffmann), *37*
Fluocaril toothbrush (Starck), 162, *163*
fluorescent lighting, 122, *123*
Ford, Henry, 26
formalist modernism, 122, 125
found objects, 131
Frisbi lamp (A. Castiglioni), 126, *127*
"From Wine Jugs to Lighting Fixtures" (Moholy-Nagy), 84
Fuller, Buckminster, *117*
functionalist modernism, 44, 79
Furniture in Irregular Forms (Kuramata), *153*
Furniture with Drawers (Kuramata), 152

Gannet, William C., 54
Gauguin, Paul, 30
Geddes, Norman Bel, 93
geometry, 37, 44, 54, 56, 78, 80, 145, 155
Gesamtkunstwerk, 26, 39, 44
Gestetner mimeograph machine (Loewy), 93, *93*, 95–97
Gibigiana table lamp (A. Castiglioni), 129, *129*
Glimpses of the U.S.A (C. and R. Eames), *117*
Global Tools, 142
Good Design, 110–15, 135, 152
Gothic Revival, 11
Grammar of Ornament, The (Jones), 11, 52
Graves, Michael, 44, 136, 162
Gray Furniture (Sottsass), 141
Green Dining Room (Webb, Burne-Jones and W. Morris), 16, *17*
Gropius, Walter, 25, 79, *81*, 84, 87, 89
Guild and School of Handicraft, 21

hanging lamps (Brandt and Przyrembel), *85*
Hankar, Paul, 27
Hans Knoll Associates, 110
Havana Cigar Company, Berlin shop of (van de Velde), 30, *31*
High-Tech movement, 131
Hoffmann, Josef, 35–45, *37*, 39, *41*, 43, 45
 chairs of, redesigned by Shiro Kuramata, 150, *151*
 critical acclaim for, 44
 geometry in design of, 37
 ornamental vs. austere in works of, 44
Hollein, Hans, 137
Hollyhock House (Wright), 54, *55*
 dining room in, 55
Homage to Josef Hoffmann, Begin the Beguine (Kuramata), 150, *151*
Homage to Josef Hoffmann Vol. 2 (Kuramata), 149–50, *151*
"Home Furnishing" chapter header (Wright), 55
Horizons (Geddes), 93
Horta, Victor, 27
Hot Bertaa teapot (Starck), 162, *163*, 164
Hotel, St Martin's Lane, lobby of (Starck), 162, *163*
House—After Five Years of Living (C. and R. Eames), 116
House Beautiful, The (Wright), 54, *55*
House of Cards (C. and R. Eames), 112, *113*

House and Garden, 108
How High the Moon armchair (Kuramata), 149, *149*, 155
Hupmobile (Loewy), 94, 97
Hussar, Joseph W., 49

IBM presentation, 1964 New York World Fair, 116
"immobile aero dynamism," 162
Imperial Hotel, Tokyo (Wright), 56, *57*
"In the Cause of Architecture" (Wright), 51
India, influence of;
 on Charles and Ray Eames, 111
 on Ettore Sottsass Jr., 145
"India Report" (C. and R. Eames), 111
indigo-discharge printing process, 19, *19*
indigo dyeing, 19
industrial design:
 Achille Castiglioni and, 121–30
 American vs. European view of, 94
 Museums of Modern Art vs. Metropolitan Museum of Art
 on, 94
Industrial Design Section, Tenth Triennale, installation for
 (Castiglioni, A. and P. G.), 121, *121*
industrial lighting, 84, *85*, 121–31
"Interior Equipment of a Dwelling" (Le Corbusier, Perriand, and
 Jeanneret), 75, *75*
"International Competition for Low-Cost Furniture Design," 108
International Exhibition, London, 1862, 15, *15*
International Exposition of Modern Decorative and Industrial
 Arts, Paris, 1925, 43, 68
International Harvester, logo for (Loewy), *101*
International Style, 44, 58, 136
Iris Craft Workshops, 21
Isozaki, Arata, 137
Issey Miyake boutique (Kuramata), 149, 155, *155*
"Italy: The New Domestic Landscape" (Sottsass), 142, *143*

Jacobson, Arne, 162
Jeanneret, Charles-Edward, *see* Le Corbusier
Jeanneret, Pierre, 59, 65, 71, *73*
"jet propulsion nose" (Loewy), 98
Johnson Wax Building, 51, 59, *59*
Jones, Owen, 11, 52
Jones, Terry, 136
Jucker, Karl Jakob, 83, *85*
Judd, Donald, 152
Jugendstil (Style of Youth), 38
Juicy Salif lemon squeezer (Starck), 165–66, *165*
jukebox (Loewy), *101*
"Jukebox on Wheels" (Loewy), 101

Kandem (Körting and Mathiesen), 87, 89
Kandem lamps (Brandt and Bredendieck), 89, *89*
Kandem double cylinder hanging lamp (Brandt and Schultz), *79*
Kandinsky, Wassily, 80
Kaufmann, Edgar, Jr., 110
Kelmscott Press, 12, 19, *21*
kidney-shaped desk (van de Velde), 30, *31*
Klee, Paul, 80
Kleinhaus music hall (C. and R. Eames), 106
Klimt, Gustav, 37, 43, *45*
Kohn, Jacob and Joseph, 41, *43*
Körting and Mathiesen (Kandem), 87, 89
Kuramata, Shiro, 137, 147–57, *149*, *151*, *153*, *155*, *157*
 humor of, 149–50
 influences on, 150, 152
 literary content in works of, 155, *155*, 156
Kuwasawa Design Studio, 152
Kyoto table (Kuramata), 156

La Marie chair, 166, *167*
lamps (Brandt and Bredendieck), *89*
Laputa bed (Kuramata), 156, *157*
Laputa restaurant (Kuramata), 156
Large Glass, The (Kuramata), 149
Larkin Company Administration Building, 51

Le Corbusier (Charles-Edward Jeanneret), 59, 63–75, *65*, *67*, *69*,
 71, *73*, 130, 138, 149, 155, 166
 and aesthetics of the machine, 68
 folk art and, 71
 Charles and Ray Eames influenced by, 111–12, 115
 and rejection of decorative design, 64
 simplicity in works of, 74
 type furniture of, 68–74
 type objects of, 66, 68–74, 126, 127
 unity through selection in works of, 71
Leipzig Trade Fair, 84
Lemmen, George, 29, *29*
living room (Le Corbusier), *69*
living-dining room (Wright), *61*
Loewy, Raymond, 59, 91–103, *95*, *101*, *103*, 130, 152, 161
 American automobile industry criticized by, 101
 commercial designs of, *93*, 97, *97*, *99*
 on consumers, 98
 commercial graphics of, *95*, 101
 and the egg as perfect functional shape, 93, 122
 and marketing, 93
 negative criticism of, 94, 98
 response to negative criticism by, 97
 redesigning and, 93, 97
 retail designs of, 101
 Time cover of, 93, *93*
Loos, Adolf, 44, 71
lotas, 111, *111*
Louis Ghost armchair (Starck), 168, *169*
lounge chair and Ottoman (C. and R. Eames), 115, *115*
lounge chairs (C. and R. Eames), 110
Low-Cost Furniture competition, 110

Machine Art, 94, 98
machine modernism, 37
"machine for living," 68
machine production, 11, 38, 61
 aesthetics of, 49–50, 66–67, 83
 Frank Lloyd Wright's acceptance of, 49–50
Mackintosh, Charles Rennie, 38
Mahogany Smoking Room (van de Velde and Lemmen), 29, *29*
Mariscal, Javier, 137
Marshall, Peter Paul, 15
Marxism, Socialism, 11–12, 27
mass production, 11, 21, 26, 83
Mauclair, Camille, 29
MAYA (Most Advanced Yet Acceptable) stage, 98, 131
Me (Brandt), 87, *87*
Meier, Richard, 44
Meissen porcelain, 32, *33*
Memphis catalog, *135*
Memphis group, 133–45, 150, 152
Mendini, Alessandro, 135–36
"Menhir, Ziggurat, Stupas, Hydrants and Gas Pumps" (Sottsass),
 145
Mercure de France, 29
metal mesh chairs (C. and R. Eames), 108–10, *109*
Meyer May house (Wright), 49, *51*
Mezzadro (Sharecropper) stool (A. and P. G. Castiglioni), 131, *131*
Mikli, Alain, 165
Milan furniture show, 134
Miller, Herman, 108–10
Minimalism, 141, 152–53, 166
Minstrel (Woman Playing a Lute) (Morris), *17*
Miss Blanche armchair (Kuramata), 155, *155*
Miss Sissi lamp (Starck), 166, *167*
Mitterrand, François, apartment of, 161
"Model 2000" coffee set (Loewy), *101*
modern design:
 black and white motif in, 38–39, 43, 153
 fashion in, 133
 form and function in, 122, 131, 149
 geometry in, 37, 44, 54, 56, 78, 80, 145, 155
 humanitarian aims of, 11–12, 27, 111, 150, 165
 lighting in, 119–31
 low-cost in, 110, 165–66
 nature in, 52–54, 59, 142
 simplicity in, 74, 122

Moderne Bauform, 43
Molded Plywood Division of Evans Product Company, 108
Moholy-Nagy, Lázlo, 80, *81*, 84, 87, *87*
Mondrian, Piet, 153
"Morris" chairs, 15
Morris and Company, 11, 15, *15*, *17*, 19, 49
Morris, Jane Burden, 12, *13*
Morris, Marshall, Faulkner and Company, 15, *15*, 17
Morris, William, 9–21, *11*, *13*, *17*, *19*, 25, 30, 74, 78, 83, 111, 159
 and craftsmanship, 11, 19
 decorative pattern design of, 17
 furniture design of, 15, *15*
 and hand production, 11, 12, 20
 and individual workmanship, 11, 12
 influence abroad of, 21
 influence of, on Josef Hoffmann, 38–39
 influence of, on Henry van de Velde, 27
 influence of, on Frank Lloyd Wright, 49–50, 52, 54
 interior decoration of, 12–16
 and mass production, 11, 21
 medieval influence on, 11–13, 15, 21
 portrait of, *11*
 printing and book making of, 19, *21*
 rejection of industrialization by, 11
 and retrogressiveness, 11, 19
 stained glass of, 15
 textiles of, 16–18, *17*, *19*
 utopian political activism of, 11–12
Morrison, Jasper, 131
Murray, Fairfax, *11*
Moser, Koloman, 37, *37*, 38–39, *39*, 43, *43*

Nabis, 30
NASA, 102
nature:
 and Ettore Sottsass Jr., 142
 in works of Frank Lloyd Wright, 52–54, 59
Nefertiti desk (Sottsass), *141*
Nelson, George, 138
Never Leave Well Enough Alone (Loewy), 93, *95*
"New Furniture Designed by Charles Eames," 108
New International Style, 137
News from Nowhere (Morris), 12
New York World's Fair, 1964, IBM presentation at, 116
Niedecken, George, 52
9 years of Bauhaus: A Chronicle (Brandt), 87, *87*

OAO, 165, *165*
Obrist, Hermann, 25
Office of an Industrial Designer (Loewy and Simonson), *95*
Olivetti, 138–41, *139*
Olympic torch (Starck), 162
"organic architecture," 51–52
"Organic Design in Home Furnishings," 107
"origami" furniture, 61
"Ornament and Crime" (Loos), 43
Ozenfant, Amédée, 65–66

packaging, 126, 164, 165, *165*
Peche, Dagobert, 41
pencil sharpener (Loewy), 94, *95*, 98
"perfect whole," 43
Perret, Auguste, 65
Perriand, Charlotte, 59, 71, 72–73, *73*, 75, 152
Pevsner, Nikolaus, 25
Playhouse (Avery Coonley school building) (Wright), 56, *57*
"Planet as Festival, The," 142
plates (van de Velde), *33*
pointillism, 30
Politecnico, 121
Poltronova, 141
Polytextil, 87
Pop art, 141
"Positions for Sitting" (Le Corbusier), 71, 74–75
Postmodernism, 130, 136, 150, 156
Powers of Ten (C. and R. Eames), 115
Prairie houses (Wright), 49, 52, 54, 56
Précisions sur un état présent de l'architecture et de l'urbanisme

(Le Corbusier), *71*
Président M. table (Starck), 161
Przyrembel, Hans, *85*
Purism, 65–66, 71
Purkersdorf Sanatorium, furnishings in (Hoffmann and Moser),
 43, *43*

RAI, pavilion for (A. and P. G. Castiglioni), 122, *123*
Red Cabinet (Kuramata), *149*
Red House (Webb), 12–13, *13*, 17, 27
redesign:
 by Achille Castiglioni, 126
 by Raymond Loewy, 93, 97
 by Shiro Kuramata, 149
Reflections (Brandt), *87*
Renault, *Vanity Fair* ad for (Loewy), *95*
"Revival di Hoffmann" (Hoffmann Revival), *45*
Richard III armchair (Starck), 161, *166*
Rietveld, Gerrit, 79
Ritz writing desk (Kuramata), 152, *153*
Rosenthal dinnerware (Loewy), 101
Rosetti, Dante Gabriel, 13, 15
Royalton Hotel, 161
rug (W. Morris), *19*
Ruppelwerk metal factory, 89
rush-seated chairs (van de Velde), *27*, *29*, *29*, 32
rush-seated chairs (W. Morris), *15*, *15*
Ruskin, John, 12, 38, 66, 111

Saarinen, Eero, 107–8, *107*, 110
Saint George and the Dragon, cabinet on stand with legend of,
 15, *15*
Salon d'Automne, 71, 74
Sanluca armchair (A. and P. G. Castiglioni), 129, *129*, 168
Sapper, Richard, 162
Saturn Five Space Station habitability study (Loewy and Snaith),
 103
Schrager, Ian, 161
Schulze, Helmut, *79*, 84
Schwintzer and Gräff, 87, 89
Sears, Roebuck and Company, 97
Secession Movement, 29, 37–38
Seggiolina da Pranzo (Little Dining Chair) (Sottsass), *137*
Semaine a Paris, La, office of the Administrator (Le Corbusier,
 Perriand, and Jeanneret), 74, *75*
Seurat, Georges, 30
Sezessionstil, 38
Shibuya Seiku department store (Kuramata), 155
Shire, Peter, 137
shopping mall design, 101
silver teapot (Hoffmann), 41, *41*
Simonson, Lee, 94, *95*
"Simple Furniture" (Hoffmann), 38
"Sixty Years of Living Architecture," *49*
Skylab Space Station, 102
Snaith, William, 97, 101, *103*
Socialism, Marxism, 11–12, 27
"Some Hints on Pattern-Designing," (W. Morris), 17
S-1 locomotive (Loewy), *97*
Sottsass Associati, 137, *137*
Sottsass, Ettore, Jr., 133–45, *135*, *137*, *139*, *141*, *143*, *145*, 150
 architecture of, 137
 ceramics of, 142–45
 influences on, 138, 143–45
South Kensington Museum, 16
Sowden, George, 135
St. James's palace, 16
Starck Eyes sunglasses (Starck), 161, *165*
Starck, Philippe, 149, 156, 159–69, *161*, *163*, *165*, *167*, *169*
 environmental content in works of, 165
 Hotel refurbishing of, 161
 human relationships as interest of, 165–66
 interior design of, 161–62
 public image of, 159
Stickley, Gustav, 21, 49
Still Life (Le Corbusier), *67*
Stocklet house (Hoffmann), 43–44, *43*, *45*
 dining room of, 45

Stones of Venice (Ruskin), 12
Strawberry Thief textile (W. Morris), 19, *19*
streamlining, 93, 94–95, 97, 162
Street, George Edmund, 12, 13
Streetcar Named Desire (Williams), **155**
Studebaker Commander Convertible (Loewy), *98, 99*
Studebaker Commander V-8 Regal Starlight coupe (Loewy),
 98, 99
Studio Alchimia, 135–36
Studio, The, 49
Sullivan, Louis, 49, 52
sumac motif, 52
Super Markets of the Sixties, 101
Superboxes (Sottsass), 141, 152
Superstudio, 142
Surrealism, 138, 149
Susan Lawrence Dana house (Wright), 52, *53*, 55
"Sussex" rush seated chairs (Morris and Company), 15, *15*
Symbolist painters, 30

table and chairs (Sottsass), *141*
table clock (Brandt), *89*
table lamp (Jucker and Wagenfeld), *85*
Taccia (Touch) table lamp (A. and P. G. Castiglioni), 124, *125*
Taliesin ensemble (Wright), 51
 fabric from, *51*
Taliesin West, living room at (Wright), *61*
Tandem Sling Seating (C. and R. Eames), 114, *115*
Tapestry Room, St. James's Palace, 16
Target stores, 164
Taut, Bruno, 152
tea infusers (Brandt), *82*, 83, *83*
Teague, Walter Dorwin, 93
teapot (Hoffmann), *41*
"Ten Automobiles," 98
"Theory and Organization of the Bauhaus, The" (Gropius), 25
Thonet, 68, 74, 150
 Stahlrohrmöbel (steel furniture) catalog of, *75*
Thun, Matteo, 135
Toio floor lamps (A. and P. G. Castiglioni), 131, *131*
Tops (C. and R. Eames), 115
"Totem" (Sottsass), 145
Towards a New Architecture (Le Corbusier), 65, 68
Triennale exhibitions, Milan, 121, *121*, 138
Tropon poster (van de Velde), 32, *33*
Tubino table lamp (A. and P. G. Castiglioni), *123*
Tulip and Willow textile (W. Morris), 17, *17*
Twilight Time table (Kuramata), 155
type objects:
 for Achille Castiglioni, 125–26
 for Charles and Ray Eames, 111, 115
 for Le Corbusier, 66, 68–74, 126, 128
typewriter table (Breuer), *75*

Umeda, Masanori, 137
unity, aesthetic, 39, 43, 61
Urban, Joseph, 41
Usonian house (Wright), 60, *61*

Valentine portable Olivetti typewriter (Sottsass), 138, *139*, 166
van de Velde, Henry, 23–33, *25*, *31*, *33*
 engineering admired by, 29, 32
 French critical response to, 29
 furniture of, *27*, 29–30, *29*
 German critical response to, 29–30
 importance of line to, 32
 influences on, 30
 recommendation of Gropius as successor to, 25
 Joseph Hoffmann vs., 37
van de Velde, Maria Sèthe, *25*, 27–29, *29*
Van Nu en Straks (Of Now and Later), cover of (van de Velde),
 30, *31*
Ver Sacrum (Sacred Spring), 37
Vingts, Les (The Twenty), 27, 30

Wagenfeld, Wilhelm, 83, *85*
Wagner, Otto, 37
Wagner, Richard, 26

wallpaper (Hoffmann), *41*
Wardle, George, *11*
Wärndorfer, Fritz, 38
Webb, Philip, 13, *13*, 15, *15*, 16, *17*, 27
weed holder (Wright), 55
Werkbund, 26
Wiener Werkstätte (Vienna Workshop), 21, 37–44, *37*, *39*, *41*, *43*
 exhibition of (Hoffmann and Moser), *39*
Williams, Tennessee, 155
Wimmer, Eduard Joseph, 41
windows (Wright), 57
Wolf house (Sottsass), 138, *139*
Woman Playing a Lute (Minstrel) (W. Morris), *17*
Works of Geoffrey Chaucer, Kelmscott edition (W. Morris and
 Burne-Jones), 19, *21*
Womb chair (Saarinen), 110
World of Franklin and Jefferson, The (C. and R. Eames), 116
Wright, Frank Lloyd, 44, 47–62, *49*, *55*, *57*, *59*, 74
 New York exhibition of, 60, *61*
 dining room furniture of, 49, *51*, 57
 prolific productivity of, 51
 and unity of design, 61

Zanini, Marco, 135, 137

Credits